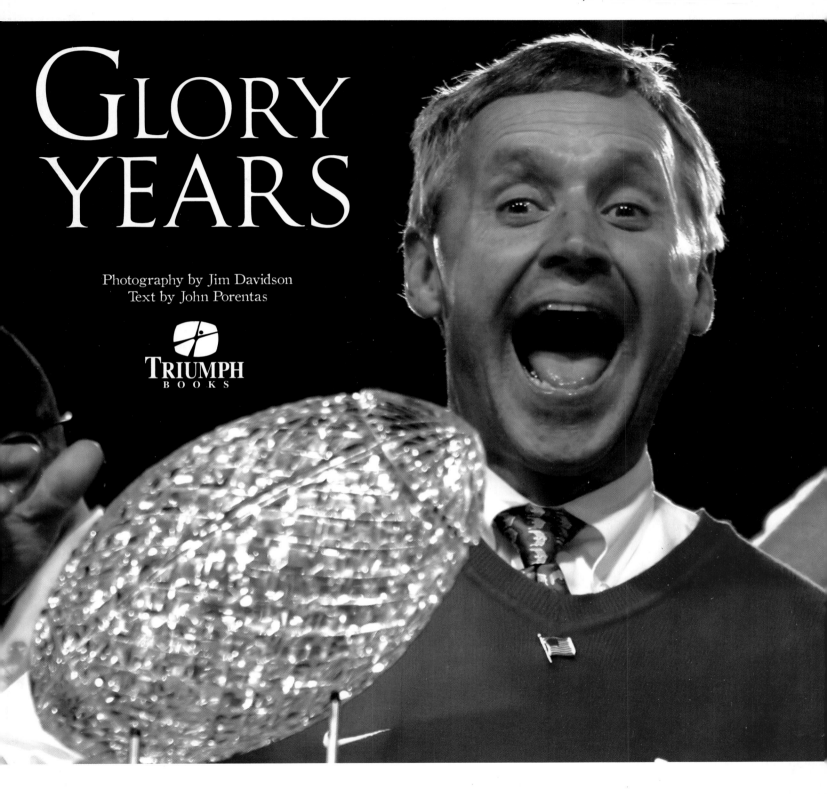

GLORY YEARS

Photography by Jim Davidson
Text by John Porentas

TRIUMPH
BOOKS

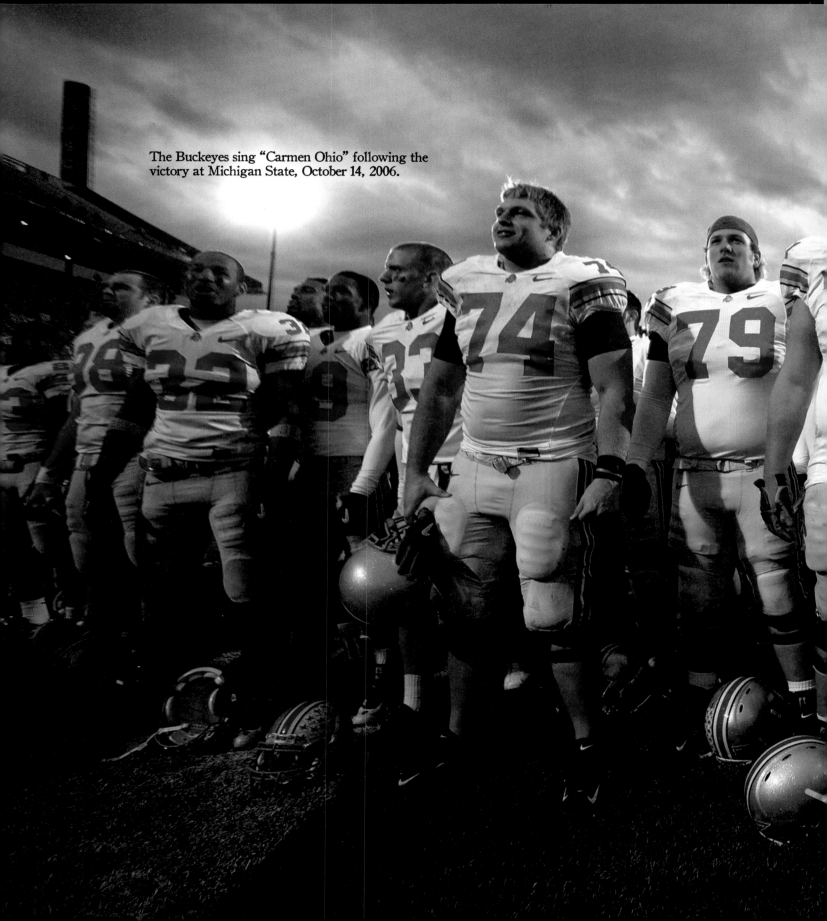

The Buckeyes sing "Carmen Ohio" following the victory at Michigan State, October 14, 2006.

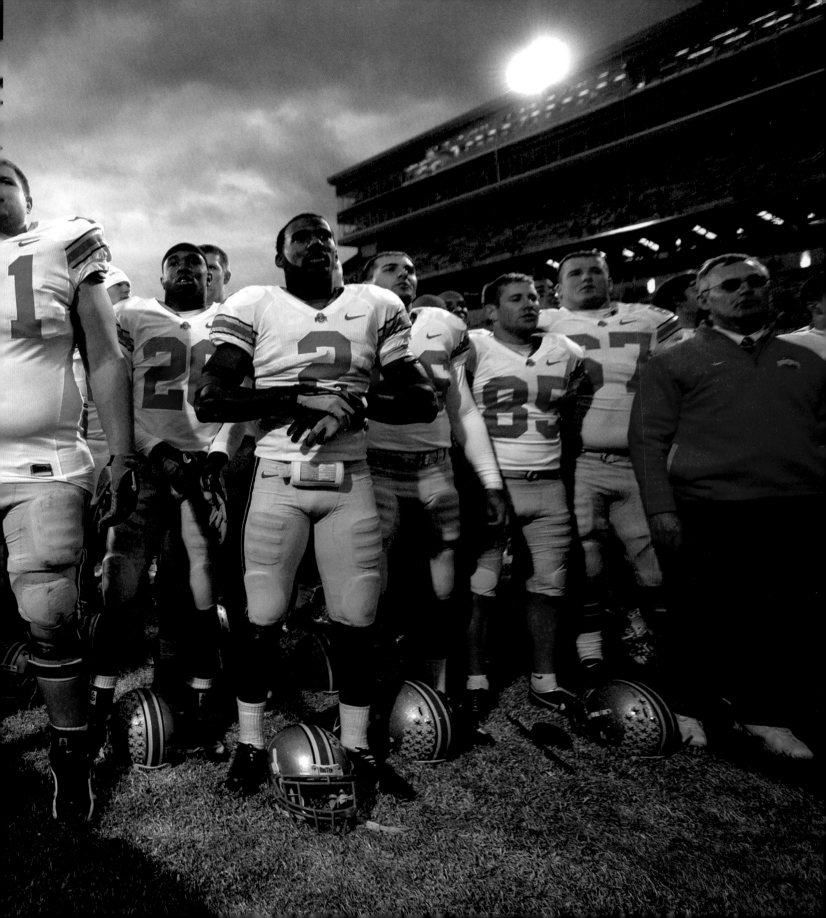

Triumph Books and colophon are registered trademarks of Random House, Inc.

This book is available in quantity at special discounts for your group or organization.
For further information, contact:

Triumph Books
542 South Dearborn Street
Suite 750
Chicago, Illinois 60605
(312) 939–3330
Fax (312) 663–3557

Printed in U.S.A.
ISBN: 978–1–60078–160–5

Content packaged by Mojo Media, Inc.
Joe Funk: Editor
Jason Hinman: Creative Director

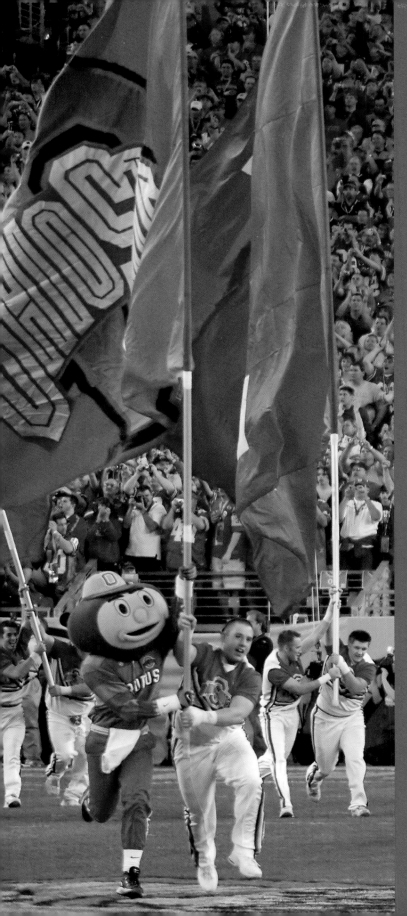

CONTENTS

Brutus Buckeye and the cheerleaders lead the team onto the field before the 2006 national championship game.

Dedication
This book is dedicated to my late father, Mick Davidson, and to my late Uncle Bob Davidson. Their interest in photography pointed me in this direction at an early age.

Publisher's Note

A go-to guy—every team needs one if they hope to succeed.

We were fortunate enough to have a go-to guy on our team in Craig Eisner. Craig has an amazing passion for anything Buckeyes. He is also among the most strategic, market-driven thinkers I know.

Many years ago, Craig suggested that we approach Jim Davidson; he felt Jim was an incredibly talented photographer with a sixth sense for getting shots others couldn't.
Fortunately, Craig stayed after me, and we ultimately connected with Jim—resulting in this stunning book, *Glory Years.* Furthermore, Craig stepped up and volunteered to play an under-pressure leadership role on the project, without skipping a beat in his day job as a senior manager with AT&T.

Happily for the Buckeyes, Craig has instilled his zeal and passion for OSU in his two sons George and Henry (though his wife Rebecca has mixed Buckeye-Wolverine allegiances).

FOREWORD

During Jim Tressel's first seven years as Ohio State's head coach from 2001 through 2007, the Buckeyes captured a national title and twice finished second, compiled a magnificent overall seven-year record of 73-16, and earned four Big Ten championships—two outright and two shared. But in the hearts of Scarlet and Gray loyalists, Ohio State's record of 6-1 against arch-rival Michigan is why these are truly "Glory Years."

Jim Tressel's 6-1 mark against Michigan is the finest of any Ohio State coach during his first seven seasons. The next best record for an Ohio State coach in his first seven efforts against the Wolverines is 4-3—held jointly by Francis Schmidt (1934-1940), Woody Hayes (1951-1957), and Earle Bruce (1979-1985).

Additionally, the Buckeyes have only once before won six out any seven consecutive games against Michigan. Hayes' teams of 1957 through 1963 were 6-1 against "that team up north," losing only in the 1959 contest at Michigan Stadium, 23-14.

This distinctive book includes amazing photos from some of Ohio State's all-time greatest victories. The Buckeyes proudly defeated highly favored Miami 31-24 in double overtime to claim the 2002 national championship. Earlier that season, Ohio State edged Purdue 10-6, thanks to a 37-yard scoring toss into the wind from quarterback Craig Krenzel to wide receiver Michael Jenkins, with just 1:36 remaining in the fourth quarter. The 2002 season included Ohio State's first-ever overtime game, a 23-16 triumph at Illinois, followed the next weekend by a cherished 14-9 home victory over Michigan.

In one of college football's all-time classic match-ups, No. 1 Ohio State hosted No. 2 Michigan in 2006. It is the only time the Buckeyes and Wolverines have collided as the nation's top-ranked teams. In the "game of the century," Ohio State used its excellent speed to outscore Michigan, 42-39, and claim the outright Big Ten championship. The two met on November 18, just one day after legendary Bo Schembechler, Michigan's retired head coach, passed away at age 77. Ohio State quarterback Troy Smith came through with his third consecutive outstanding game against the Wolverines, and later that year was awarded the coveted Heisman Trophy.

And who better to provide this exciting pictorial journey than sports photographer Jim Davidson? I have known Jim for several years. He is a good friend, and I have always admired his talented work and superb attention to detail. Several of his unique photos proudly hang in my office. Jim is a true professional in every aspect of his work.

Enjoy this breathtaking pictorial voyage through *Glory Years*—one of the top periods in all of Ohio State football!

—Jack Park
Commentator, The Ohio State Football Radio Network
Author, *The Official Ohio State Football Encyclopedia*
and *The Ohio State University Football Vault*

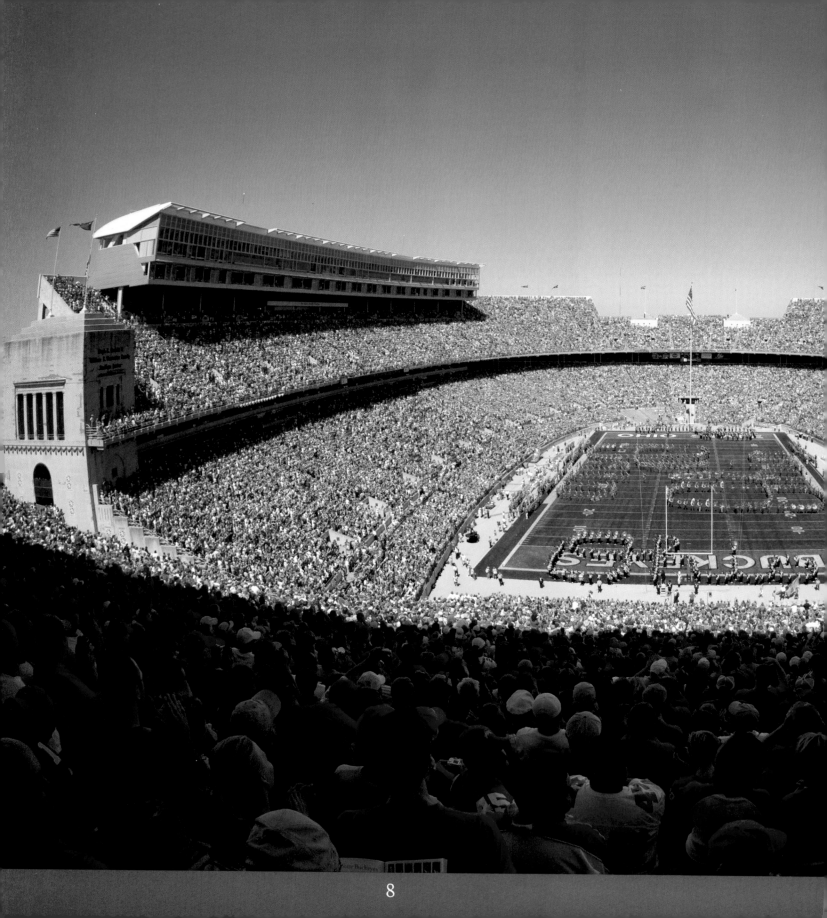

The OSU Marching Band and the Alumni band form a Quad Script Ohio during halftime of the September 2, 2006, game versus Northern Illinois.

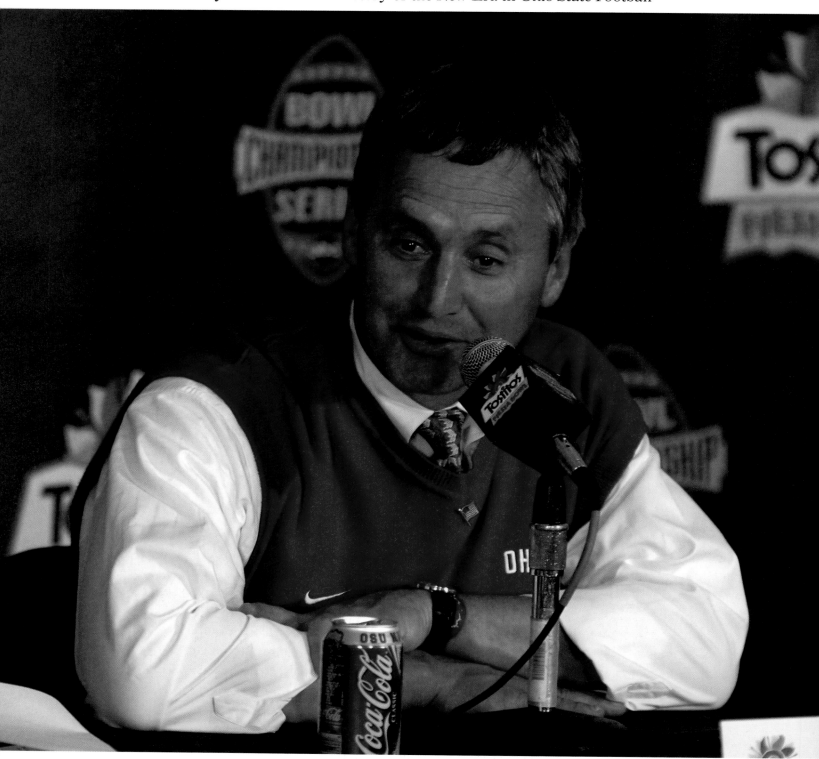

INTRO
Glory Years Buckeyes Style

In Ohio State football, victories are a given. Glory requires something more. The true Buckeyes glory years begin with wins, but also require dominance against archrival Michigan and runs at national championships. OSU fans are currently living through another stretch of glory years that has been long awaited by the Buckeye Nation.

The last era in OSU football considered a glory era began in 1951 and ended in 1978. During that time the Buckeyes held a 16–11–1 edge against Michigan and captured five national championships—in 1954, 1957, 1961, 1968, and 1970.

The coach in that era was Wayne Woodrow Hayes. His overall record was 205–61–10, but it was his record against Michigan and his national championships that created the legend of Woody Hayes and made his era one of glory. Today there is a road named after Hayes that runs in front of Ohio Stadium. There is also a building named after him; new generations of Buckeyes now train in the Woody Hayes Athletic Center.

Hayes' two immediate successors, Earle Bruce and John Cooper, are both members of the College Football Hall of Fame. Both are outstanding men, outstanding coaches and winners, but neither produced what Buckeyes fans would consider glory years. There are no streets or buildings named after either Bruce or Cooper on the Ohio State campus.

Hired from Iowa State and a former OSU football player under Hayes, Bruce had a winning record against Michigan at 5–4–1. In his first season as the Buckeyes head coach, the former Hayes assistant came within one win of capturing a national championship, but a loss to Southern Cal by one point in the Rose Bowl denied him. After that season his teams never contended for a national championship again. Eventually he earned the mantle of "9-3 Earle." His overall record at Ohio State of 81–26–1 included five bowl wins in eight bowl appearances. Despite the fact that he won

Head Coach Jim Tressel forces back a big smile while answering questions from reporters after the Buckeyes defeated the Miami Hurricanes to win the 2002 BCS National Championship.

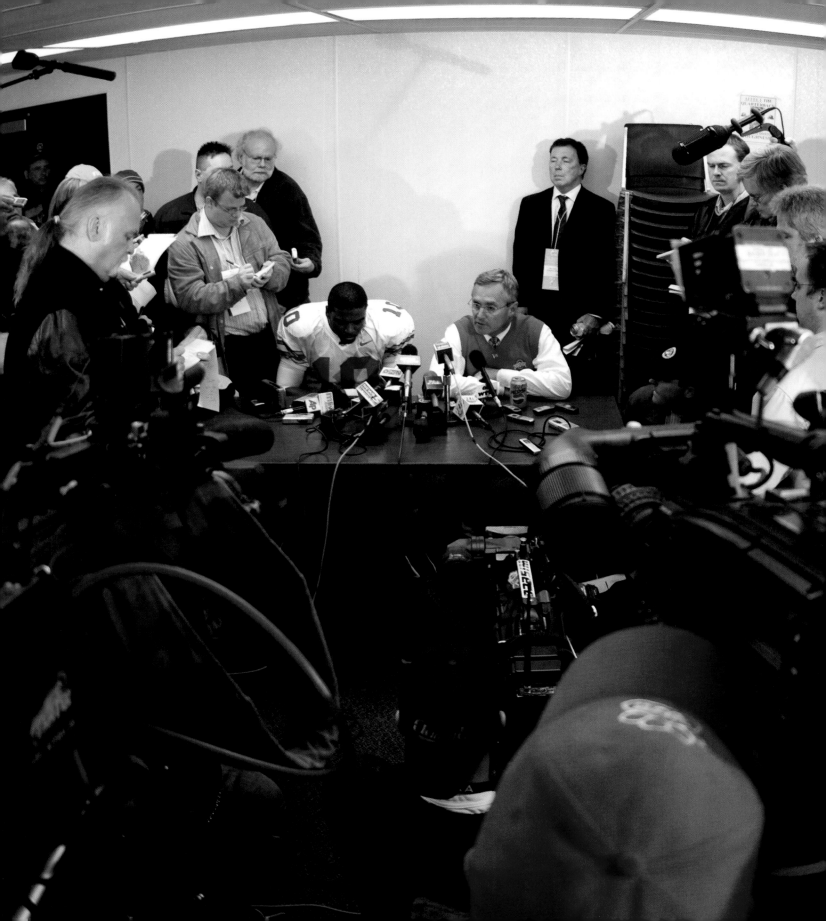

against Michigan, in the eyes of Buckeyes fans, Bruce did not create a reign of glory years because after his initial season his teams were not perennial national contenders. He was fired in 1987 and replaced by Cooper, the head coach at Arizona State.

John Cooper's teams won consistently and were often highly ranked, but his record against Michigan of 2–10–1 will forever exclude his era from the category of glory years in Ohio State football. His overall record of 111–43–4 is second only to that of Hayes in Ohio State football history, but his era is considered one of mediocrity. In 1996 and 1998 his teams finished the season ranked second in the nation, but his Michigan losses overshadow all those achievements in the eyes of Buckeyes fans. Losses to Michigan trump winning in Ohio, and Cooper's era will be forever remembered for those losses, not the many wins he produced. Cooper was fired after the 2000 season, which prompted a change in Ohio State football that ushered in an era of glory that is still continuing today.

Jim Tressel was hired to succeed John Cooper as the Ohio State head football coach. Tressel was a life-long Ohioan whose father, Lee, was a football coach at Baldwin-Wallace College in Ohio. Tressel had served on Bruce's coaching staff at Ohio State as an assistant coach. He left that position to take the head coaching position at Youngstown State. Tressel's Ohio background gave him an understanding of what is important in Ohio State football, which he proved at his introduction to the public as Ohio State's new head football coach. During halftime at the Ohio State men's basketball game, coincidently against Michigan, Tressel was introduced to the crowd and immediately served notice that he understood the importance of the Michigan rivalry.

"You'll be proud of our young people in the classroom, in the community, and most especially in 310 days on the football field in Ann Arbor, Michigan," Tressel said, eliciting a roar from the delighted crowd. Though technically, Tressel did not predict victory, he delivered it in his first season when his team won in Ann Arbor in 2001.

Since then, the Buckeyes have averaged more than 10 wins per season, have beaten Michigan six out of seven years, and played in the BCS National Championship game three times, winning it once. These are truly glory years in Ohio State football; Buckeyes fans may one day be driving down Tressel Avenue.

This book is a history of those years as seen through the lens of sports photographer Jim Davidson. Davidson began photographing Ohio State football in 2002 and has chronicled every game since then with his camera. His photos catch not only the critical moments on the field, but often capture the response of the fans in attendance. The narrative supplied is intended to paint a background for the photos and establish the defining moments and personalities of the various seasons. ◾

Head Coach Jim Tressel and quarterback Troy Smith address the media, crammed into the tiny visiting-team interview room, following Smith's second (of three) consecutive victory over the Michigan Wolverines.

2001
The foundations for glory are laid in a year of tragedy

The Buckeyes won seven games in 2001 and lost five, but one of those wins was a 26–20 win over Michigan in Ann Arbor to end the regular season. Predictably, that win completely salved the sting of the losses that season. It was, after all, OSU's first win in Ann Arbor since 1979.

The season was marked by tragedy both for Jim Tressel personally and for the nation. Tressel dealt with the death of his mother Eloise that year and the nation dealt with the terrorist attack on the World Trade Center. The game against San Diego State scheduled for September 14 was postponed in the aftermath of the 9/11 attack. A memorial service was held in Ohio Stadium that Saturday instead and more than 10,000 people attended. The game was eventually played on October 20 since that date was conveniently open on both team's original schedules.

Throughout that first season Tressel introduced "Tressel Ball" to his team and the fans. The Buckeyes relied on stout defense, exceptional special teams play, and an opportunistic offense. The power running game featuring tailback Jonathan Wells was the backbone of the offense. Senior quarterback Steve Bellisari improved as the season progressed after struggling during his previous years at OSU. Seven or fewer points decided six of the 12 games played—a trend that would continue in subsequent seasons.

The lowlight of the season occurred the week of the Illinois game when Bellisari was arrested on drinking-related charges. Tressel suspended Bellisari and named Scott McMullen the starter

Jonathan Wells rushed for 101 yards on 21 carries with one touchdown in the victory over the Boilermakers in West Lafayette, Indiana, on November 10, 2001. *Photo by Chance Brockway Jr.*

2001

for the contest that weekend against the Illini. With just two days to prepare as the OSU starter, McMullen guided the Buckeyes to a touchdown and a field goal in the first quarter. The Buckeyes offense then became stagnant, and Tressel called on Craig Krenzel to relieve McMullen. Krenzel rallied OSU from a 21–10 deficit to a 22–21 lead, but the No. 12 Illini finally prevailed 32–22 over the No. 25 Buckeyes.

The Buckeyes lost to Illinois but in the process found a quarterback. Krenzel's performance earned him the starting quarterback position and a week later he led the unranked Buckeyes to a 26–20 win over heavily favored No. 11 Michigan in Ann Arbor. That win highlighted the season, particularly in view of Tressel's pronouncement 310 days earlier. In that game, Wells scored on runs of one, 46, and 11 yards to help take OSU to a stunning 23–0 lead at the half. The Buckeyes then used "Tressel Ball" to hold on for the win. Wells rushed for 122 yards on 23 carries while Krenzel was 11 of 18 for 118 yards passing. The Ohio State defense came up with a safety, four interceptions, and a fumble recovery to thwart the Wolverine offense. The Buckeye win also knocked Michigan out of the Big Ten championship and gave it to Illinois.

Quarterback Steve Bellisari entered the game on OSU's second possession of the January 2, 2002, Outback Bowl versus South Carolina. This marked his first appearance on the field since being suspended before the Illinois game. *Photo by Chance Brockway Jr.*

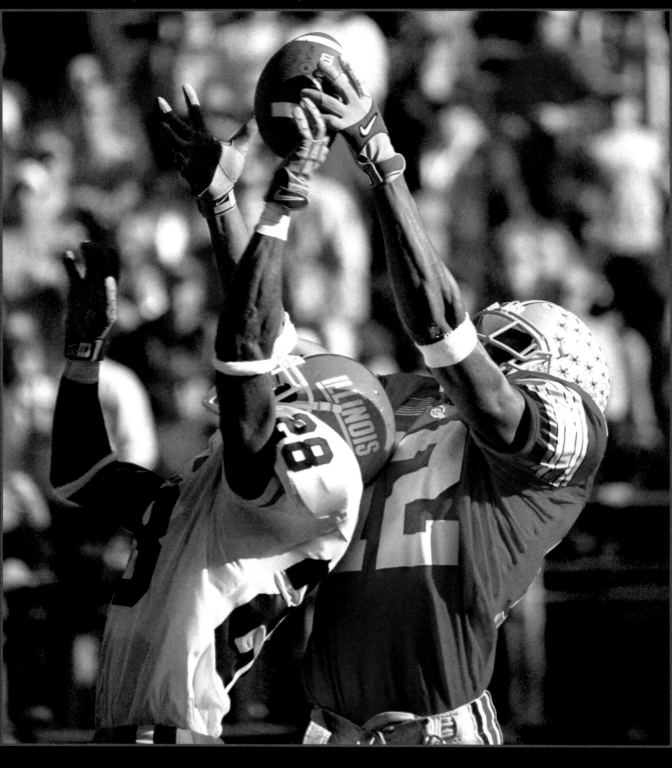

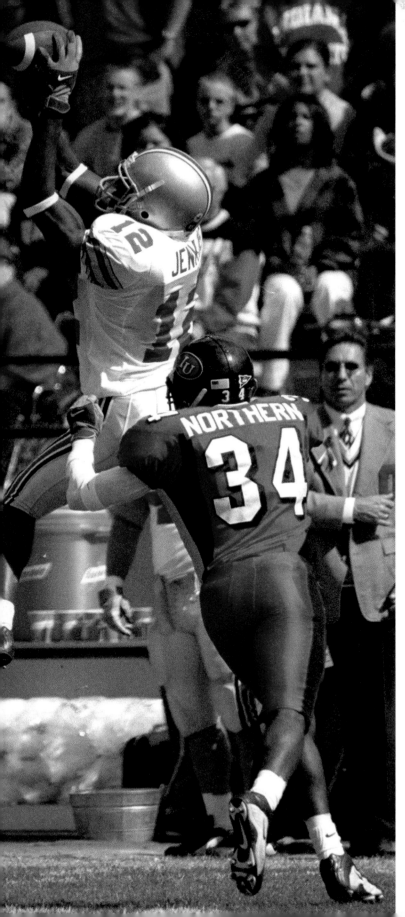

2001

OSU played South Carolina in the Outback Bowl for the second-consecutive season. Rimington Award winner LeCharles Bentley was unable to play in that game due to a chronic shoulder injury and was replaced by former walk-on Mike Jacobs. Krenzel started at quarterback but was relieved by Bellisari early in the game. OSU trailed 14–0 at the half but Bellisari rallied OSU to tie the game at 28–28 in the fourth quarter. The Gamecocks finally won on a last-second field goal following an interception and a long runback by South Carolina's Sheldon Brown. Bellisari was 21–35 passing for 320 yards and two touchdowns and also scored a touchdown, but his late interception on a pass intended for Michael Jenkins proved too costly.

Krenzel got valuable experience in 2001, as did young players such as sophomore wide receiver Michael Jenkins, freshman wide receiver Chris Gamble, sophomore offensive linemen Shane Olivea and Alex Stepanovich, and sophomore defensive linemen Will Smith and Darrion Scott. Freshman kicker Mike Nugent struggled but persevered to excel the following season. Former

(opposite) Michael Jenkins elevates over Illinois' cornerback Eugene Wilson, taking away a possible interception. Jenkins had a huge day with 10 receptions for 155 yards and one touchdown in the 34–22 loss to the Illini.
Photo by Chance Brockway Jr.

(left) Michael Jenkins comes down with a catch over Hoosier defender Willie Northern in Bloomington, Indiana, September 29, 2001. Jenkins lead all Buckeye receivers on a day that the ball was spread widely across the roster, with 60 yards on three catches. Nine different Buckeyes hauled in at least one reception as OSU handled Indiana 27–14. *Photo by Chance Brockway Jr.*

2001

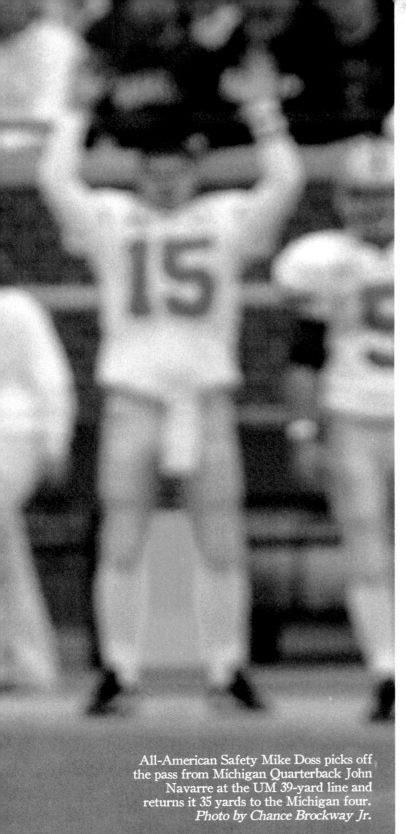

All-American Safety Mike Doss picks off the pass from Michigan Quarterback John Navarre at the UM 39-yard line and returns it 35 yards to the Michigan four. *Photo by Chance Brockway Jr.*

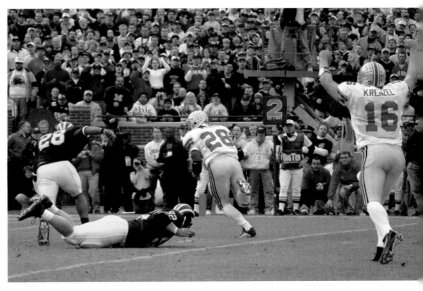

walk-on punter Andy Groom established himself as a premier kicker. Additionally, "Tressel Ball" was firmly established at OSU. All of that would pay dividends in upcoming years.

The season kicked off in the newly renovated Ohio Stadium. The three-year, $150 million renovation project was completed on schedule and in time for the season-opener against Akron. Ohio State played before crowds of more than 100,000 in every home game that year for the first time ever. ■

(above) Quarterback Craig Krenzel raises his hands in celebration as Jonathan Wells heads into the end zone for his third touchdown of the first half. Wells had an outstanding day in Ann Arbor, racking up 129 yards on 25 carries to go with his three touchdowns in the game. The victory marked the first time since 1979 that the Buckeyes managed to defeat the Wolverines inside Michigan Stadium. *Photo by Chance Brockway Jr.*

(opposite) Quarterback Craig Krenzel points the way as he leads the team on the first possession of the Outback Bowl. *Photo by Chance Brockway Jr.*

(left) Scott McMullen drops back for a pass. McMullen completed only four of 13 passes for 42 yards during the game versus the Illini. *Photo by Chance Brockway Jr.*

(above) The Buckeyes come together before taking on the Indiana Hoosiers. *Photo by Chance Brockway Jr.*

2001 STATS

Overall: 7–5 · **Big Ten**: 5–3 · **Final Ranking**: Unranked
Major Award Winners: LeCharles Bentley – Rimington Award
First Team All-American: LeCharles Bentley (center), Mike Doss (safety)
First Team All-Big Ten: LeCharles Bentley (center), Tyson Walter
(offensive tackle), Mike Doss (safety)

W/L	Date	PF	Opponent	PA	Location
W	09–08–2001	28	Akron	14	Columbus, OH
L	09–22–2001	6	UCLA	13	Los Angeles, CA
W	09–29–2001	27	Indiana	14	Bloomington, IN
W	10–06–2001	38	Northwestern	20	Columbus, OH
L	10–13–2001	17	Wisconsin	20	Columbus, OH
W	10–20–2001	27	San Diego St.	12	Columbus, OH
L	10–27–2001	27	Penn St.	29	State College, PA
W	11–03–2001	31	Minnesota	28	Minneapolis, MN
W	11–10–2001	35	Purdue	9	Columbus, OH
L	11–17–2001	22	Illinois	34	Columbus, OH
W	11–24–2001	26	Michigan	20	Ann Arbor, MI
L	01–01–2002	28	South Carolina	31	Tampa, FL

Jonathan Wells draws first blood with a one-yard
touchdown run through the middle of Michigan's defense.
Photo by Chance Brockway Jr.

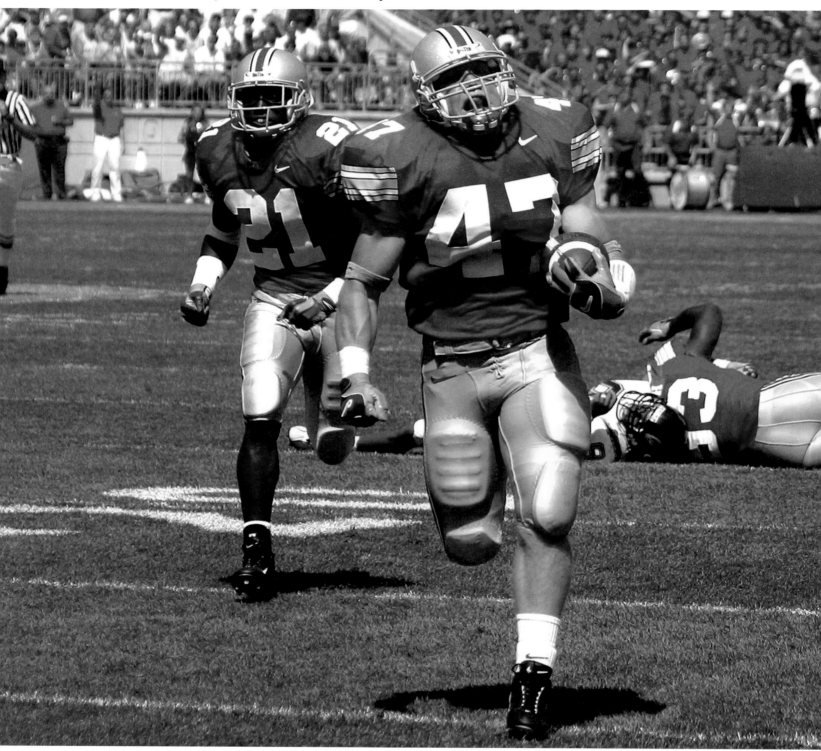

2002
The Glory Begins

Ohio State entered the 2002 season ranked as the No. 13 team in the nation. By season's end, they were the BCS National Champions and had concluded a perfect 14–0 season.

From a talented and troubled freshman running back to a stifling defense to a string of close calls that culminated in an overtime championship upset, the number of story lines that emerged as the 2002 season progressed is truly remarkable.

On offense, freshman tailback Maurice Clarett burst onto the scene in the season opener. He rushed for 175 yards on 21 carries and scored three touchdowns on runs of 58, 45, and one yard to help Ohio State bury Texas Tech in the Pigskin Classic by a final of 45–21. Over the course of the season, Clarett rushed for 1,237 yards in 11 games,

an average of 112.5 yards per game. He scored 18 of OSU's 48 touchdowns. His yardage total established a new freshman rushing record at Ohio State, eclipsing the mark set by Robert Smith.

On the other side of the ball, it was next to impossible to run on the Ohio State defense engineered by defensive coordinator Mark Dantonio. The Buckeyes gave up a paltry average of 77.7 yards rushing per game, stuffing even the best backs in the land. Penn State's Larry Johnson led the nation in rushing with 2,087 yards, the seventh-highest rushing total in NCAA history. He averaged 160.5 yards per game, but against the Ohio State defense, Johnson rushed for 66 yards on 16 carries.

The Ohio State defense also terrorized and mauled opposing quarterbacks. Texas Tech

A portent of things to come. True-freshman linebacker A. J. Hawk (47) returns an interception 34-yards for his first score as a Buckeye. The play put OSU up 38–0 in the second quarter over Kent State.

2002

Heisman candidate Kliff Kingsbury completed just 26 of 44 passes in the season opener and was sacked seven times. Washington State Heisman candidate Jason Gesser was intercepted twice and sacked four times in OSU's 25–7 win over the Cougars. Wisconsin's Brooks Bollinger was knocked out of the game with a concussion after he was sacked for the fourth time midway through the second quarter and did not return. Cincinnati quarterback Gino Guidugli was blind-sided by defensive end Darrion Scott and fumbled the football after a bone-jarring hit. Ohio State capitalized on the turnover for the game-winning touchdown. The Buckeyes sacked Illinois quarterback Jon Beutjer nine times. In the national championship game, Miami's Ken Dorsey was sacked four times. With the national title hanging in the balance in the second over-time, he was knocked out of the game for a play after an enormous hit by blitzing linebacker Matt Wilhelm. Dorsey spent several hours in a local hospital after the game suffering from dehydra-tion and a possible concussion. In all, the OSU defense recorded 40 sacks, intercepted 18 passes, and recovered 12 fumbles. OSU scored 80 points off turnovers, the opposition just 10.

The Buckeyes earned their share of lopsided wins in 2002, but it was the number of close games they won that helped make the season remarkable.

In the game against Cincinnati, a late interception

Tight end Ryan Hamby scored on an 18-yard pass reception from Scott McMullen to put OSU up 51–17 on Kent State.

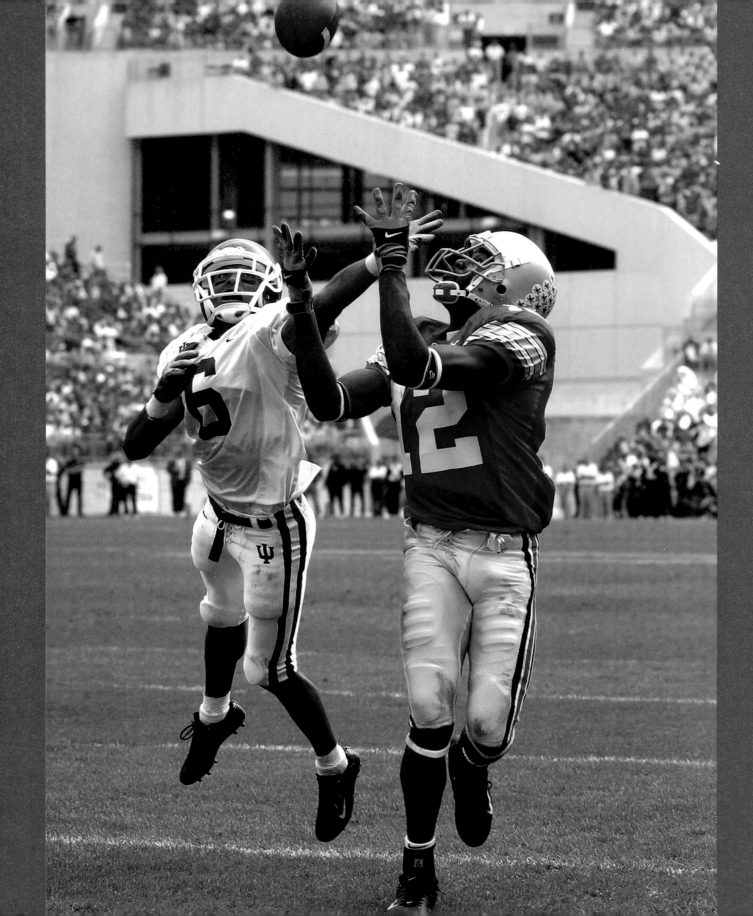

2002

in the end zone by safety Will Allen preserved a 23–19 OSU win over the Bearcats at Paul Brown Stadium. The play capped four-consecutive pass attempts into the end zone by Guidugli after Cincinnati had reached the OSU 20-yard line with 1:05 remaining on the game clock.

The Buckeyes trailed Wisconsin 14-13 going into the fourth quarter in Madison. Tight end Ben Hartsock caught a three-yard touchdown pass from Krenzel with 9:59 remaining to put OSU up 19-14. The Buckeye defense then held on the rest of the way.

Ohio State did not score an offensive touchdown against Penn State and trailed 6–3 at the half, but ended up with a 13–7 win on the strength of two 37-yard field goals by Mike Nugent and a 40-yard interception return in the third quarter by defensive back Chris Gamble.

The last four games of the season were all nail-biters. At Purdue, the No. 3 Buckeyes trailed the Boilermakers 6–3 with just 1:36 remaining in the game. On fourth-and-one from the 37-yard line and with an undefeated season on the line, Krenzel went deep to wide receiver Michael Jenkins who caught the ball in the end zone for the game-winning touchdown. ABC announcer

(left) On the first drive of the second half wide receiver Chris Gamble went 43 yards on a reverse to put OSU up 28–10 against Indiana. It was Gamble's first career touchdown. The Buckeyes won the game 45–17.

(opposite) Michael Jenkins hauled in a 15-yard touchdown pass from Scott McMullen for OSU's final score against the Hoosiers.

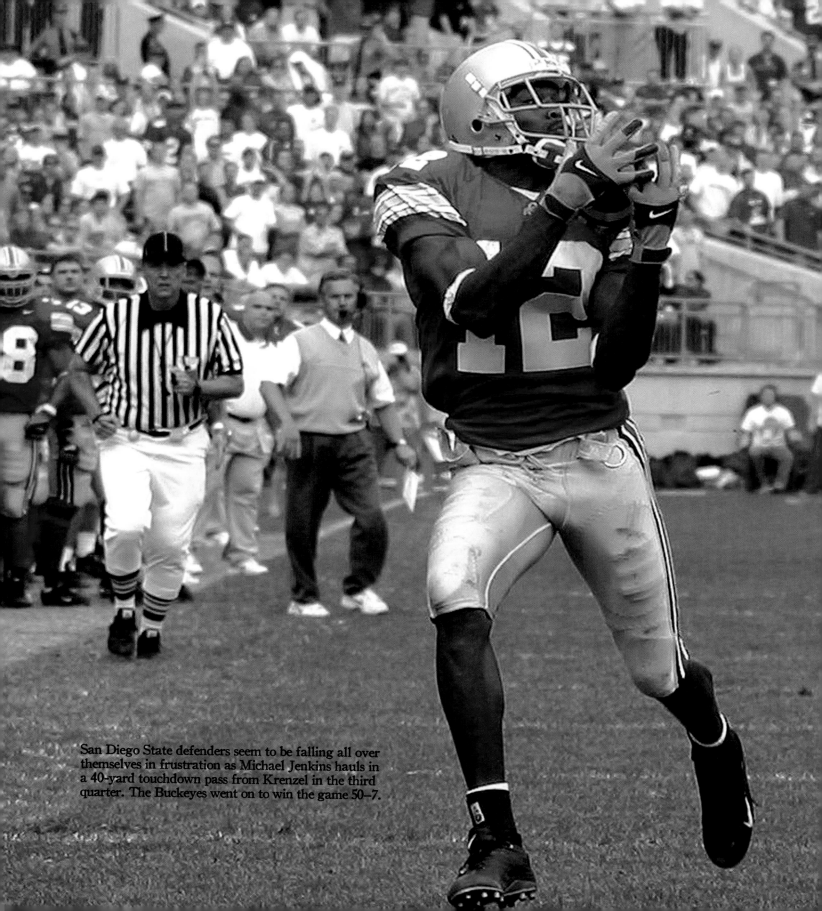

San Diego State defenders seem to be falling all over themselves in frustration as Michael Jenkins hauls in a 40-yard touchdown pass from Krenzel in the third quarter. The Buckeyes went on to win the game 50–7.

Brent Musburger further immortalized the play with his "Holy Buckeye" call that caught the imagination of Buckeyes fans.

The win over Purdue moved Ohio State into second in the national ranking and in line for a spot in the national championship game. All the Buckeyes had to do to get there was win out, but the following weekend at Illinois the game was tied 16–16 at the end of regulation and went to overtime. OSU kicker Mike Nugent missed two field goals in regulation—one from 41 yards out and the other from 37—that were his only two misses of the regular season. Buckeyes tailback Maurice Hall scored on an 8-yard touchdown run on OSU's first possession in overtime. The Ohio State defense then made a stand to preserve the win. The key play came on third down when a hit by OSU defensive back Dustin Fox drove Illinois receiver Walter Young out of bounds in the end zone just as Young bobbled the football, thwarting what would have been the tying score. Defensive lineman Tim Anderson batted down a pass at the line of scrimmage on fourth down to end the game.

(opposite) Maurice Clarett takes a handoff from Craig Krenzel and goes five yards for a touchdown to put OSU up 24–7 in the second quarter against San Jose State. Clarett rushed for 132 yards on 18 carries. He also caught a seven-yard pass from Krenzel for a touchdown.

(left) Fullback Brandon Schnittker goes for 12 yards against the Badgers after taking a pass from Craig Krenzel.

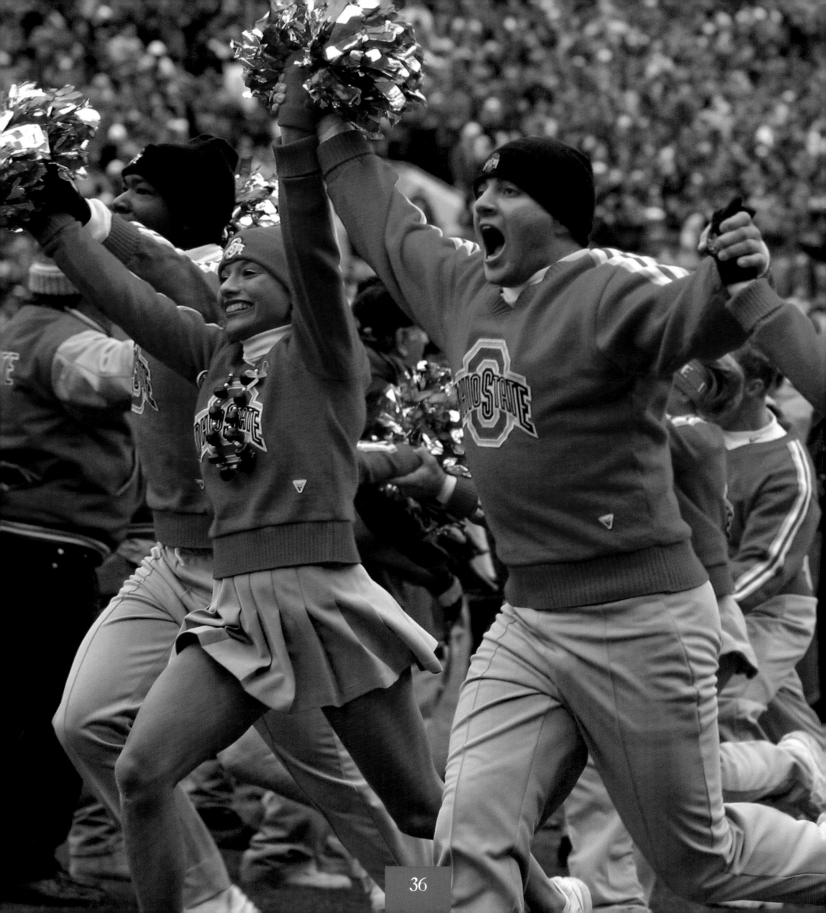

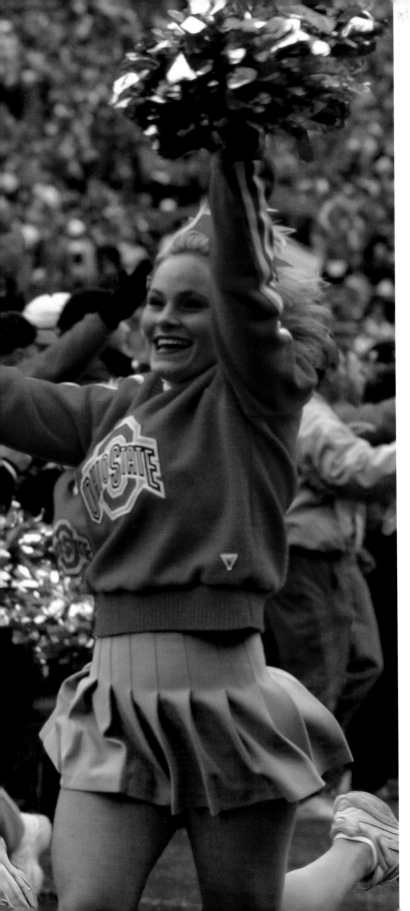

2002

One opponent stood between the Buckeyes and the chance to play for their first national title since 1968. OSU needed a win at home over No. 12 Michigan in the final game of the season to earn as spot in the BCS championship game. That game proved to be as thrilling as the previous two, as the Wolverines won everywhere but where it mattered.

Michigan outgained Ohio State (368 yards to 262), led in time of possession (34:53 to 25:07), and led on the scoreboard (9–7 at the half), but a 3-yard run around right end by Hall with 4:55 remaining put OSU up 14–9. Michigan made two desperate drives in the last 4:55 but came up empty on both. The Wolverines drove for a first down at the OSU 30 with 2:02 remaining, but defensive lineman Darrion Scott knocked the ball loose from Michigan quarterback John Navarre. Fellow defensive lineman Will Smith recovered for OSU for the turnover.

The Buckeyes offense just needed a first down to salt away the game but couldn't produce it, forcing the Buckeyes to punt. Michigan regained possession on its own 20-yard line with no time-outs and only 58 seconds remaining to play. Navarre somehow drove the Wolverines to the OSU 24-yard line. With seven seconds left to play, Navarre threw the final pass of the game that was intercepted near the goal line by OSU safety Will Allen. Had Allen not made the play, a

OSU cheerleaders lead the Buckeyes onto the Ohio Stadium field on a cool day in November.

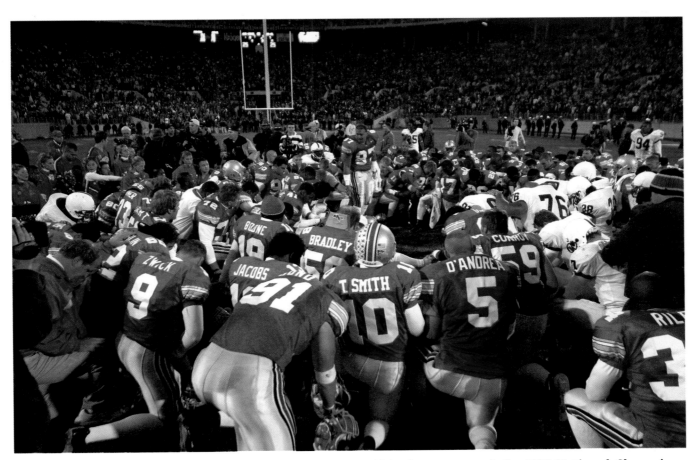

(opposite) Chris Gamble celebrates a touchdown with his teammates. (above) Following OSU's 13–7 win over Penn State, the Buckeyes and Nittany Lions convene in the middle of the field for a post-game prayer.

Michigan receiver was open behind the OSU defense for the potential score, but the interception ended the contest and sent the Buckeyes to the national championship game. Pandemonium reigned as Krenzel was carried around the Ohio Stadium turf by OSU students.

As thrilling as the last three games of the regular season were, they were nothing but a warm-up for the sheer hysteria that followed in the national championship game at the Fiesta Bowl in Tempe, Arizona.

Ohio State entered the BCS National Championship game as prohibitive 12-point underdogs to the No. 1-ranked Miami Hurricanes. Miami was the defending national champion and undefeated for the season. Quarterback Ken Dorsey, running back Willis McGahee, tight end Kellen Winslow Jr., and wide receiver Andre Johnson spearheaded the Hurricane offensive attack that operated behind a big, rugged, experienced offensive line. On the defensive side of the ball, middle linebacker Jonathan Vilma led Miami with 132 tackles and defensive back Sean Taylor recorded four interceptions and 15 pass breakups. Up front, Jamaal Green recorded 10 sacks and 20 quarterback hurries, while Vince Wilfork had 15 tackles for loss

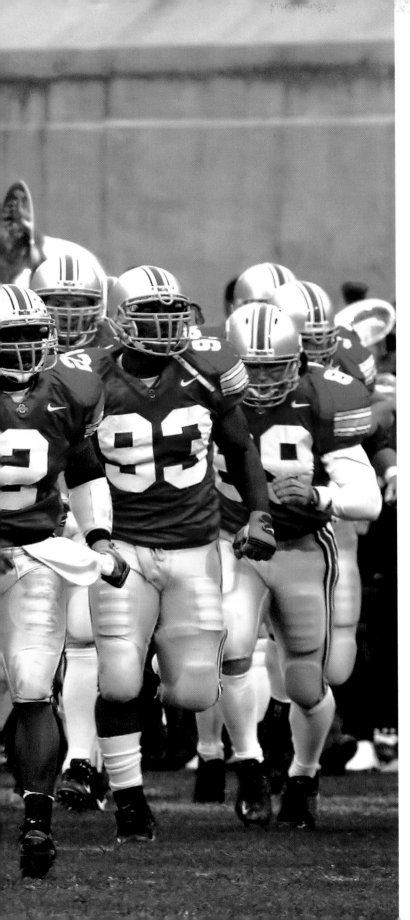

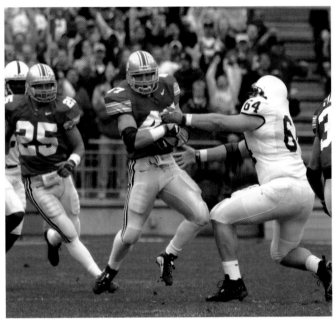

to his credit. The Hurricanes were truly an imposing opponent, and almost no one gave the Buckeyes a chance.

OSU's chances seemed even bleaker after they arrived at the bowl site. An enormous controversy erupted when Clarett told reporters that Ohio State officials had denied him permission to return to Ohio for the funeral of a friend despite his request to do so. The firestorm that arose following Clarett's statement caused OSU Director of Athletics Andy Geiger and Tressel to hold a press

(left) Jim Tressel leads a determined group of Buckeyes onto the field for the second half against Penn State.

(above) Linebacker A. J. Hawk (47) returns an interception of Penn State quarterback Zack Mills for 10 yards in the first quarter.

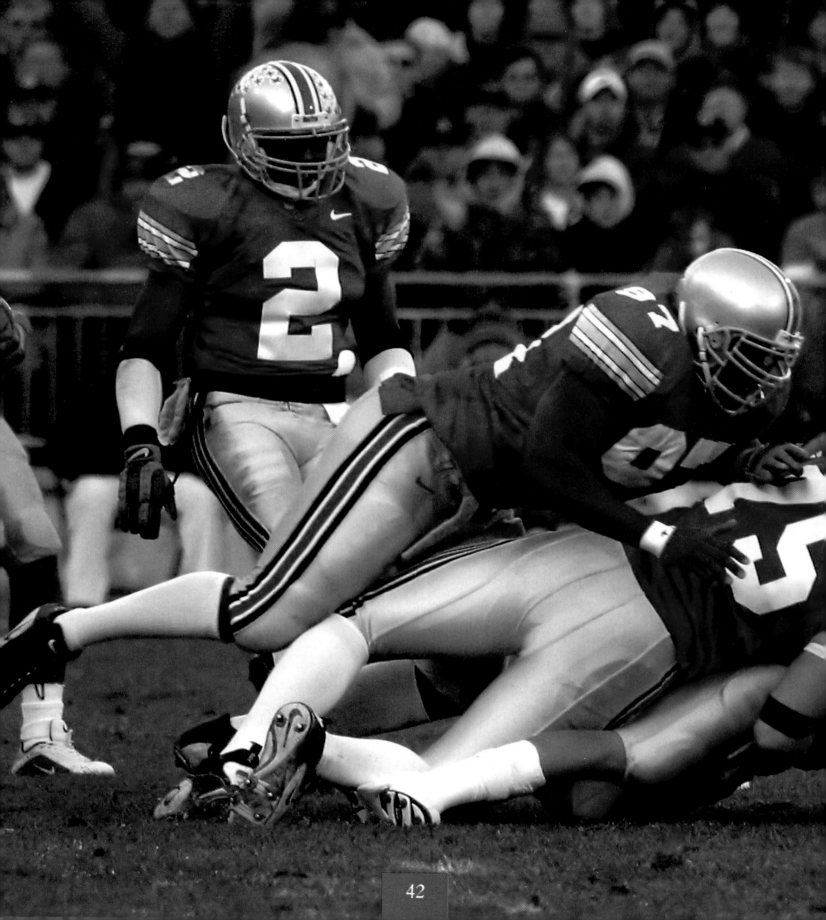

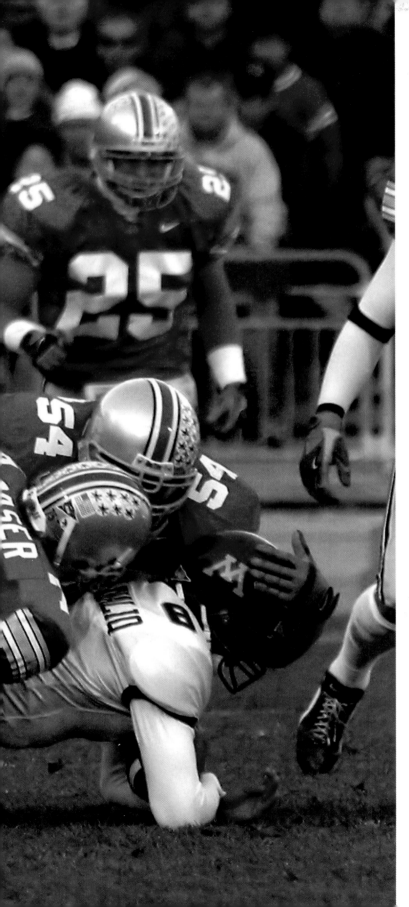

2002

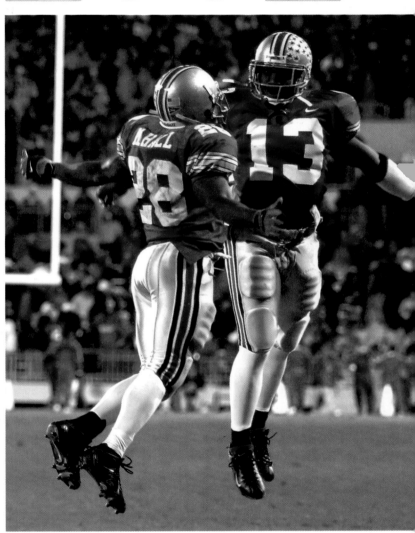

(left) Simon Fraser (75), Kenny Peterson (97), and Tim Anderson (54) combine to sack Minnesota quarterback Asad Abdul-Khaliq for a loss of three yards. The Buckeyes defeated the Gophers 34–3 in Columbus.

(above) Maurice Hall (28) and Maurice Clarett (13) celebrate after Hall's four-yard touchdown run in the fourth quarter against Minnesota.

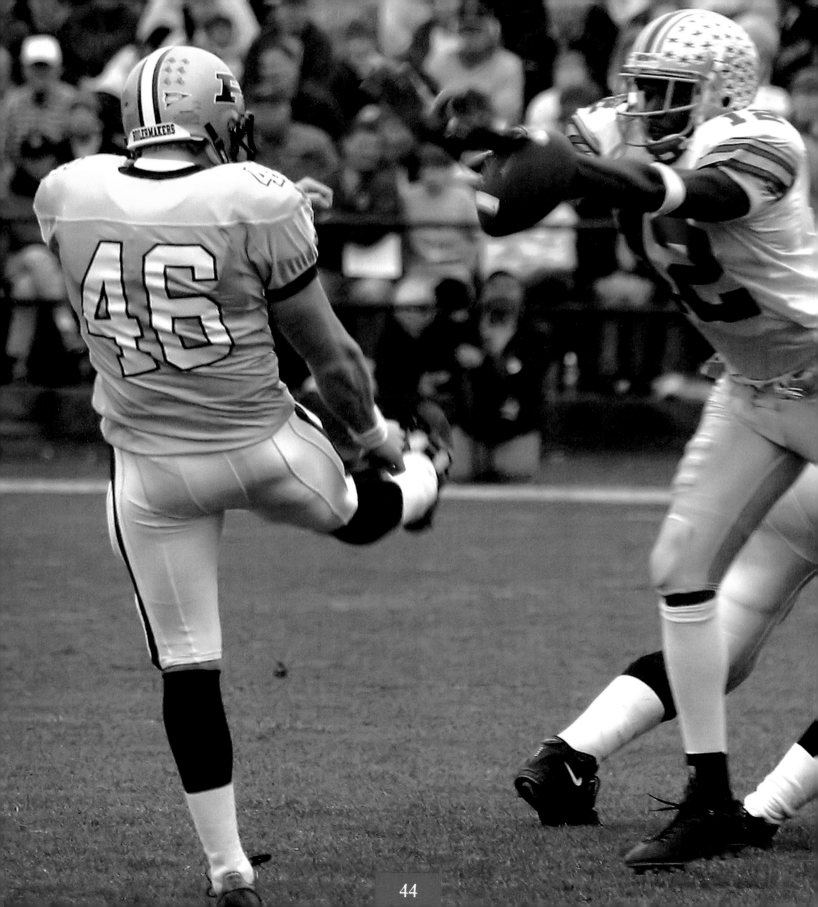

2002

(opposite) Michael Jenkins (12) blocks a punt by Purdue's Brent Slaton (46). Jenkins also recovered the ball at the Purdue 37-yard line.

(above) The Buckeyes celebrate Michael Jenkins' touchdown catch for the winning score. OSU fans are elated (in the background) while Purdue's fans are less than pleased.

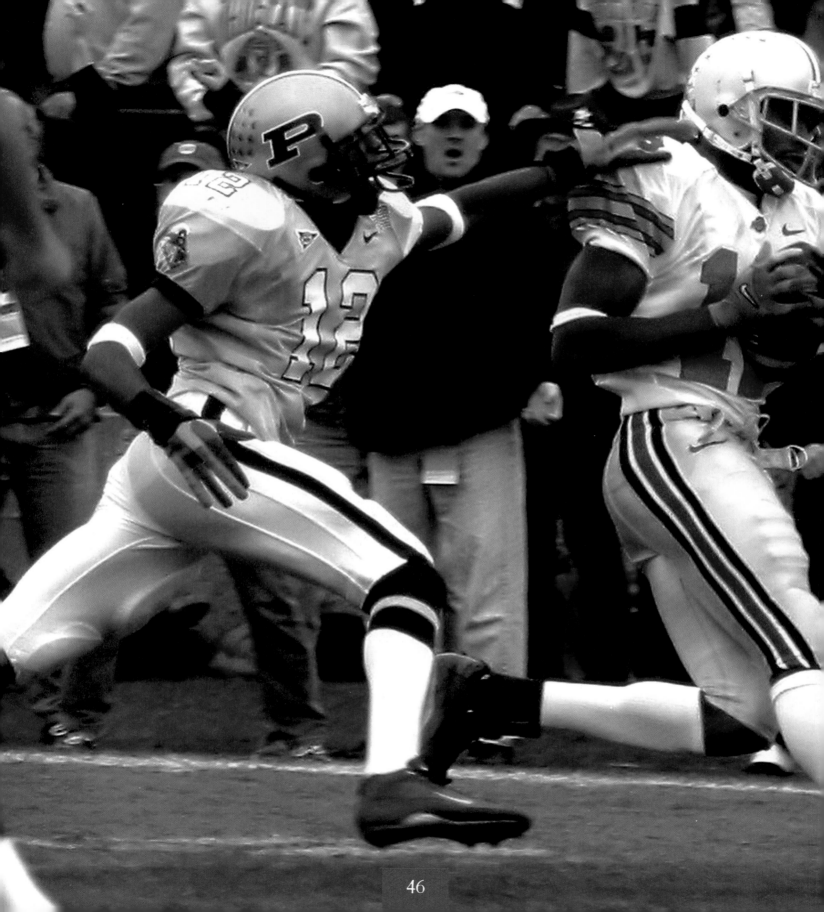

(opposite) Facing a fourth-and-one late in the fourth quarter against Purdue, Craig Krenzel completed a pass to Michael Jenkins for 37 yards and the winning touchdown with just 1:36 left on the clock. Everyone in stadium expected a conservative call in an attempt to get the first down, but when he saw him open deep Krenzel went to Jenkins for all the marbles and got them. The dramatic play was accompanied by a dramatic call by ABC television announcer Brent Musberger that immediately earned the name "Holy Buckeye" with OSU fans and went as follows:

"Krenzel is a very good runner in this situation. If they roll him, I have seen him come out for a huge first down up in Madison, Wisconsin. They're going to put him up underneath center though. They're going to show the I back behind the fullback here on fourth down. Could be up to the offensive line. No, Krenzel's going to throw for it! Gotta get it off! They go for the ball game! Touchdown! Touchdown! Michael Jenkins! On fourth and one! Would you believe it! Craig Krenzel strikes, with a minute and a half left! Holy Buckeye! A big-time play, as people said all year, at some time Craig Krenzel would have to win a game, and on fourth-and-one he goes 37 yards!"

(above) Tight end Ben Hartsock celebrates with the fans as the team leaves the field. Nearly half the stadium was filled with OSU fans who made the trek to West Lafayette with their team. The OSU crowd was so raucous that at times it seemed like an OSU home game.

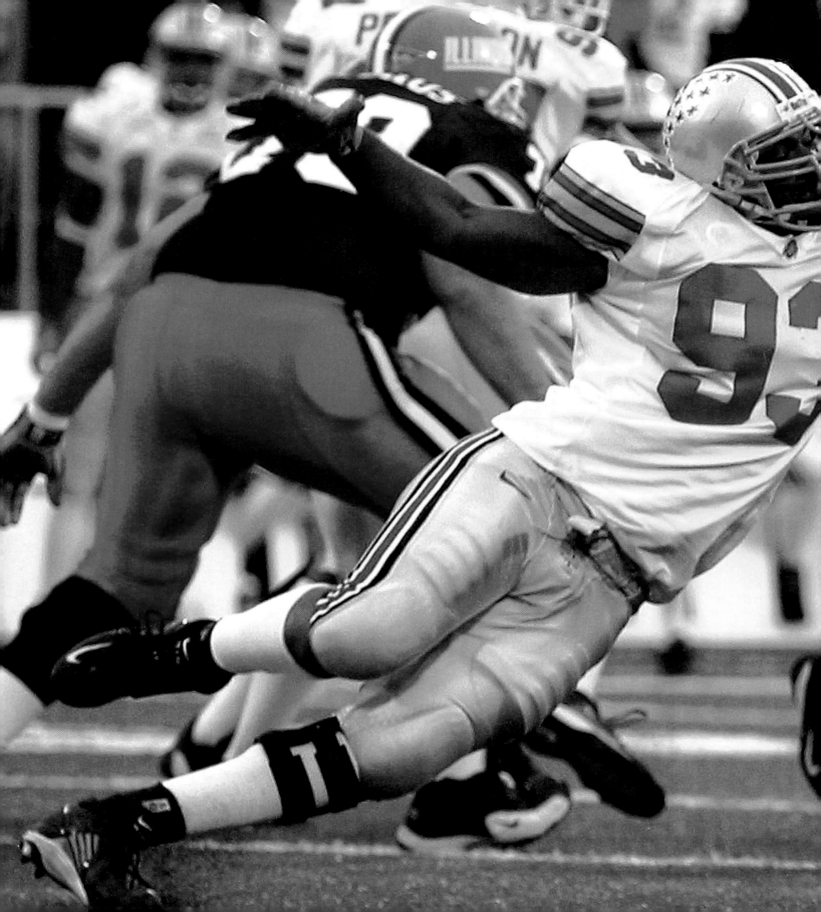

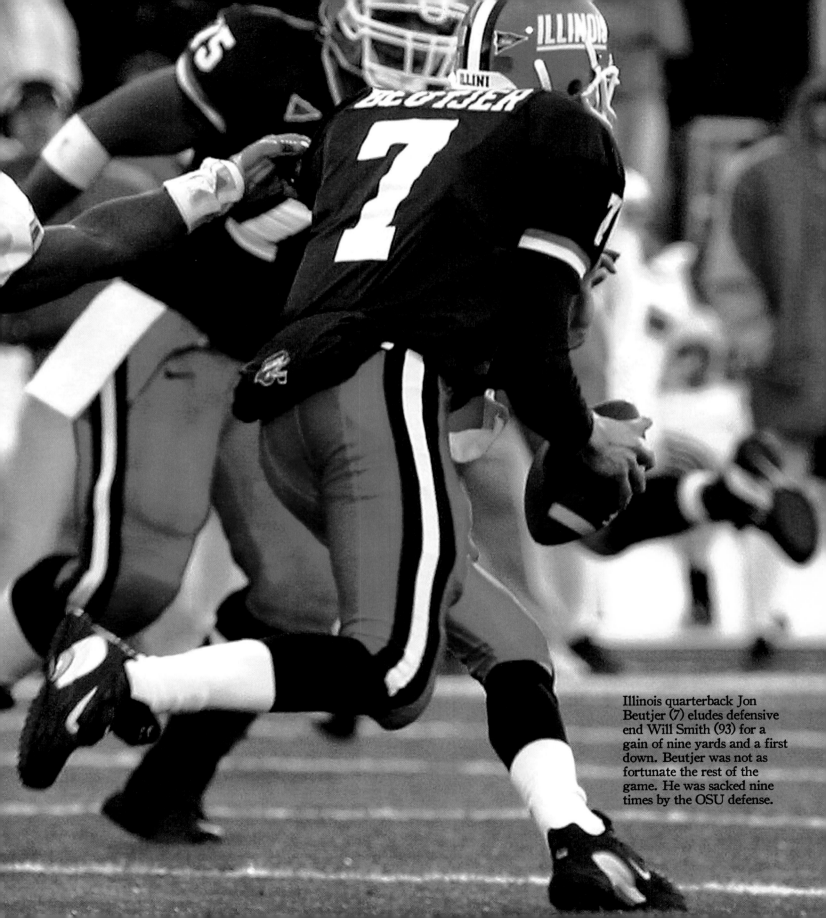

Illinois quarterback Jon Beutjer (7) eludes defensive end Will Smith (93) for a gain of nine yards and a first down. Beutjer was not as fortunate the rest of the game. He was sacked nine times by the OSU defense.

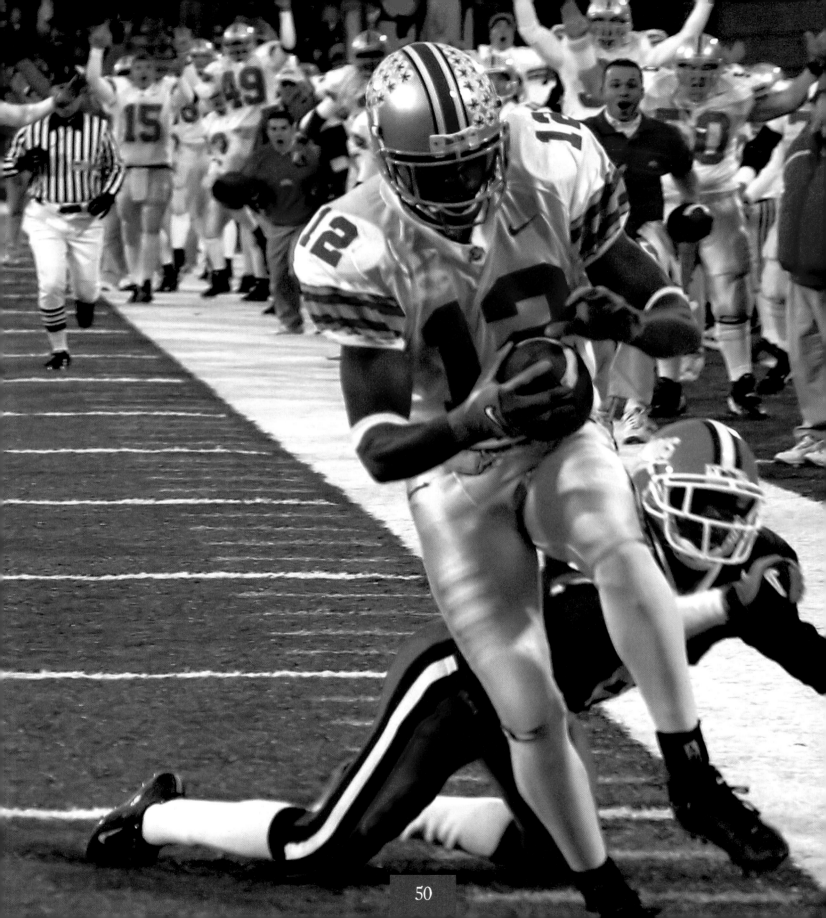

2002

conference at the OSU practice site later that day to give their side of the story. Reporters lined up at the outskirts of the practice facility more than an hour before the press conference began, but security officials denied admittance into the facility at Pinnacle High School in Scottsdale. When they were finally allowed in, reporters were so anxious to get the story that they stormed into the facility, prompting sports reporter Dave Maetzold to quip, "This looks like the opening of the wedding dress sale at Filene's Basement."

Geiger and Tressel denied Clarett's charge. They

(left) The OSU bench explodes as Michael Jenkins crosses the goal line. Craig Krenzel's touchdown pass to Jenkins in the third quarter went for 50 yards and OSU's only touchdown in regulation against Illinois.

(above) Craig Krenzel was credited with six yards but not a touchdown on second-and-goal against Illinois. A series of three consecutive false-start penalties moved the ball back to the 16-yard line and OSU settled for a 33-yard Mike Nugent field goal to go up 3–0 in the first quarter.

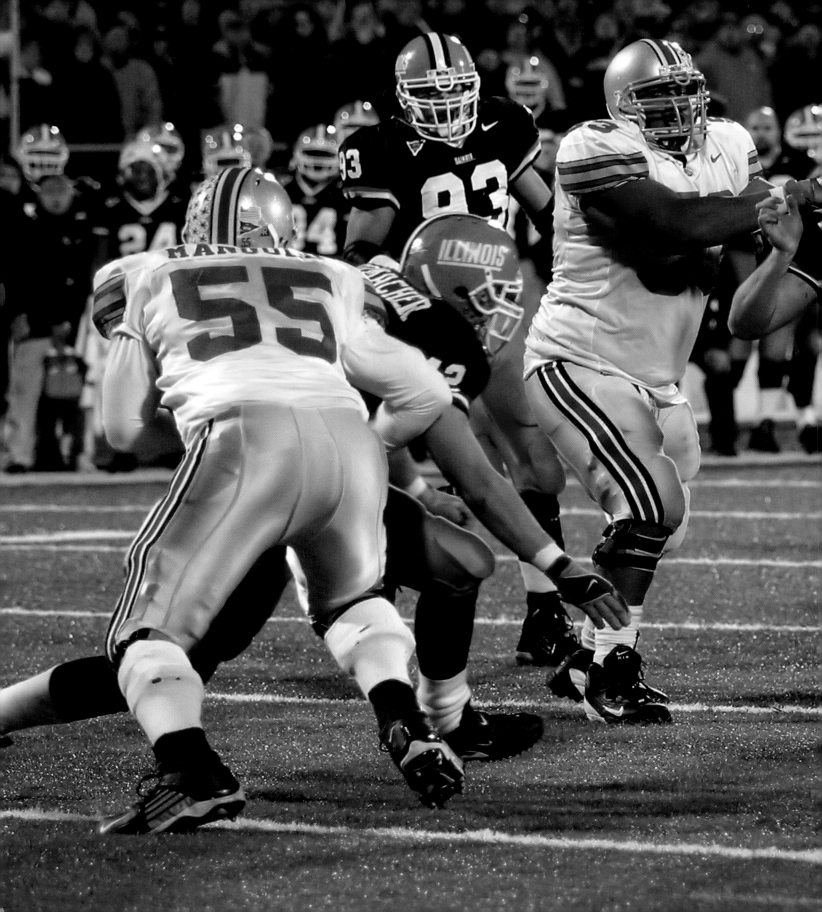

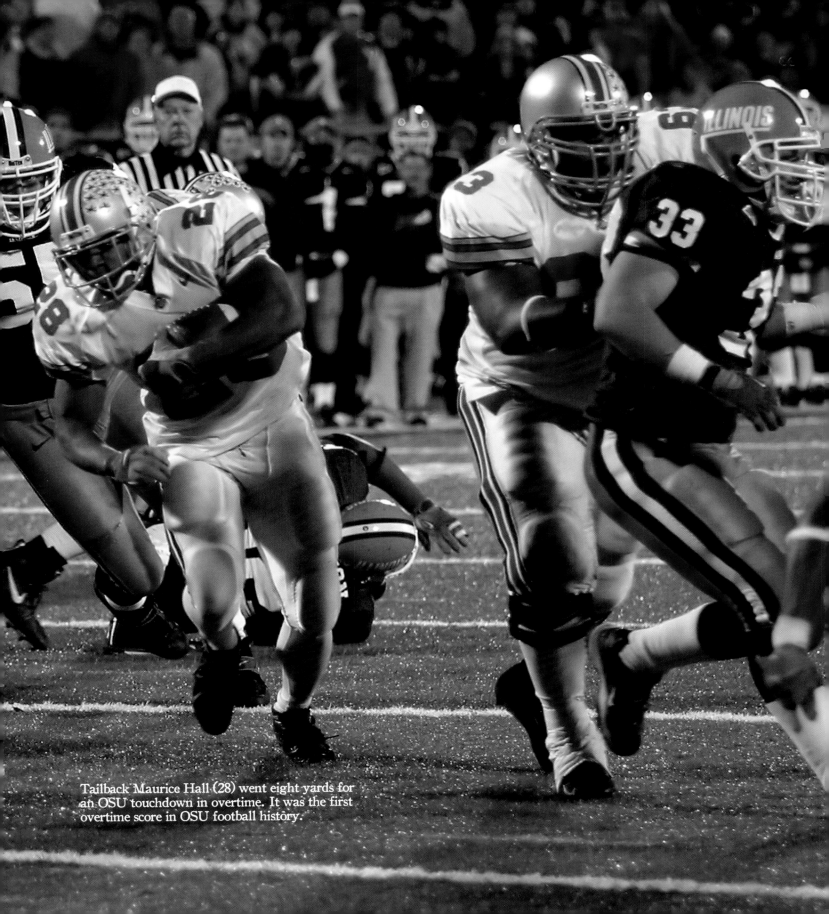

Tailback Maurice Hall (28) went eight yards for an OSU touchdown in overtime. It was the first overtime score in OSU football history.

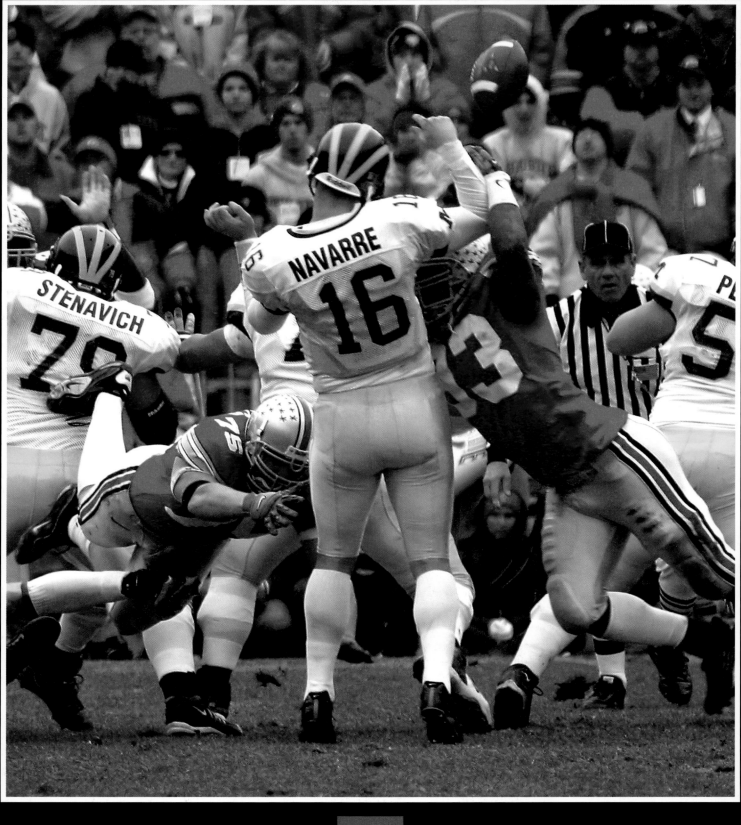

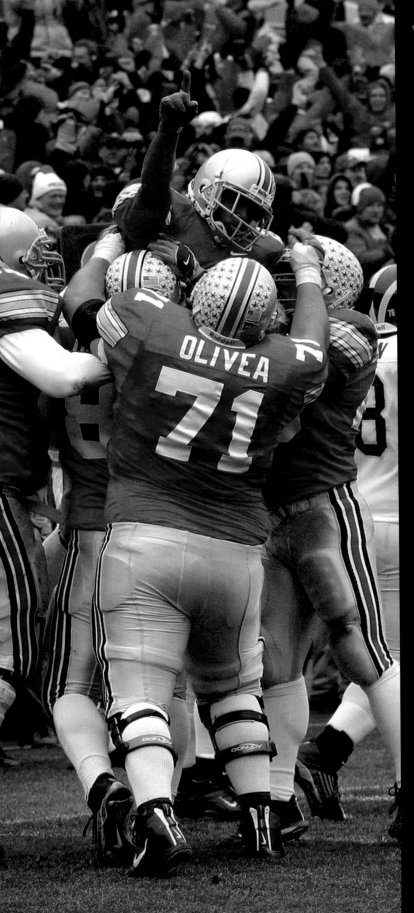

2002

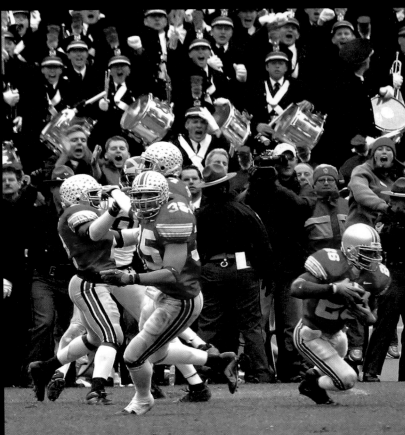

(opposite) Will Smith (93) and Simon Frasier (75) pressure Michigan quarterback John Navarre.

(left) Senior running back Maurice Hall is hoisted aloft by his teammates after his three-yard run around right end put OSU up 14–9 with 3:55 remaining to be played in the game. The winning drive went 43 yards and was highlighted by a 15-yard completion from Krenzel to fullback Brandon Schnittker and a 26-yard pass from Krenzel to tailback Maurice Clarett that carried to the Michigan 6-yard line.

(above) Will Allen (26) ends the game when he intercepts John Navarre in the end zone to frustrate Michigan's last-ditch drive and send the OSU faithful into delirium.

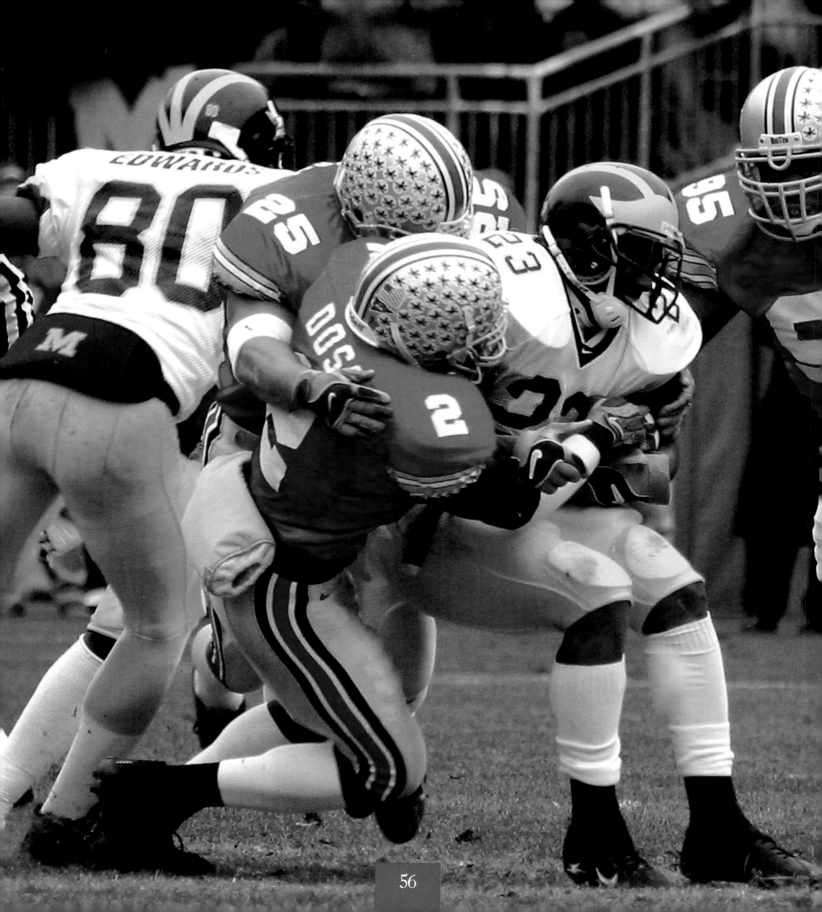

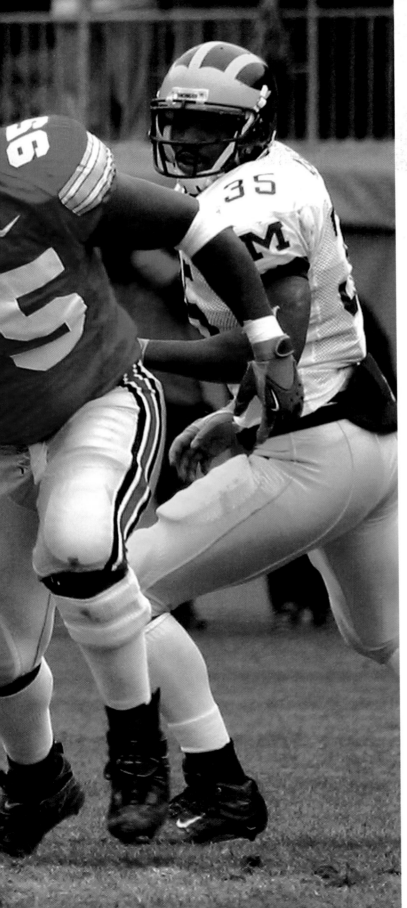

2002

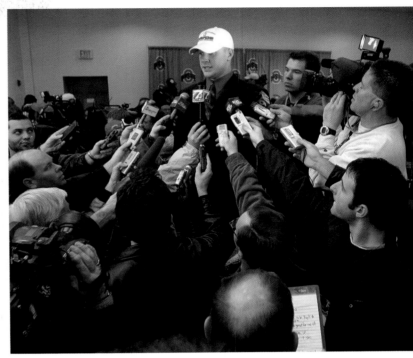

said Clarett was given permission to go, but that Ohio State could not pay for the trip because it would violate NCAA rules.

The next day at a press conference Clarett claimed their side of the story was false. The Buckeyes camp appeared to be in disarray and the center of the storm was their star tailback.

The game that followed was one of the classics in college football. Despite the controversy

(opposite) Mike Doss (2) and Donnie Nickey (25) put the clamps on Michigan tailback Chris Perry as defensive tackle David Thompson (95) comes in to help. The play went for a one-yard loss.

(above) Craig Krenzel takes questions after the big win over Michigan.

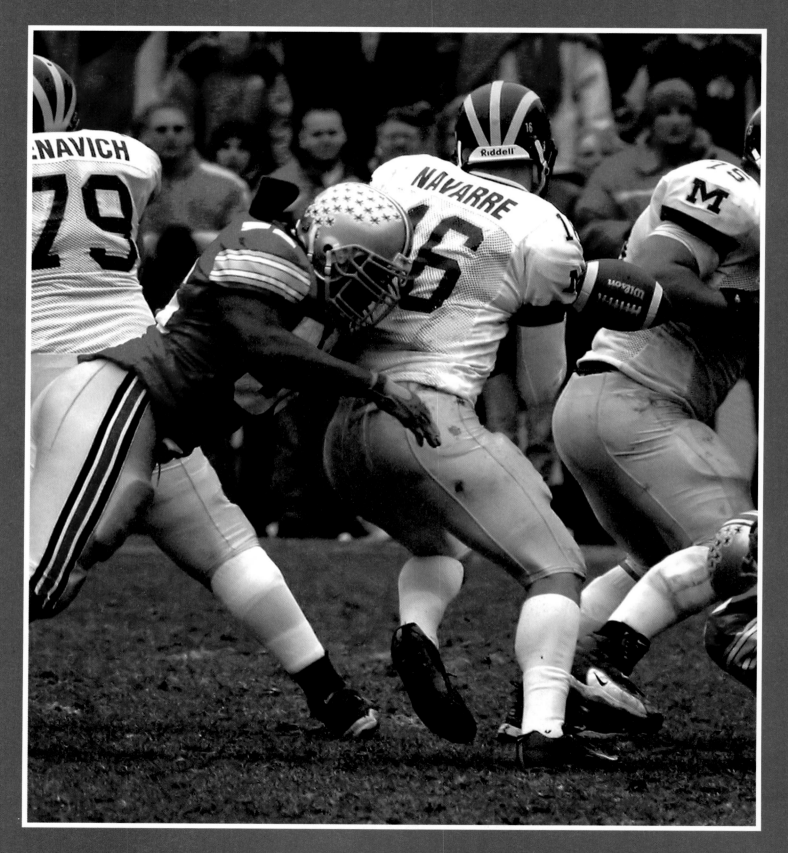

2002

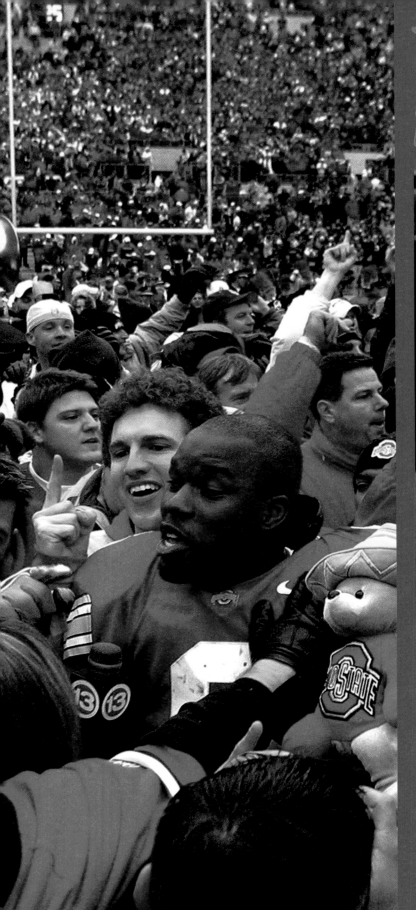

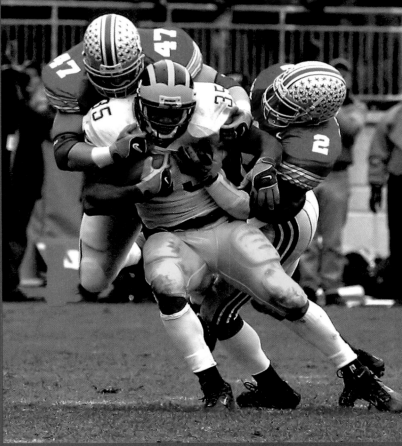

(opposite) Darrion Scott dislodged the football from Michigan quarterback John Navarre with this hit in the fourth quarter to stop Michigan at the OSU 30-yard line. OSU defensive end Will Smith recovered the fumble to turn the ball over to the Buckeyes with 2:02 left on the game clock. OSU was clinging to a 14–9 lead at the time. The play thwarted a 50-yard Michigan drive.

(left) Linebacker Cie Grant is surrounded by fans while a local television station interviews him after the Buckeyes' win.

(above) Linebacker A. J. Hawk (47) and safety Mike Doss (2) bring down Michigan running back B. J. Askew.

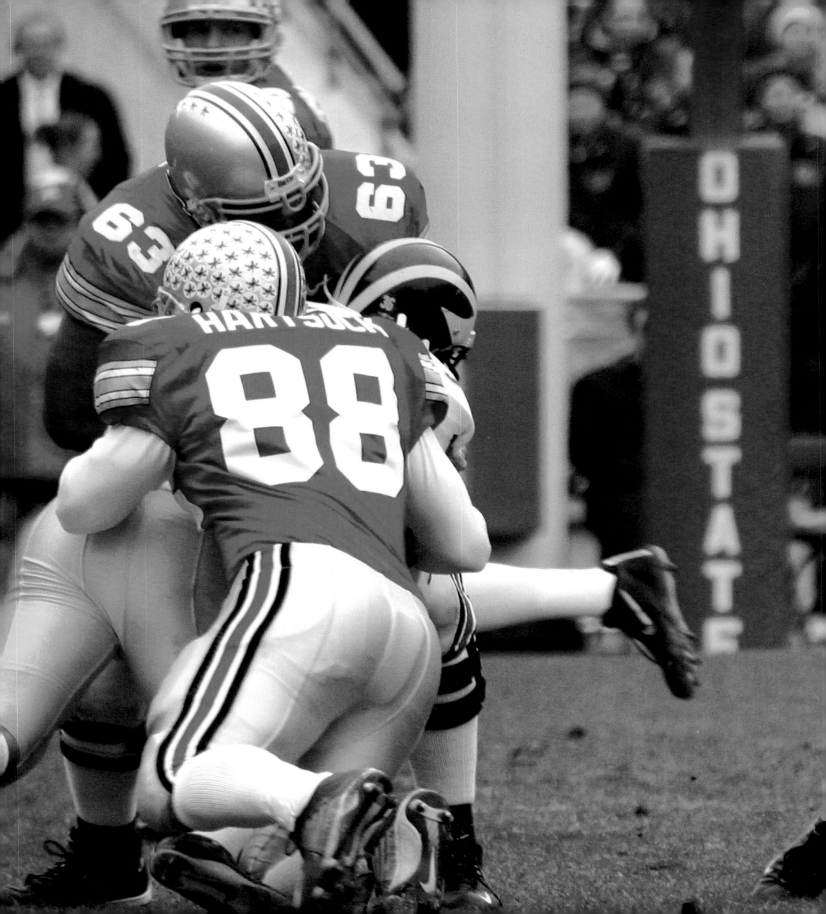

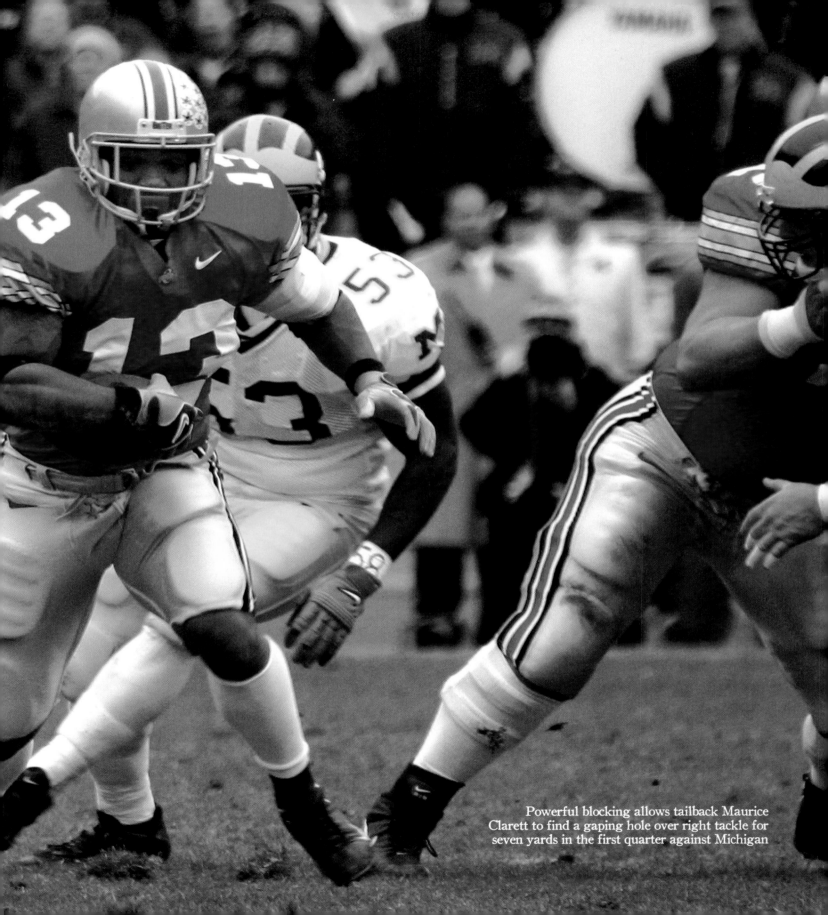

Powerful blocking allows tailback Maurice Clarett to find a gaping hole over right tackle for seven yards in the first quarter against Michigan

The OSU cheerleaders lead the team onto the field before the game. The wide-angle photo gives some idea of the number of scarlet-clad Buckeyes in the stadium that night.

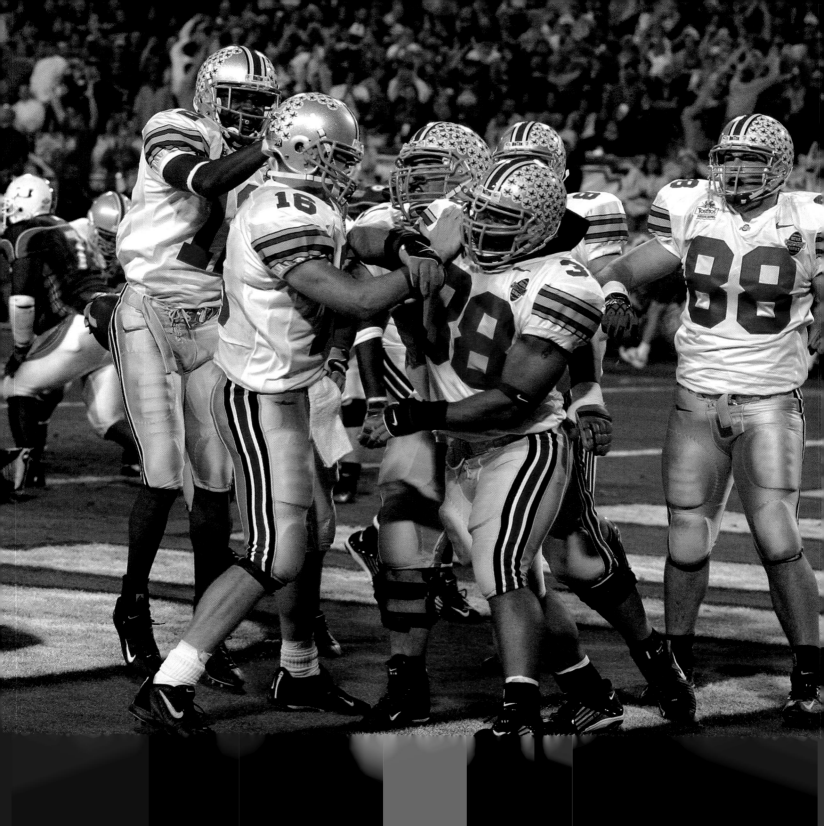

2002

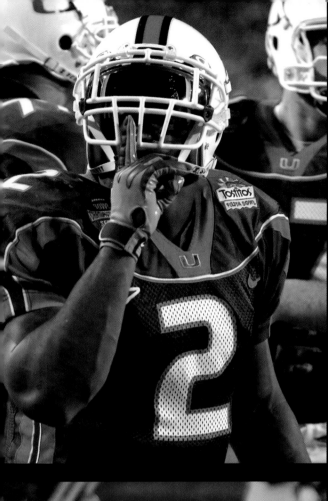

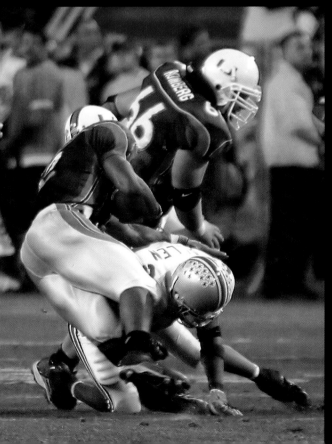

(opposite) The Buckeyes celebrate Craig Krenzel's touchdown to tie Miami 7–7.

(top) Miami tailback Willis McGahee quiets the OSU cheering section after his nine-yard touchdown run in the third quarter. McGahee's run cut OSU's lead to 17–14.

(left) In the fourth quarter Dorsey completed a pass to McGahee for a loss of two yards to the OSU 37. McGahee was tackled by Will Allen and suffered a severe knee injury, which took him out of the remainder of the game.

(above) Miami receiver Rosco Parish will not be denied as he hauls in a Ken Dorsey pass then drags OSU safety Mike Doss into the end zone for a 25-yard touchdown play to put Miami up 7–0 in the first quarter.

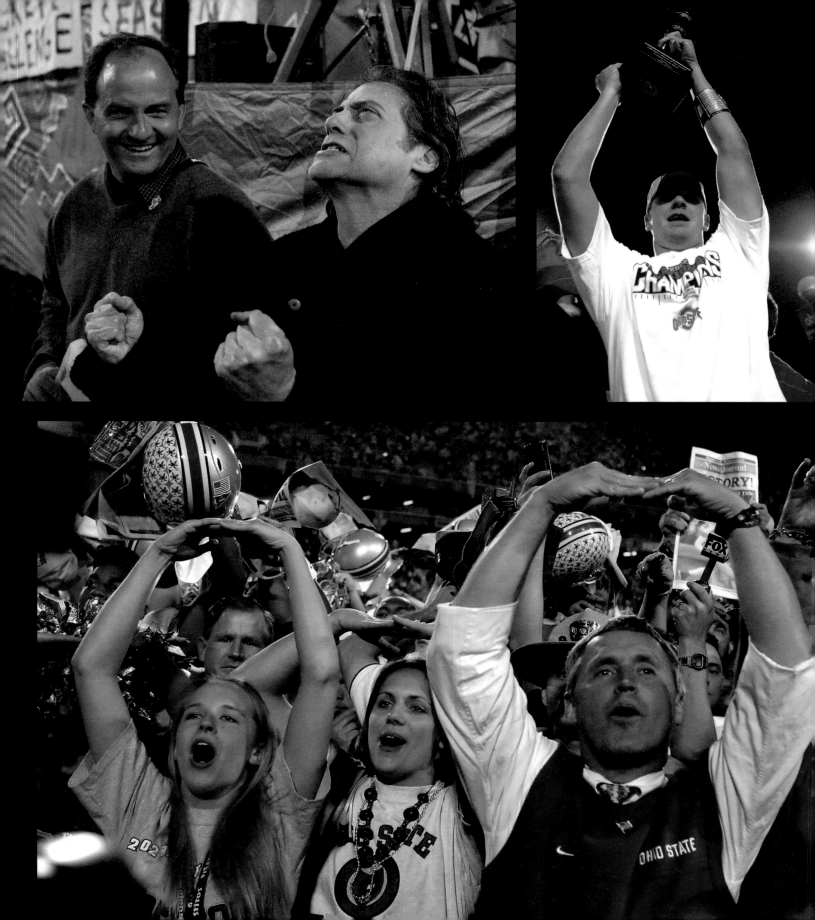

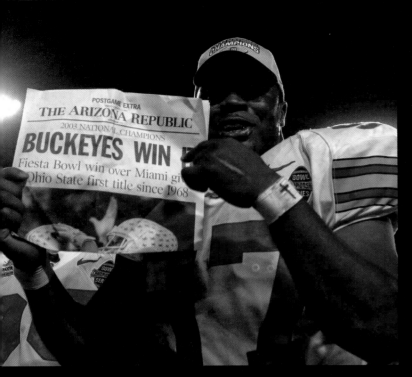

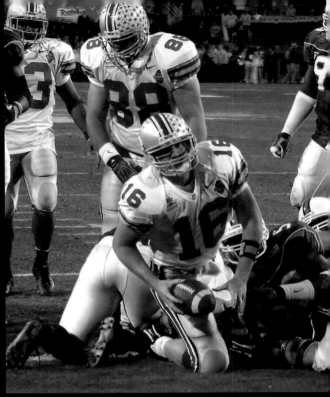

(clockwise from top left) Comedian and OSU alumnus Richard Lewis celebrates the touchdown in overtime with his newfound friend, Columbus newsman Dave Maetzold.

Craig Krenzel hoists the Offensive Most Valuable Player trophy following OSU's win.

Defensive tackle Kenny Peterson displays the headline proclaiming OSU's national championship win.

Craig Krenzel evened the score in overtime and kept the Buckeyes alive with this one-yard touchdown run. OSU converted two fourth downs before reaching the goal line. Krenzel completed a 17-yard pass to Michael Jenkins to convert a fourth-and-12 from the 29-yard line. Later a pass interference penalty on fourth-and-three from the 5-yard line gave OSU a first down on the Miami 2-yard line.

Mike Doss gets a measure of revenge after being unable to keep Parish out of the end zone for Miami's first score. Doss points to the heavens after returning a second-quarter interception 35 yards to the Miami 17-yard line. The play led to OSU's first touchdown which tied the game 7–7 in he second quarter.

Head Coach Jim Tressel sings the OSU alma mater "Carmen Ohio" with his daughters Whitney and Carlee (left to right).

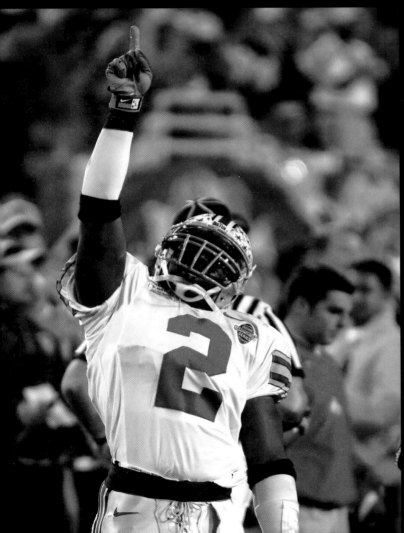

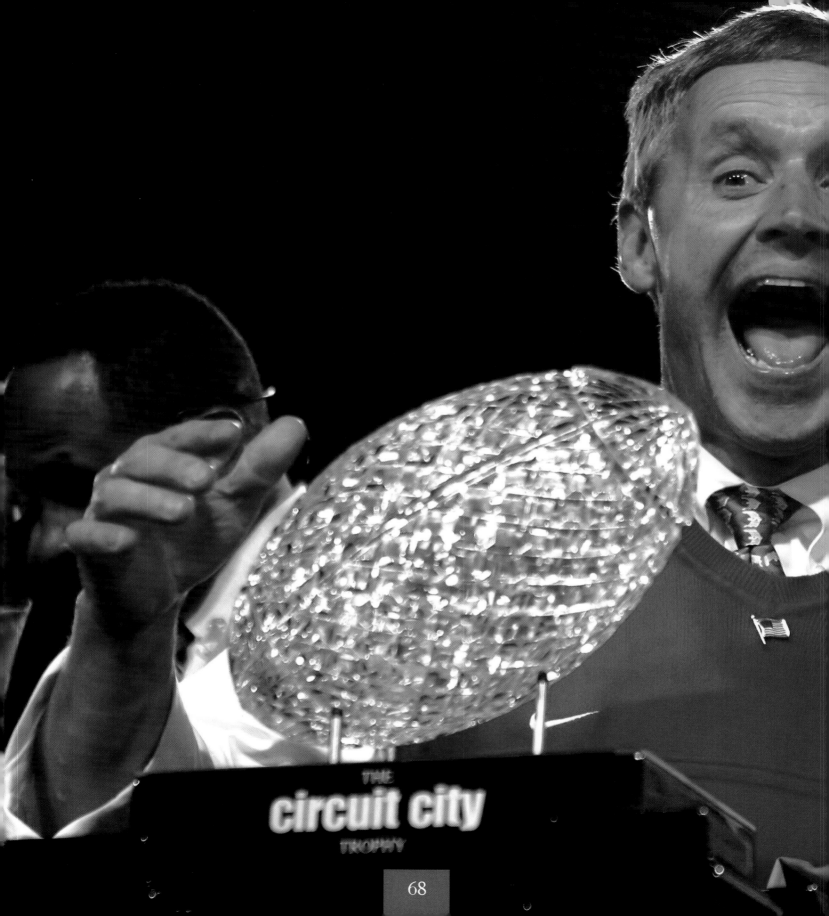

circuit city

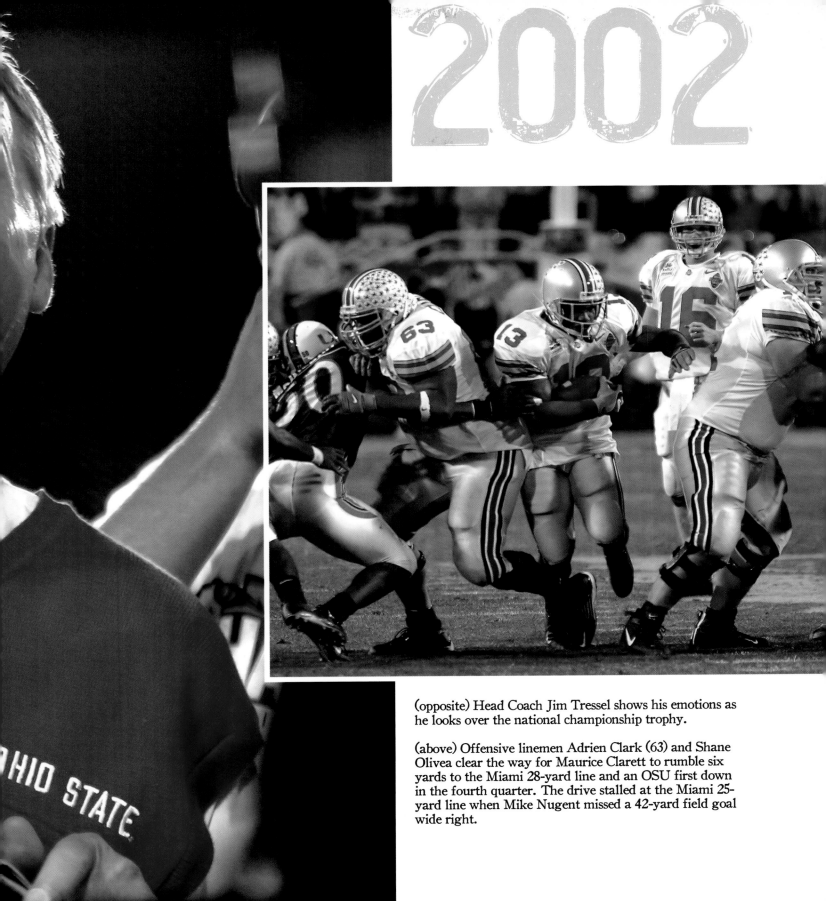

2002

(opposite) Head Coach Jim Tressel shows his emotions as he looks over the national championship trophy.

(above) Offensive linemen Adrien Clark (63) and Shane Olivea clear the way for Maurice Clarett to rumble six yards to the Miami 28-yard line and an OSU first down in the fourth quarter. The drive stalled at the Miami 25-yard line when Mike Nugent missed a 42-yard field goal wide right.

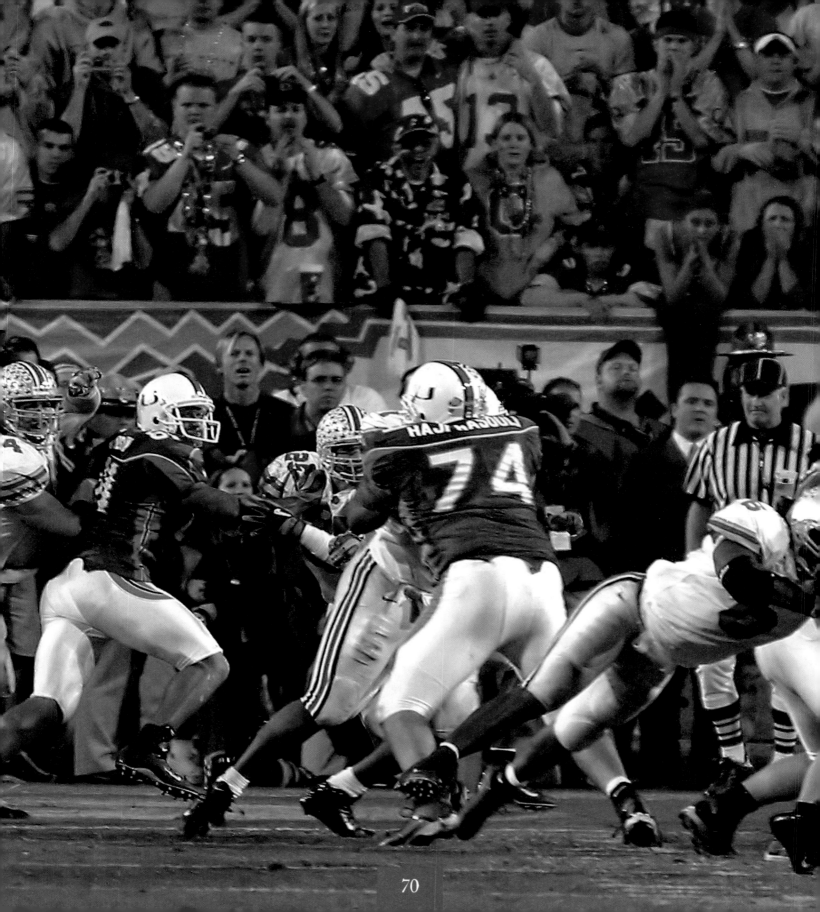

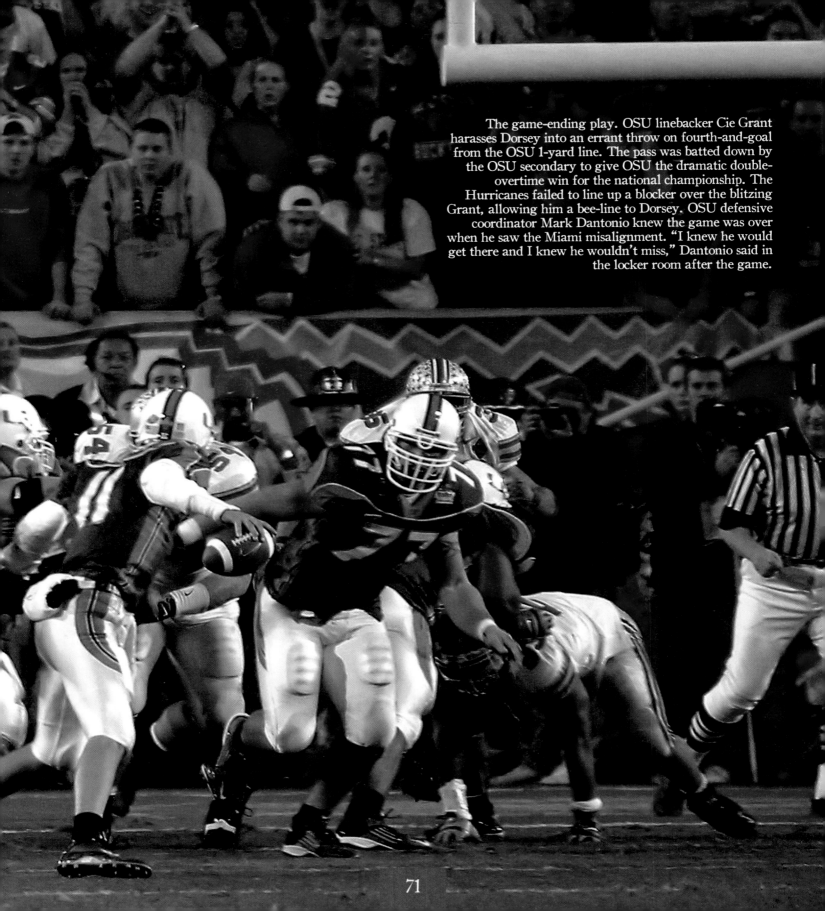

The game-ending play. OSU linebacker Cie Grant harasses Dorsey into an errant throw on fourth-and-goal from the OSU 1-yard line. The pass was batted down by the OSU secondary to give OSU the dramatic double-overtime win for the national championship. The Hurricanes failed to line up a blocker over the blitzing Grant, allowing him a bee-line to Dorsey. OSU defensive coordinator Mark Dantonio knew the game was over when he saw the Miami misalignment. "I knew he would get there and I knew he wouldn't miss," Dantonio said in the locker room after the game.

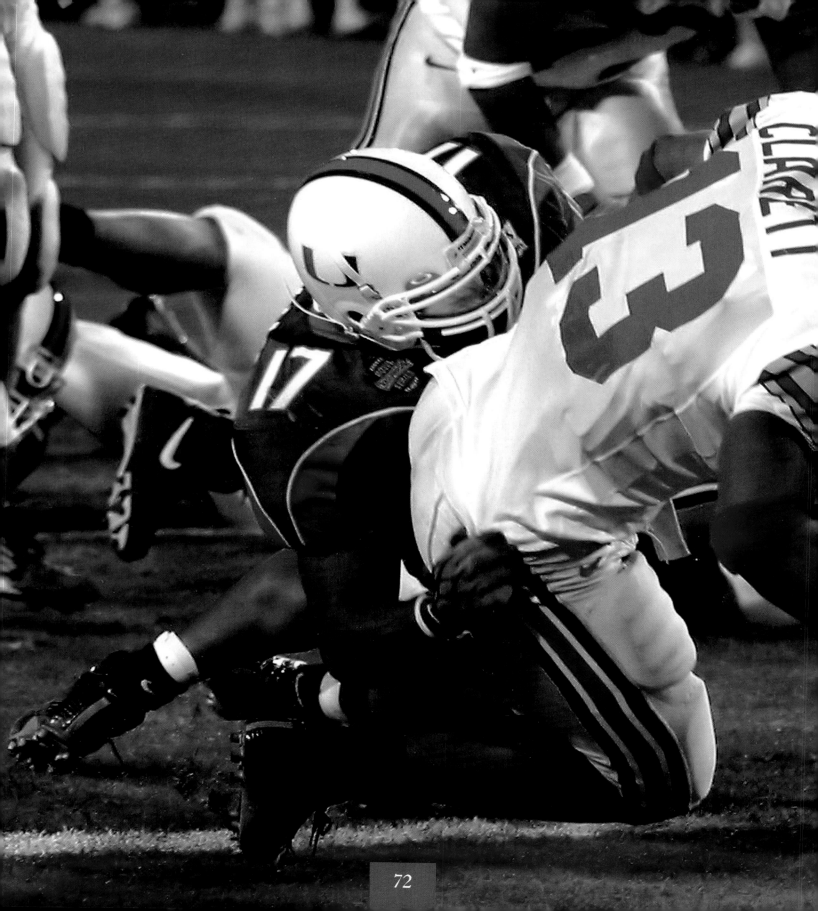

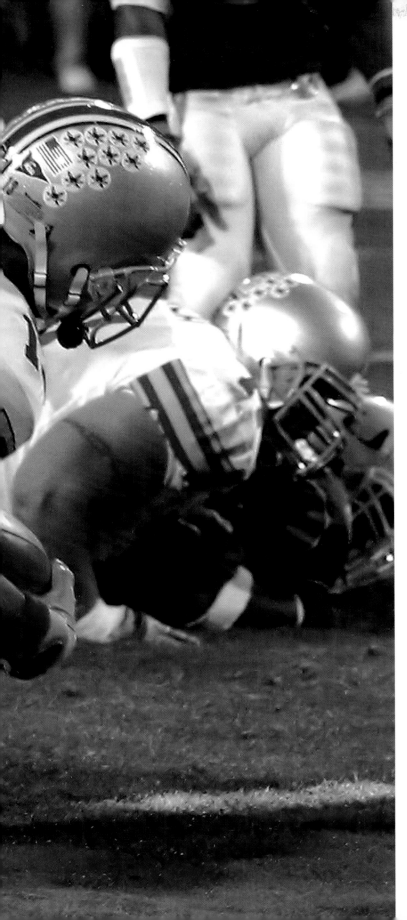

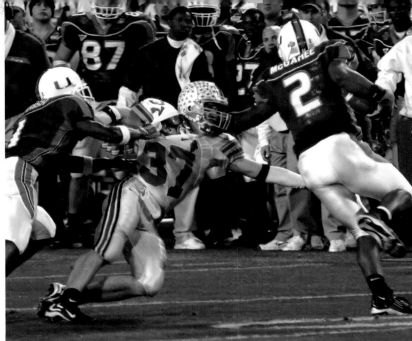

surrounding him, Clarett not only scored two touchdowns including the game-winner in the second overtime, but also made the play of the game. Taylor intercepted a Krenzel pass to apparently thwart a promising OSU drive, but Clarett stole the ball from him during the return to save the day for the Buckeyes.

The Ohio State defense was magnificent that day. It produced four turnovers on two fumble recoveries and two interceptions. Clarett's steal of the ball from Taylor tallied OSU's fifth turnover. They also sacked Dorsey four times and

(opposite) Just one minute and 24 seconds of playing time after Krenzel scored OSU's first touchdown of the game, Maurice Clarett scored OSU's second touchdown on a seven-yard run. The score was set up when Dorsey fumbled after he was sacked by Kenny Peterson. The fumble was recovered by Darrion Scott at the Miami 14-yard line. A short gain by Lydell Ross and a five-yard penalty on Miami moved the ball to the Miami seven before Clarett traveled the final distance for the go-ahead score.

(above) Dustin Fox (37) is unable to get to Miami tailback Willis McGahee (2). This play resulted in a 10-yard gain for the Hurricanes.

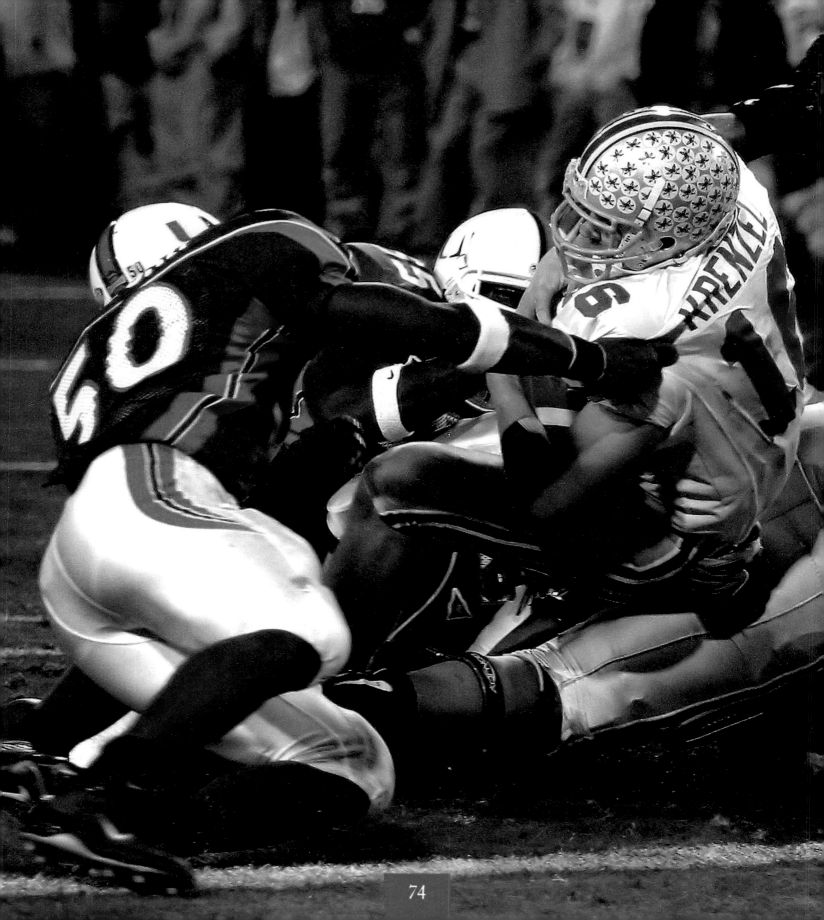

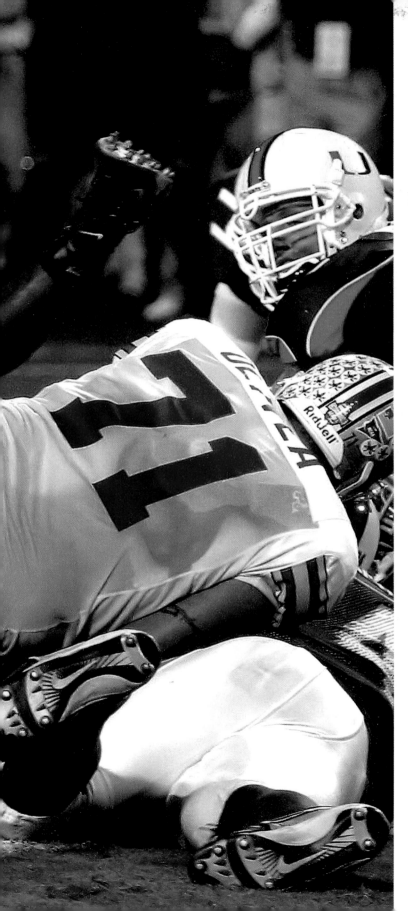

(left) Craig Krenzel goes for one yard to score OSU's first touchdown against Miami.

(above) OSU cheerleader Tara Zinslen celebrates her successful 20-yard field goal. The kick earned a local Phoenix charity $25,000. Her kicking coach, former Arizona State and NFL place-kicker Luis Zendejas, was just as excited as Tara.

2002

knocked him down throughout the game. Miami scored first to go up 7–0, but OSU answered with 17 points to take a 17–7 lead. Both OSU touchdowns in regulation followed Miami turnovers. Miami scored a touchdown in the third quarter to cut the lead to 17–14. Miami kicker Todd Sievers then forced overtime when he made a 40-yard field goal with no time remaining on the clock in regulation.

Miami scored first in overtime to take a 24–17 lead. OSU overcame a fourth-and-14 for a first down on a completion from Krenzel to Jenkins to stay alive. They overcame a second fourth-down situation with the help of a pass interference penalty. The Buckeyes then tied the game when Krenzel scored from one yard out. Clarett scored from five yards out to give OSU the lead in the second overtime. Fittingly, the OSU defense was on the field for the last play of the game, a dramatic fourth-and-one from the one-yard line where linebacker Cie Grant blitzed Dorsey to force a wild pass that was promptly batted down by the OSU secondary to end the game.

Upon their return to Ohio, more than 50,000 fans turned out at Ohio Stadium for a victory celebration with the team. Temperatures were in the single digits but nobody seemed to mind the cold because the glory had returned to Ohio State football. ■

Junior wide receiver Maurice Lee (86) helps whip the Buckeyes into a frenzy before the national championship game against Miami.

2002 STATS

Overall: 14–0 · **Big Ten:** 8–0, Co-Champions with Iowa
Final Ranking: BCS National Champions, Associated Press No. 1
First Team All-Americans: Mike Doss (safety), Andy Groom (punter),
Mike Nugent (place kicker), Matt Wilhelm (linebacker)
First Team All-Big Ten: Maurice Clarett (running back), Mike Nugent (kicker),
Matt Wilhelm (linebacker), Mike Doss (safety), Andy Groom (punter),
Darrion Scott (defensive line), Chris Gamble (defensive back).

W/L	Date	PF	Opponent	PA	Location
W	08–24–2002	45	Texas Tech	21	Columbus, OH
W	09–07–2002	51	Kent St.	17	Columbus, OH
W	09–14–2002	25	Washington St.	7	Columbus, OH
W	09–21–2002	23	Cincinnati	19	Cincinnati, OH
W	09–28–2002	45	Indiana	17	Columbus, OH
W	10–05–2002	27	Northwestern	16	Evanston, IL
W	10–12–2002	50	San Jose St.	7	Columbus, OH
W	10–19–2002	19	Wisconsin	14	Madison, WI
W	10–26–2002	13	Penn St.	7	Columbus, OH
W	11–02–2002	34	Minnesota	3	Columbus, OH
W	11–09–2002	10	Purdue	6	West Lafayette, IN
W	11–16–2002	23	Illinois	16	Champaign, IL
W	11–23–2002	14	Michigan	9	Columbus, OH
W	01–03–2003	31	Miami (FL)	24	Tempe, AZ

Buckeyes flags fly proudly in the Fiesta Bowl.

MEMORIES

The Day the Buckeye World Stood Still

You never know when they will occur, those moments in time that last a lifetime and seem to stand still in your memory.

For an old guy like me, it is moments like when Kennedy was shot, when men first landed on the moon, when we first learned that bombs were falling on Baghdad, when I first attended an OSU versus Michigan game in 1963, an OSU victory by the way.

Those attending the 2003 Fiesta Bowl knew when they came to the stadium they were going to a big game. What they couldn't possibly know is they were about to experience one of those incomprehensible moments in time that become frozen in memory, a memory that when conjured up years later seems like it happened just an instant before. I know I didn't.

The 2003 Fiesta Bowl remains such a memory.

Setting the Scene

The scene outside the stadium before the game was unforgettable. There were thousands of fans milling about, and it seemed like all of them were wearing Buckeyes gear. I spoke to probably 100 of them, asking them how far they had come, did they have tickets. They had come from everywhere—from Ohio, New York, California, Maine, Arizona, Indiana, Texas—to be there in Phoenix with their Buckeyes. I didn't keep an official count, but it is not be an exaggeration to say that less than half had tickets. They didn't care; they just wanted to be there with their team, because this was important to them.

Near the entrance to the stadium there was a line, about 200 feet long, of people waiting for a souvenir program stand. At the front of the line were Buckeyes fans. In the middle of the line were

OSU Head Coach Jim Tressel hugs senior defensive lineman David Thompson during the postgame celebration. Hugs were the order of the day on the field and in the stands after the Buckeyes won the national championship.

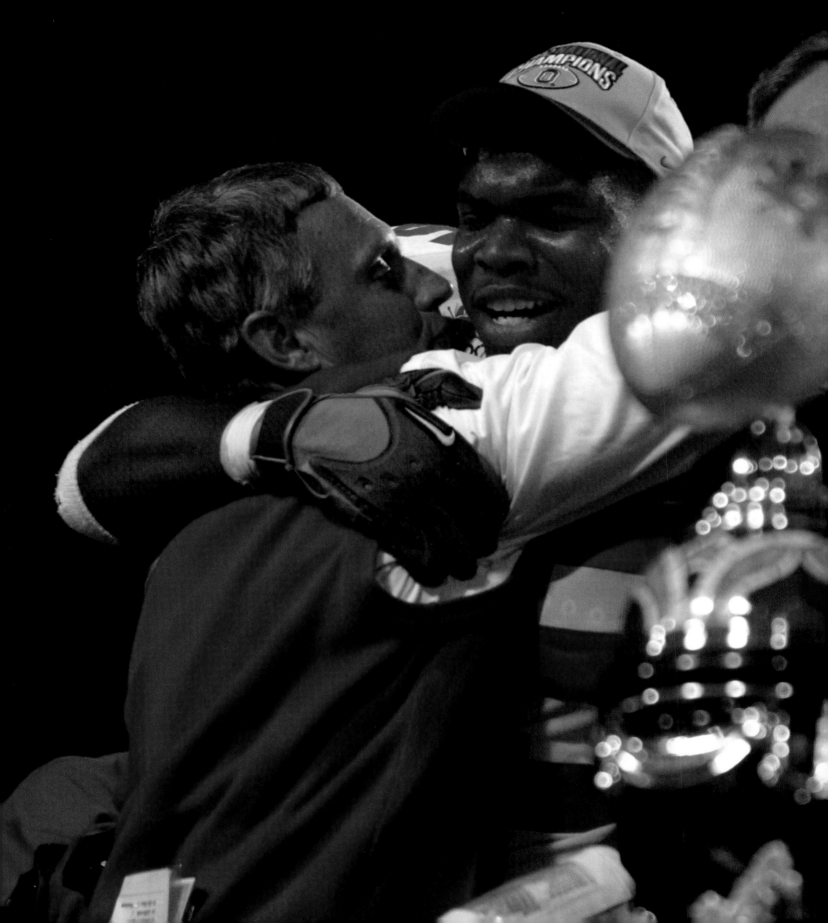

Buckeyes fans. At the end of the line were Buckeyes fans. Everywhere in between in the line there were Buckeyes fans. I counted four Miami fans.

The stand finally opened, and I watched the first three Buckeyes fans in line buy a total of 17 programs. The salesperson looked bewildered as the fans bought programs for not only themselves, but also for friends and loved ones that could not be there. At $10 a copy, money was changing hands rapidly. Nobody complained about the price. They just wanted their little permanent piece of the day they could take home to prove they were really there.

Going to Work

It was a working day for me. As usual, I entered the stadium early and find my seat in the press annex. It was a great seat, located below the press box and in front of the luxury suites on the west side of the stadium.

I got an inkling that this game might be something special when I turned around and saw who was sitting behind me in the big-money seats. Roger Clements, Cal Ripken Jr., and Senator John McCain were all there already, a full 90 minutes before the game was to begin. Other notables joined them before the stadium was totally filled.

A loud rendition of the O-H-I-O cheer soon went up around the stadium. That in itself was not remarkable, but what was remarkable was that we were more than 2,000 miles from Ohio Stadium where that usually happened, and the

clock on the stadium scoreboard that was counting down to kickoff said that it was a full 70 minutes away. The Buckeyes fans simply could not contain themselves, and the cheer continued around and around.

It was beginning to become one of those moments.

My seat was directly behind the first row of seating in the stadium. I sat between journalists from Youngstown and Cleveland, both on-air radio personalities. The Buckeyes fan sitting in front of us, a young man in perhaps his late 20s or early 30s, turned around and politely asked if we could see over his head. That's when I first noticed it. The young man was standing and he was standing, because he just couldn't sit. The most amazing thing was that he was not the only one doing it. I could not find a seated fan anywhere in the nearby stands. Anybody wearing red was standing. It would be that way until I left that press area at the end of the game.

In the parking lot before the game began it seemed like every tailgate was a Buckeyes tailgate. In the stands as the game began the difference is fan support became even more clear-cut. The Buckeyes presence was unbelievable. It was clear that they owned the stadium. OSU fans outnumbered Miami fans by at least four to one, maybe even five to one. The OSU band took the field and completely outclassed the Miami band with a double Script Ohio and precision marching to a drum solo like no one had ever seen before. When the band played "Hang on Sloopy" there was a

moment of concern. The press annex actually began moving and swaying as the fans joined the band and got into the moment. Journalists began looking at one another and wondered if they should be getting out of there. The song ended, the swaying stopped, and everybody relaxed. We decided to stay put. No one yet knew how the game would turn out, but OSU had clearly won the battle of the bands and of fan support.

The P.A. announcer began his pregame chores, and the crowd cheered everything Buckeyes and booed everything Miami. They even booed the Miami season highlight video that was played on the stadium scoreboard screen before the game.

Football alumni of every conference making up the BCS were announced and presented on the field prior to the game. The last one announced was the Big Ten representative. As OSU legend and two-time Heisman Trophy–winner Archie Griffin took the field, scarlet hat in hand and waving to the crowd, the press annex once again swayed. The media helds its ground, and the swaying stopped when Archie left the field.

The Game

The game played out in a way that only the most fervent optimist could have hoped. It was full of drama, big plays, momentum shifts, and memorable moments. The game that was supposed to be a one-sided affair turned into a veritable life-and-death struggle between two teams that wanted to be national champions. Neither would bend, neither would quit.

In fact, the contest turned into one of the finest college football games ever played, and without question the finest BCS championship game ever played. Both teams made plays, both teams made mistakes, both team competed like champions.

It was a championship game to be dreamed of in a championship environment that was dominated by Ohio State fans. They were one with their team, those fans, willing them to play at a level at which no one outside the Buckeye Nation thought possible. The world was shocked as OSU slugged it out with Miami and played them even through four quarters.

Overtime

At every college football game, five minutes prior to the end of regulation, the media leaves the press box for the sideline to be able to be on hand for the postgame interviews. Little did we know that when we did so that day that we would have the privilege of seeing up close some of the most dramatic moments in OSU and college football history. When I arrived on the sideline it was jammed with people. Reporters, television crews, and cameramen were everywhere. Somehow, entertainer and OSU alumnus Richard Lewis has gotten down there, too, and stepped on my foot as he tried to get a better view of the game. He politely excused himself, and I made room for him to see the next play.

I was standing next to Columbus radio and tele-

vision personality Barry Katz as the Buckeyes faced a fourth-and-12 trailing by seven. I looked at Katz and said, "Well, it was close, but it's over." We were standing on about the 10-yard line at the end where the Buckeyes were trying to score and I began walking toward the interview area. I got about 10 feet, and I stopped. Something told me it wasn't over. I looked up, and the football was spiraling right at me. Michael Jenkins came from somewhere—to this day I don't know where—and caught it. First down Buckeyes. I looked at Buckeyes sideline broadcaster Jim Karsatos and we both began to laugh. We both admitted to nearly soiling ourselves.

I scurried back toward the sideline and was disappointed that all the good viewing spots were taken. I ended up deep in the corner of the end zone. I stood there, about 30 yards from the ball, as the Buckeyes faced another fourth down, wishing I had a better view. My opinion on that changed in a blink.

The ball was snapped, and Chris Gamble came running at me, or at least tried. A Miami defender was all over him, trying to stop him from running his route. I wanted to go block the guy. I wanted a holding call.

Gamble separated from him for an instant. I looked up, and once again the ball was coming at me, but it was clear that Gamble probably wouldn't catch it since he had been held off his route. He made the effort, and the defender once again wrapped himself around him a mere eight or ten feet from me.

I was sure there had to be a flag, but for what seemed like an eternity, none appeared. I looked up, and Miami was coming onto the field to celebrate their victory. Fireworks were going off. I looked back down, and the back judge who was standing in front of me was reaching for his flag. The fireworks exploded to celebrate the Miami win that wasn't. The Buckeyes were still alive with a first-and-goal. They scored to tie the game and force another overtime.

We all migrated to the other end of the field. As I passed behind the OSU bench, I saw Eddie George giving pointers to Maurice Clarett. Jonathan Wells and Keith Byars were helping him. Whatever they said must work. Clarett eventually scored the go-ahead touchdown.

I looked up at the OSU crowd from the sideline, and the sight was surreal. They were all standing, and they were all exhausted. They had invested in every way humanly possible in willing their team to victory. Just prior to every snap in the overtime, they collected themselves and raised the noise and energy in the stadium to levels that I would not have thought possible. When the plays ended, they collectively sagged like the air had been let out of them, almost as exhausted as the teams on the field. Like the teams, they refused to quit. They remained standing but slumped until the next play, then somehow found the energy to rise once again and lend their support to their team. It was one of the most unbelievable things I have ever seen.

Maurice Clarett had plowed his way to the go-ahead touchdown and Miami had driven to a first-and-goal at the OSU 2-yard line. This time

All-American place kicker Mike Nugent (85) and long snapper Kyle Andrews hug just seconds after the last play of the game.

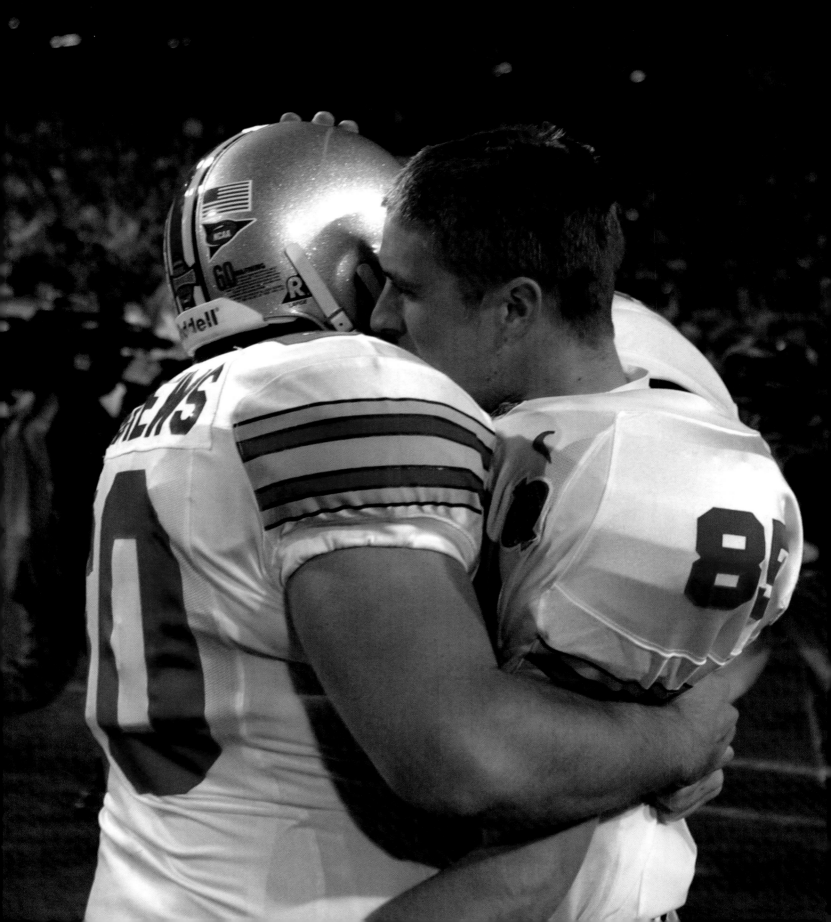

my view was terrible. I was looking through the clear audio parabola held by the ABC television crewmember on the sideline as the Buckeyes surrendered one yard in three plays. The game had come down to a one-play struggle for one yard.

The ball was snapped and through the parabola I saw the distorted image of a Buckeye (later I would find out Cie Grant) force Dorsey into throwing up a pass that fluttered like a wounded duck coming down over an Ohio marsh on the Lake Erie shoreline. Three Buckeyes were there, the ball was batted down, and through that parabola I saw a sight Buckeyes fans had waited 34 years to see: the OSU football team was sprinting onto the field as national champions.

Postgame

I raced to the field and Buckeyes fullback Brandon Schnittker high-fived me so hard I thought my hand was broken. Jonathan Wells grabbed me and wouldn't let go. It wasn't that we were particularly tight friends. I just think he needed someone to hug, and I was a familiar face nearby.

I saw freshman defensive back Tyler Everett. He had found a bag of Tostitos and he was stuffing them in his mouth as fast as he could, as if eating them would somehow preserve the moment.

Eddie George was hugging everybody, and there were smiles, hugs, and bedlam everywhere. I interviewed several players, all of whom were nearly delirious. I shook more hands and offered more congratulations than I can remember.

The fans were roaring. Conversations and interviews were not conducted by speaking, but by shouting. It all stopped when Jim Tressel took the podium. He proclaimed that OSU not only had the best damn band in the land, but now also the best damn football team in the land. Pandemonium erupted.

I found the-Ozone photographer Jim Davidson, and he was alternating between tears and uncontrollable laughter. Jim gave me a big hug. He had never done that before (and hasn't done it since). I was glad he was in the laughing phase as he hugged me.

We conducted more interviews, took pictures, and had our pictures taken. Nobody wanted to leave the field, but we had to get back to work. Tressel's press conference would start soon. In the postgame locker room I asked defensive coordinator Mark Dantonio when he first thought the game was won. Dantonio said he knew before the final snap was made.

"We had run that blitz with Cie all year but it was the first time we ran it in this game," said Dantonio. "When I saw they hadn't lined up to block him I knew he would get there, and I knew he wouldn't miss."

He didn't, and anybody who was there will never forget it, any of it. It always will remain a Buckeyes moment frozen in memory and frozen in time. ∎

Senior defensive lineman David Thompson cradles the million-dollar, 24 karat gold, diamond-crusted Fiesta Bowl trophy like the football it represents. The trophy traveled to many events leading up to the game, always guarded by a cadre of serious-looking security. The Buckeyes passed it around after the game like it was a seasoned game ball.

WATCH

Tom Orr is a former sports editor of *The Ohio State Lantern* and has been a sports and news producer for television stations in Columbus, Ohio, and Detroit, Michigan. In 2002 Tom was a contributing writer for the-Ozone.net, a web publication dedicated to Ohio State sports. He currently holds a position with Thepalestra.com

Tom could not attend the national championship game. His assignment the night of the game was to attend a game party at the Blackwell Hotel. The Blackwell is an on-campus hotel and the game-night home of the Buckeyes football team.

Tom was asked to submit a minute-by-minute report of his game-day experience. His column that night eventually evolved into a regular feature called *The Buckeyes Watch* that he wrote for several seasons. It is now written by Tony Gerdeman and is published on the-Ozone.net.

Reproduced below with his permission and the permission of the-Ozone.net is Tom's report from that night.

Minutes That Will Last a Lifetime By Tom Orr

So wait a minute. You're telling me that the Ohio State Buckeyes...the break your heart every year...never, ever finish the big one...guaranteed to leave you disappointed Ohio State Buckeyes football team is the national champion?

Huh.

How 'bout that?

Somehow, sitting here right now, all the agony, all the heartbreak, all the devastating losses were all worth it. Because without experiencing the lows, how are fans supposed to measure and enjoy the true heights of the highs?

Without the lows, you'd just be a Yankees fan, or a Celtics fan from decades past. Then, championships would be nothing more than fulfilling

Head Coach Jim Tressel raises the national championship trophy crystal football for everyone to see.

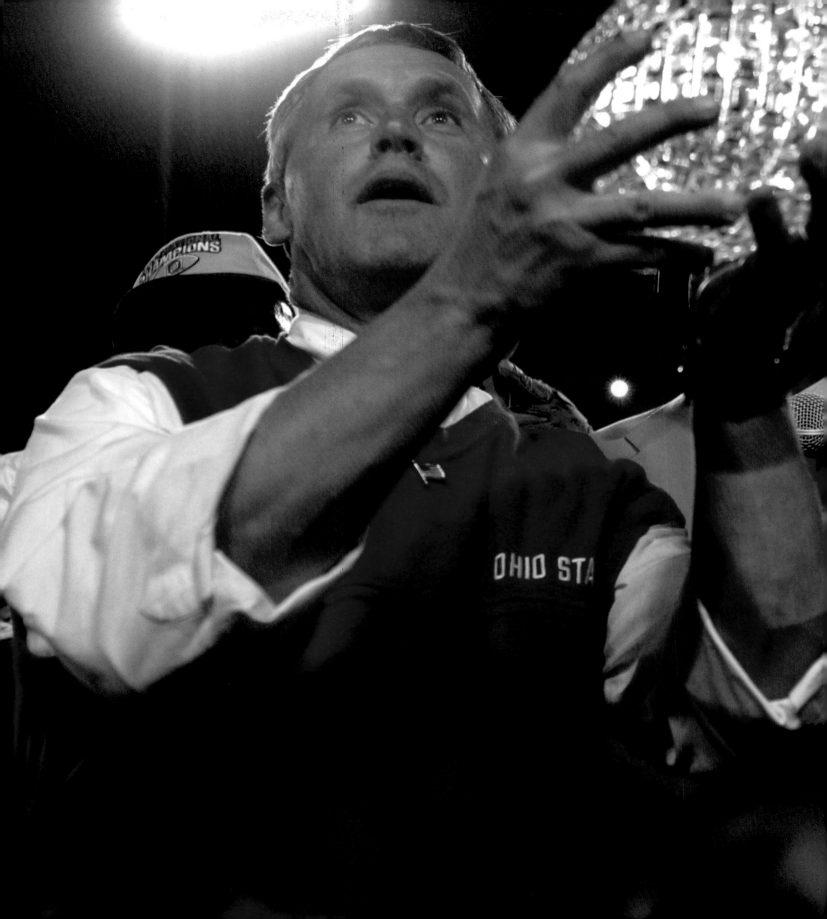

your annual destiny, no more worthy of celebration than successfully taking out the garbage.

No, this is truly as sweet as it gets as a fan. We know what it feels like to be the other guy. Now, finally...after 34 long years...the Ohio State Buckeyes are national champions.

The journey through the evening made the end result even more special. So here is the story of one fan's trip from pre-game to celebration, as his school FINALLY fulfilled its destiny.

Pregame: Arrived at the Blackwell and was absolutely stunned at the crowd. They were loud, boisterous, and ready to rock. I was afraid it was going to be a wine-and-cheese affair. No sweat. This was a Buckeyes crowd.

7:51 pm: The Ohio State University Marching Band enters the field. I get full-body chills just watching them drive, drive on down the field.

7:55 pm: OSU president Karen Holbrook is being interviewed on the local pregame show. I think she said something about being really excited about the Sugar Bowl and clapping politely when Miami enters the field. Fans behind me start chanting "Get her off! Get her off!" My kind of people.

8:02 pm: Just noticed that Keith Jackson is wearing a day-glow security wristband. Who doesn't know Keith Jackson? Is he really a security threat?

8:12 pm: Sideline reporter Todd Harris says that a win would "Signal a new era in Ohio State football." Does the phrase "In 310 days" mean any-

thing to you? I think the era's already underway.

8:17 pm: Coin toss time: Donnie Nickey calls heads, it's tails. Let the second-guessing begin.

8:21 pm: Ohio State starts the game with 12 men on the field. We only had five weeks to get this one straight, guys. I'm guessing it's just an unprecedented case of nerves.

8:24 pm: Bucks go three-and-out. Andy Groom punts the ball to Scottsdale. Field position could be a deciding factor tonight.

8:26 pm: Matt Wilhelm just swallowed Willis McGahee, then got up and did the "Diamond-cutter" move that McGahee does after touchdowns. I think these guys might be a little fired up to play this uber-hyped Miami squad.

8:32 pm: Kenny Peterson just sacked Ken Dorsey, making it two sacks on one drive, after the Canes allowed just eight all year. Is this defense really this good? It's starting to look like it.

8:41 pm: OSU has gone three-and-out twice as I watch the 57th Ford commercial of the night. The defense needs to force a turnover to get the O going.

8:43 pm: Willis McGahee just held Robert Reynolds like no one I've seen before. I hope he bought him dinner first. No call, and a big completion to Winslow.

8:47 pm: More holding. So THIS is what it takes to win 34 straight!

9:00 pm: End of the first quarter, Miami 7, Ohio State 0. This has got the feel of a four-quarter

game. I don't think Miami has what it takes to score repeatedly on this Buckeyes defense.

9:03 pm: Another booming punt by Andy Groom, followed by the greatest combination block in the back and hold I have ever seen. No call. Did they say this was a Big East crew?

9:09 pm: Dorsey throws an interception. The Bucks are in business! Dorsey looks rattled. I don't think he's been hit like this before.

9:13 pm: Dan Fouts comments on OSU's four penalties and says, "Miami: remarkably no penalties tonight." You got that right, Danno.

9:15 pm: A fake field goal? Last year I would have understood that, but Nugent has been so close to automatic that it's like taking points off the board. I would have disagreed whether we made it or not, but I hope this doesn't come down to us trailing by three (or six) late.

9:20 pm: Is John Saunders 6-foot–8 or is Terry Bowden 5-foot–2?

9:27 pm: Third-and-goal at the one. Just run two sneaks by Krenzel. He's been money all year.

9:31 pm: Touchdown Krenzel! We're tied at 7, and they just showed Ken Dorsey with an "Uh-oh" look on his face. I wonder if Miami was ready to play four quarters.

9:34 pm: Nugent's kickoff is a touchback. Don't give Miami's skill position guys extra touches tonight. Touchbacks are huge on kickoffs.

9:34 pm: Another Dorsey interception. He just

looks shell-shocked out there right now. This is supposed to be the greatest leader of all time?

9:37 pm: Maurice Clarett stops dancing and just plows into the end zone. 14–7 Ohio State, and the fans at the Blackwell are just delirious. This is insane. Tim "48–10" Brando must be loving this one.

9:39 pm: About a minute left in the half, and you absolutely cannot let Miami score before the half. They did that to Pitt, and it just killed the Panthers. Let them rot in the locker room facing a deficit.

9:44 pm: Halftime, OSU 14, Miami 7. I can't help thinking how great 17–7 would look. Using those two early timeouts just killed Miami on that last drive. With three timeouts, that's a whole different drive.

9:48 pm: Call college buddies (I feel so old writing that!) to exchange "Can you believe this game?" comments.

9:55 pm: The first drive of the third quarter will set the tone. OSU could really put Miami behind the 8-ball by forcing a three-and-out and then driving for some points.

10:07 pm: "We're going to play as hard as we can and see if we deserve it," Jim Tressel comments, talking to the ABC sideline guy. No other coach in America talks that way. These guys won't be too cocky coming out.

10:09 pm: A graphic on Dorsey passing numbers shows that the Bucks are conceding the

underneath stuff but just killing the Canes on the deep passes. Those guys, who are used to scoring at will, are going to be frustrated.

10:14 pm: Chris Gamble just blows past a Miami defender and goes down at the six. Thank God Chris doesn't have rear-view mirrors. The view of those lightning-quick Miami defenders in his wake might have left him too intimidated to catch the ball.

10:15 pm: Krenzel overlooks a wide-open guy in the flat, throws it directly to a Hurricane, and then Maurice Clarett chases the guy down and rips it away. That stuff never happens. The word "Destiny" comes to mind. (If we lose, that's not going in the column, credibility be damned)

10:18 pm: Another dropped pass. OSU isn't playing perfectly and they're still winning. Just run a draw on third-and–12 and kick the field goal.

10:19 pm: After a QB draw (thankyouverymuch) Nugent's field goal splits the uprights. It's 17–7 OSU, and I'm wondering how many times during the streak Miami has faced a double-digit deficit. I know FSU was up 13, but that might be it.

10:22 pm: Andre Johnson takes the kick return to the 40. This is why touchbacks are huge. Buckle up for the longest 25 minutes of football of your life.

10:27 pm: I'm sorry, but the guy screaming in the Bud Light ad (with the guys breaking into the back of his fridge) might be the greatest beer

commercial since "I'm Mister Gal-E-Week-Itch. You mean Doctor Galakiewicz? Yes, I am."

10:32 pm: Andy Groom trots on, and I wonder out loud if a punter has ever been the MVP of a bowl game. He promptly shanks one 30 yards. I vow to stop thinking for the rest of the evening.

10:40 pm: Miami takes a time out. That could cost them late, just like it did before the half.

10:43 pm: Willis McGahee scores a touchdown, and it's 17–14. I brace myself for the bumpiest quarter of football of my life.

10:50 pm: 17–14 and the Ohio State Buckeyes are 15 minutes away from a national championship. I still can't quite comprehend that sentence.

11:00 pm: Forget the final score, the fact that Miami hasn't been flagged for holding might be the greatest upset in the history of college football.

11:01 pm: EEEEEWWWWWW! That's not how a knee is supposed to look. I can't help wondering if this is just ammo for Trev, Mark, and the rest to say "Miami was playing without their best guy..." Of course, I've been about as effective as McGahee tonight. Mark Dantonio is unreal.

11:03 pm: Sievers misses a field goal. This is why we love Mike Nugent. Still 17–14.

11:11 pm: Nugent misses a field goal. What did I just tell myself half an hour ago about thinking?

11:17 pm: Dustin Fox lays a nice hit on Parrish, who obligingly coughs the ball up. I really don't think the Miami guys are used to getting drilled.

Someone dumps a bucket of Gatorade over a jubilant group of celebrating Buckeyes.

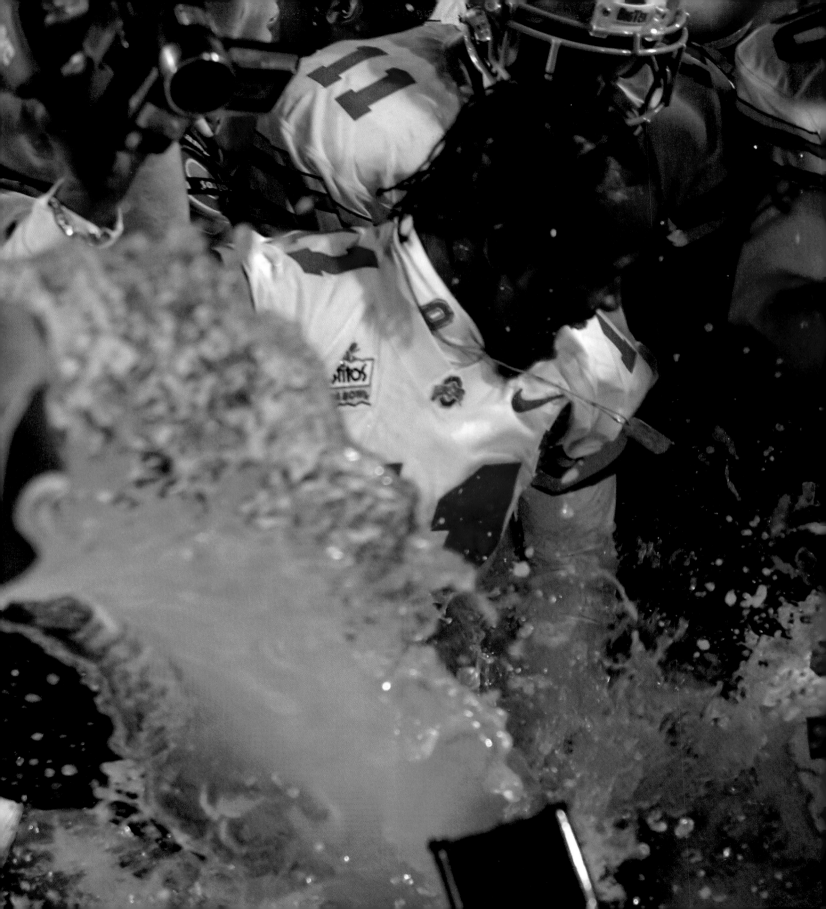

Fox has very quietly put together a great game. We haven't heard his name all night, and that's the mark of a great cornerback. Excellence in anonymity, like long-snappers.

11:20 pm: Clarett limps off. Oh, crap. But it looks like just a cramp.

11:22 pm: Craig Krenzel scrambles to convert another third down. Did Miami not receive any game film from this year? Is this scrambling ability somehow a surprise? If OSU wins, Krenzel is my MVP, passing stats or not.

11:23 pm: Miami takes a time out to stop the clock. Burning that early one hurts, they're down to just one.

11:30 pm: Simon Fraser with the huge sack of Dorsey. I couldn't be happier for anyone in the world. Fraser is a shining example of what's right about college football, just a great kid. And where the heck is this vaunted Miami offensive line? Did they leave early for the NFL combine?

11:31 pm: Miami takes a timeout, and gets ready to line up for a field goal. Ohio State is exactly three seconds from a national title. My head is spinning.

11:34 pm: The Buckeyes just spent their second time out in a row to "ice" Sievers. I don't know about him, but they've iced me very effectively.

11:35 pm: Crap.

11:36 pm: OSU has a kicking advantage and the turnover advantage heading into OT. Miami has the big-play guys. But you just know this is going to be brutal.

11:46 pm: Kellen Winslow catches a touchdown. Man, I absolutely hate that kid. He's a good player, but his preening and trash talk have gotten old quickly. 24–17 Miami.

11:50 pm: fourth-and–14. What ever you do, don't throw a pass short of the first down line.

11:50 pm: Krenzel completes the pass, first down. This is absolutely unwatchable.

11:54 pm: fourth-and–three at the five. Do-or-die again. Why does this team hate me?

11:54 pm: FLAGFLAGFLAGFLAGFLAG! There it is. Dan Fouts is a moron. That was pass interference, holding, and everything else. Miami fans can whine all they want, but they should be looking at about three miles of holding calls tonight. Maybe the universe is balancing itself out. If the Bucks manage to pull this one out, people will hold this call over our heads forever.

11:59 pm: Touchdown!!! Don't be an Osborne, just kick the point. Thank you. 24-all. Win or lose, this is the greatest college football game I have ever, ever seen. Period, end of story.

12:06 am: Clarett touchdown. 31–24 Bucks! There's something about 300 seemingly sane people sitting in a hotel ballroom, watching a game going on 2000 miles away, and just screaming at the top of their lungs that puts this all in perspective. There's nothing like college football.

12:07 am: Ken Dorsey just got another taste of life in the Big 10. It tastes like facemask and grass. The license plate number was 35, Ken.

12:09 am: Can we waive the rule about having

to sit out a play when you get hurt? I would love to see Dorsey dazed and on the field. He looks like Admiral Stockdale out there right now.

12:09 am: Miami is facing fourth down. Ohio State is one play from being national champions.

12:10 am: Timeout. "Hang on Sloopy" has never meant so much to Buckeyes fans. Just... hang...on.

12:11 am: First down to that damn Winslow again.

12:16 am: Fourth-and-goal at the 1. We're one play away again. I finally understand how the fans of the 1986 Red Sox were feeling. Sooooo close, and it keeps getting pulled away from you at the last second. But I'm a Mets fan. We always pull these things out.

12:17 am: Now serving number 14! Trev Alberts, Mark May, Tim Brando, and all the rest of you can shove it. (Columbus radio and television personality) Joe Weasel and I are screaming, hugging and jumping up and down like we just hit the Powerball. I can't believe this. My guys finally...FINALLY...won. I'm so happy for the seniors...guys like Donnie Nickey, Mike Doss, and Matt Wilhelm who have gone through all the awful times here. I sat in the Meadowlands that dreadful day when Miami handed it to us in 1999. These guys missed a bowl their freshman year. Think about that. Now they leave as champions. What a draining game. I'm really trying not to cry. I just can't believe this.

12:26 am: Lynn Swann is up on the podium looking for Maurice Clarett. He can't find him. He settles for Craig Krenzel. What a fitting end to Krenzel's season. He plays an MVP-caliber game and he's still second-fiddle. By the way, if the MVP doesn't go to Krenzel, I'd be stunned. Do they give an MVP award?

1:00 am: Leaving the Blackwell, I look around. Cars are honking their horns with people shrieking out the windows. The Horseshoe sits off to my left, giving off a soft, white glow and proudly displaying those beautiful stained-glass windows. They've never looked as pretty as they do tonight. And I've never been prouder of my school, my team as I am tonight. All they heard was how they were going to lose and how they had no business being on the same field as Miami. They proved everyone wrong. They played like champions. And now, after 34 years, they finally are the champions of college football once again. ∎

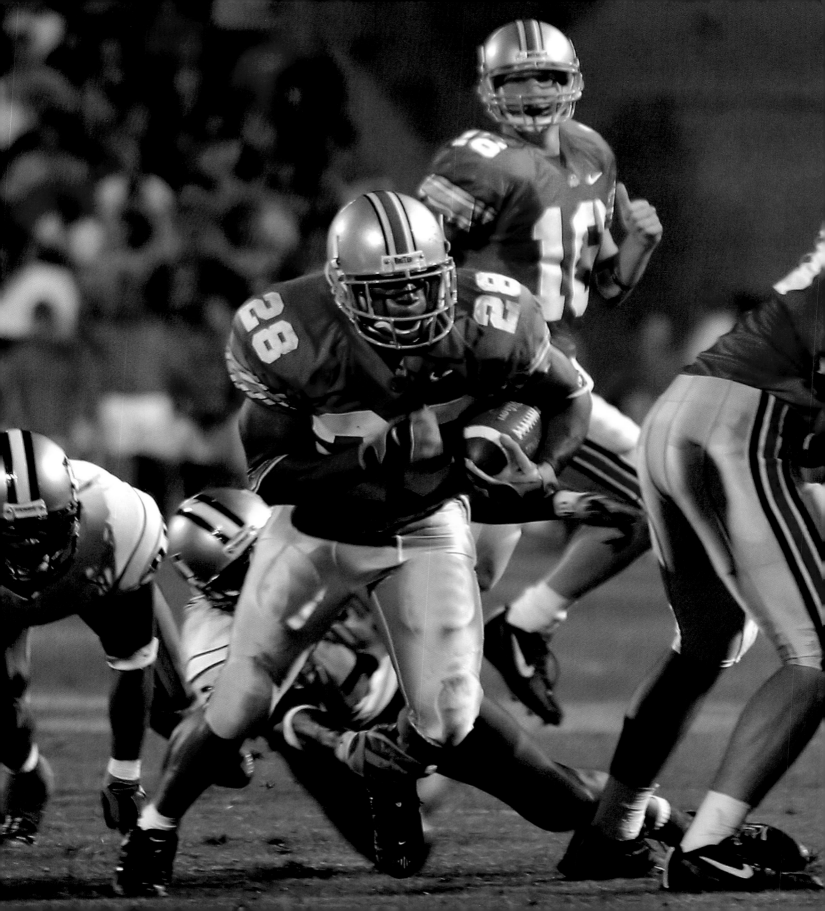

2003

Just a Little Short

Ohio State fans were excited about the 2003 season, and why not? The Buckeyes returned 42 letter winners from a national championship squad—20 on offense, 20 on defense, and two on special teams.

Quarterback Craig Krenzel was back to lead the offense. Up front, offensive linemen Adrien Clarke, Nick Mangold, Shane Olivea, Rob Sims, Alex Stepanovich, Bryce Bishop, and tight end Ben Hartsock all were back. Mike Jenkins returned at wide receiver along with Santonio Holmes and Drew Carter.

The OSU defense was once again expected to be dominant. Players such as defensive backs Will Allen, Chris Gamble, and Dustin Fox were back. Defensive linemen Will Smith, Darrion Scott, Simon Frasier, and Tim Anderson all returned. At linebacker, 2002 starter Robert Reynolds returned.

A.J. Hawk and Bobby Carpenter were a young but solid duo while Fred Pagac Jr. and Thomas Matthews were veterans adding depth.

The kicking game looked very strong. Mike Nugent returned as the place kicker and B.J. Sander was on the field as the punter for what would be a Ray Guy Award-winning season.

The Buckeyes returned enough talent and depth to be a legitimate national championship contender, but they had one major flaw. After a tumultuous freshman season, tailback Maurice Clarett was declared ineligible for one year by the OSU Department of Athletics. Clarett was allowed to practice with the team but had severe restrictions on his football-related activities, including involvement with the media. That left the tailback position to Lydell Ross and Maurice Hall. Hall had been hampered with knee injuries his

Maurice Hall rushes six yards over left tackle for a first down against Washington as quarterback Crag Krenzel watches from the backfield. Hall led OSU in rushing against the Cougars with 60 yards on 15 carries and one touchdown.

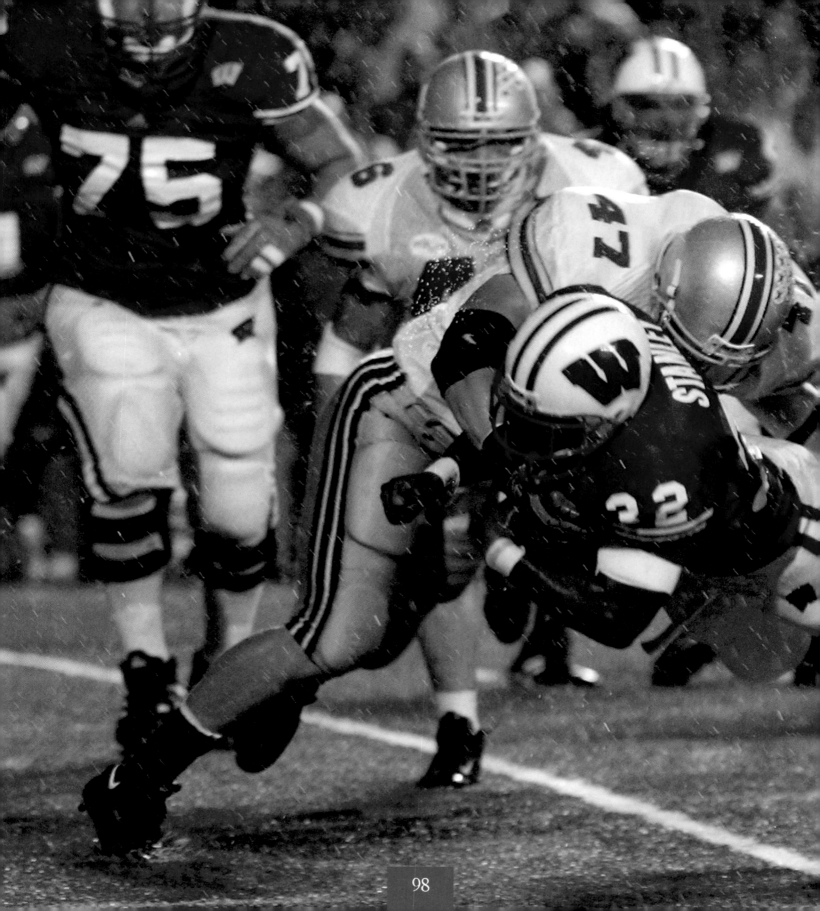

2003

entire career. Ross simply could not match Clarett's talent. In short, the Buckeyes were without a strong running game.

OSU entered the season ranked No. 2 in the national polls but slipped to No. 4 when they needed three overtimes to defeat Phillip Rivers and the North Carolina State Wolfpack. The Buckeyes were held to just 44 yards rushing on 32 attempts in that game. Krenzel completed 26-of-36 for a career-high 273 yards and four touchdowns to bail out the Buckeyes, but their weakness had been exposed.

Three weeks later against No. 22 Wisconsin, the No. 3 Buckeyes suffered their first defeat in two seasons. The game was played in a driving rain-storm making it difficult to throw the football, and OSU's lack of a running game came back to haunt them. The Buckeyes rushed for just 69 yards but were still in the game late in the fourth quarter. With 5:20 left to play and the score tied at 10–10, Wisconsin star receiver Lee Evans made his only catch of the night and went 79 yards with it to score.

The Buckeyes fell to No. 8 with the loss but returned to the winning track the following week on the road against No. 9 Iowa. OSU won the game 19–10, but the Buckeyes offense failed to score a touchdown. OSU's scoring came on a field

A. J. Hawk couldn't stop Badgers running back Booker Stanley before he entered the end zone. The game in Madison was played in a driving rainstorm.

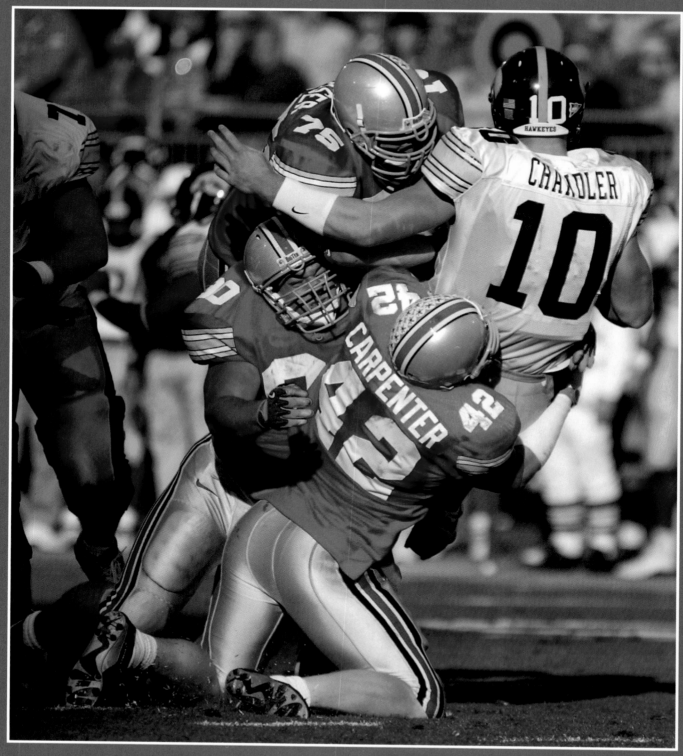

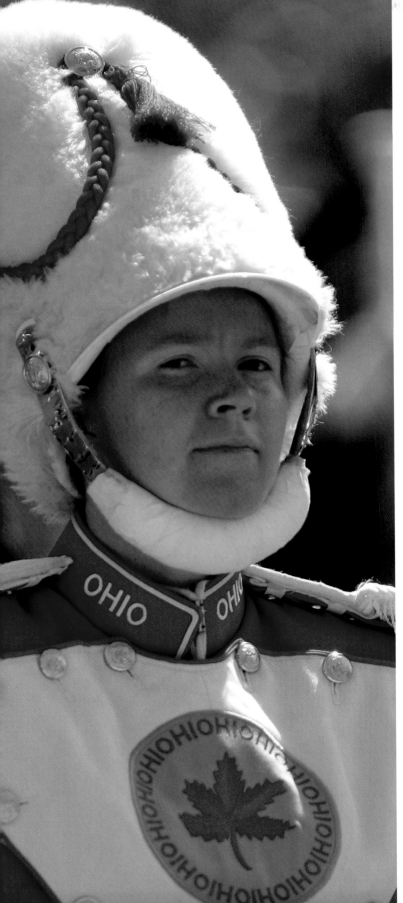

2003

goal by Nugent, a 54-yard punt return for a touchdown by Michael Jenkins and a blocked punt return for a score by freshman defensive back Donté Whitner. The Buckeyes were held to 56 yards rushing and 129 passing in that game but still came out with a win due to special teams play and the defense.

Despite the offensive woes, the Buckeyes kept on winning and kept on rising in the polls. They reached No. 4 prior to their date with No. 5 Michigan in Ann Arbor. The schedules of the teams ahead of them in the polls made it a very real possibility that the Buckeyes could return to the national championship game if they could beat the Wolverines for the third straight season.

The Buckeyes played to their strengths in the Michigan game. Punter B.J. Sander was incredible, punting for an average of 49.1 yards on nine kicks. Krenzel and Scott McMullen combined for 329 passing yards on 28-of-46 passing, but the Buckeyes could not pull off the win and fell 35–21 to the Wolverines. The difference in the game was Michigan running back Chris Perry who rushed for 154 yards and two touchdowns on 31 carries. The OSU rushing attack was once again exposed and

(opposite) Linebacker Bobby Carpenter (42), defensive tackle Quinn Pitcock (90), and defensive end Simon Fraser (75) flatten Iowa QB Nathan Chandler just after he releases the ball. The pass was incomplete.

(above) OSU Drum Major Kathryn Mitchell fulfilled her long-time dream in 2003 and became one of the few female drum majors in OSU history.

2003

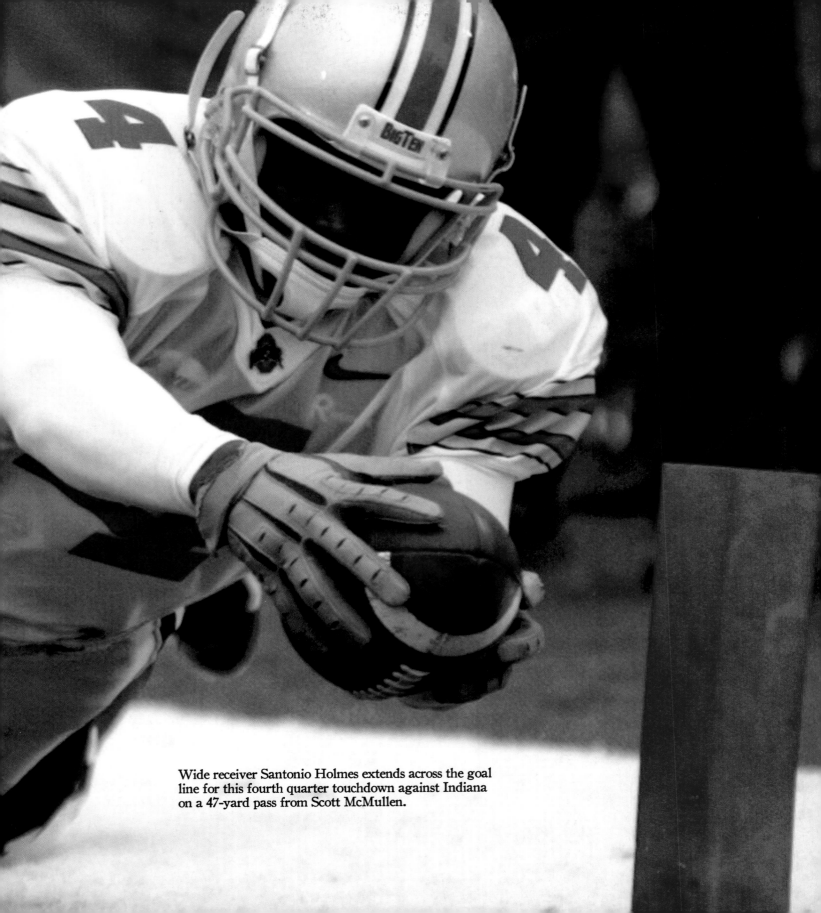

Wide receiver Santonio Holmes extends across the goal line for this fourth quarter touchdown against Indiana on a 47-yard pass from Scott McMullen.

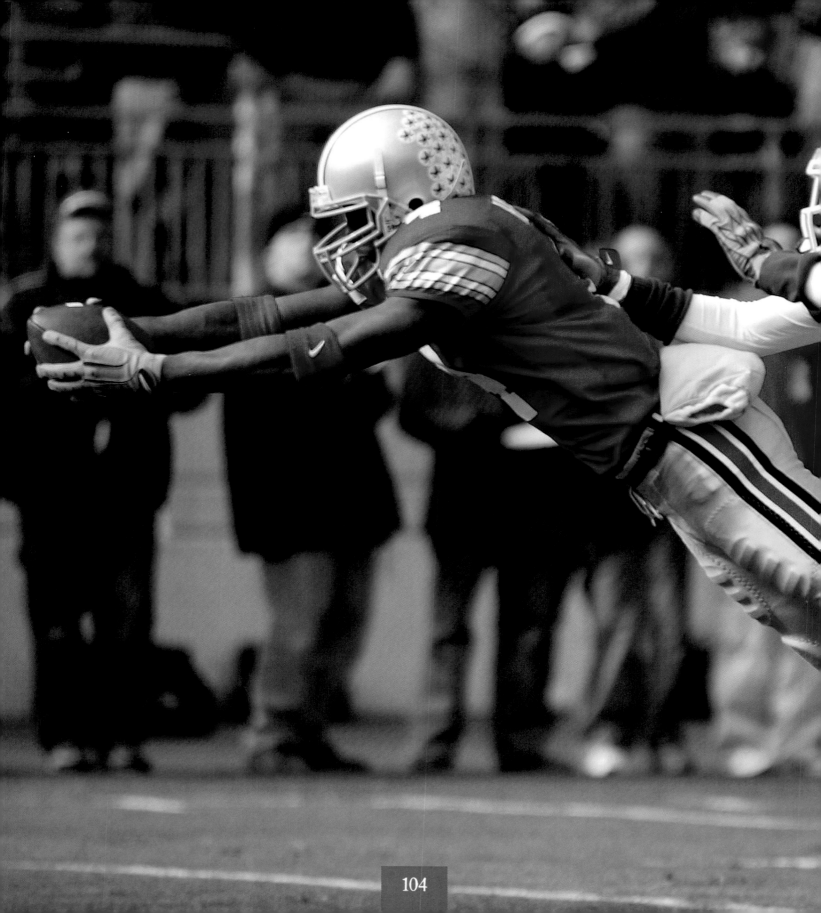

2003

accounted for only 54 total yards in the game.

Despite the loss the Buckeyes fell just three spots in the polls and were invited to return to the Fiesta Bowl against No. 10 Kansas State. OSU took a 35–14 lead through three quarters and then used tried-and-true "Tressel Ball" to earn a 35–28 win and finish the season with an overall record of 11–2.

The 2003 season also marked the beginning of a culture change surrounding the Ohio State football program. Prior to the 2002 national championship OSU practices were open to both the media and the public. Autograph seekers hounded both players and coaches making it nearly impossible for them to come and go at practices. Many of the autograph seekers were there with the intention of selling the signed items on websites like eBay.com. Additionally, growing demand for news coverage of the team, particularly from Internet publications, began to reveal information from practice sessions that the OSU coaching preferred to keep private. In response to the hounding, Tressel closed practices to the public, and press access was severely limited. The open door that Tressel had created prior to 2002 was suddenly slammed shut and the Woody Hayes Athletic Center became a closed facility. ■

Santonio Holmes extends for the goal line against Michigan State and gets there. His touchdown gave OSU a 17–7 lead over the Spartans.

2003 STATS

Overall: 11–2 • Big Ten: 6–2
Final Ranking: Associated Press No. 4, USA Today No. 4
National Award Winners: B. J. Sander — Ray Guy Award
First Team All-Americans: Will Allen (safety), Will Smith (defensive end)
First Team All-Big Ten: Will Smith (defensive end), Will Allen (safety),
Alex Stepanovich (offensive guard), Ben Hartsock (tight end), Tim Anderson
(defensive tackle), A. J. Hawk (linebacker), Chris Gamble (cornerback),
B. J. Sander (punter)

W/L	Date	PF	Opponent	PA	Location
W	08–30–2003	28	Washington	9	Columbus, OH
W	09–06–2003	16	San Diego St.	13	Columbus, OH
W	09–13–2003	44	North Carolina St.	38	Columbus, OH
W	09–20–2003	24	Bowling Green	17	Columbus, OH
W	09–27–2003	20	Northwestern	0	Columbus, OH
L	10–11–2003	10	Wisconsin	17	Madison, WI
W	10–18–2003	19	Iowa	10	Columbus, OH
W	10–25–2003	35	Indiana	6	Bloomington, IN
W	11–01–2003	21	Penn St.	20	State College, PA
W	11–08–2003	33	Michigan St.	23	Columbus, OH
W	11–15–2003	16	Purdue	13	Columbus, OH
L	11–22–2003	21	Michigan	35	Ann Arbor, MI
W	01–02–2004	35	Kansas St.	28	Tempe, AZ

Tight end Ben Hartsock scores Ohio State's first
touchdown of the game against Michigan State on a
17-yard sideline pass from Craig Krenzel.

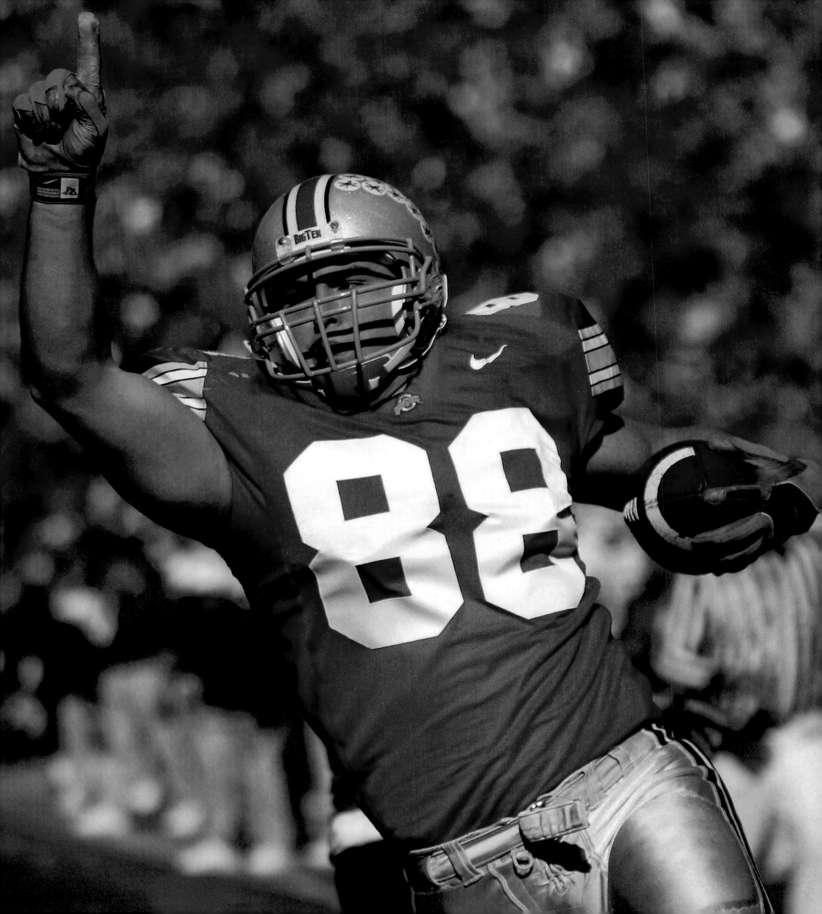

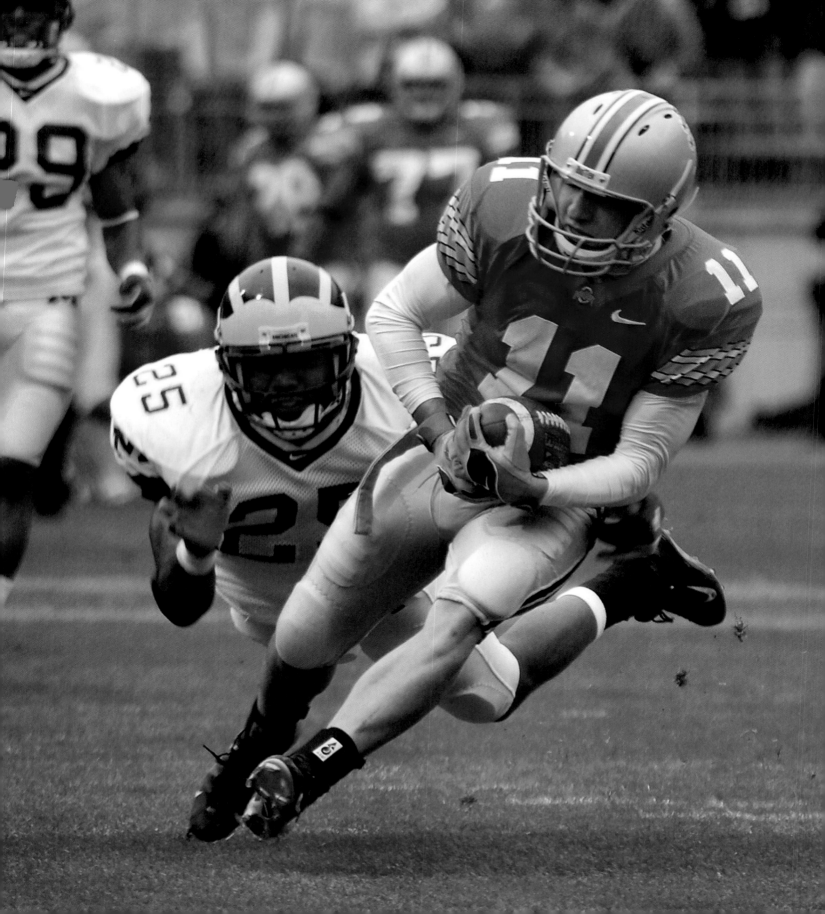

2004
A Year of Change

The bulk of the players who made up the 2002 and 2003 teams were gone in 2004. Additionally, there were just 14 fifth-year seniors and six fourth-year seniors on the entire roster. The Buckeyes were young, relatively inexperienced, and searching for an identity. In 12 games that season the Buckeyes used 12 different starting lineups.

On offense, Tressel selected sophomore Justin Zwick as the starting quarterback ahead of fellow sophomore Troy Smith. The only returners on the offensive line were Nick Mangold and Rob Sims. Santonio Holmes was back at wide receiver, and running backs Lydell Ross, Maurice Hall, and Brandon Joe also returned.

It was much the same story on defense. Linebacker A.J. Hawk and defensive end Simon Frasier were the only returning starters in the front seven. Dustin Fox and Nate Salley returned in the secondary. The rest of the defensive lineup was new. Mike Nugent returned for his senior season as the OSU kicker, but the Buckeyes were once again looking for a punter.

There was also major turnover in the OSU coaching staff. Gone was the architect of the defense, Mark Dantonio. Dantonio took the head coaching position at Cincinnati following the 2003 season. Mark Snyder had served as OSU's linebackers coach and was elevated to the coordinator's position following Dantonio's departure. New to the OSU coaching staff were John Peterson and Darrell Hazell. Peterson took over as the recruiting coordinator and tight ends coach after long-time assistant Bill Conley left the staff. Hazell was appointed to the position of wide receivers coach while running backs coach

The Buckeyes strike first. With 1:13 elapsed on the game clock, quarterback Troy Smith hits Anthony Gonzalez with a deep pass for a 68-yard touchdown. Gonzalez eluded Michigan defender Ernest Shazor for the score.

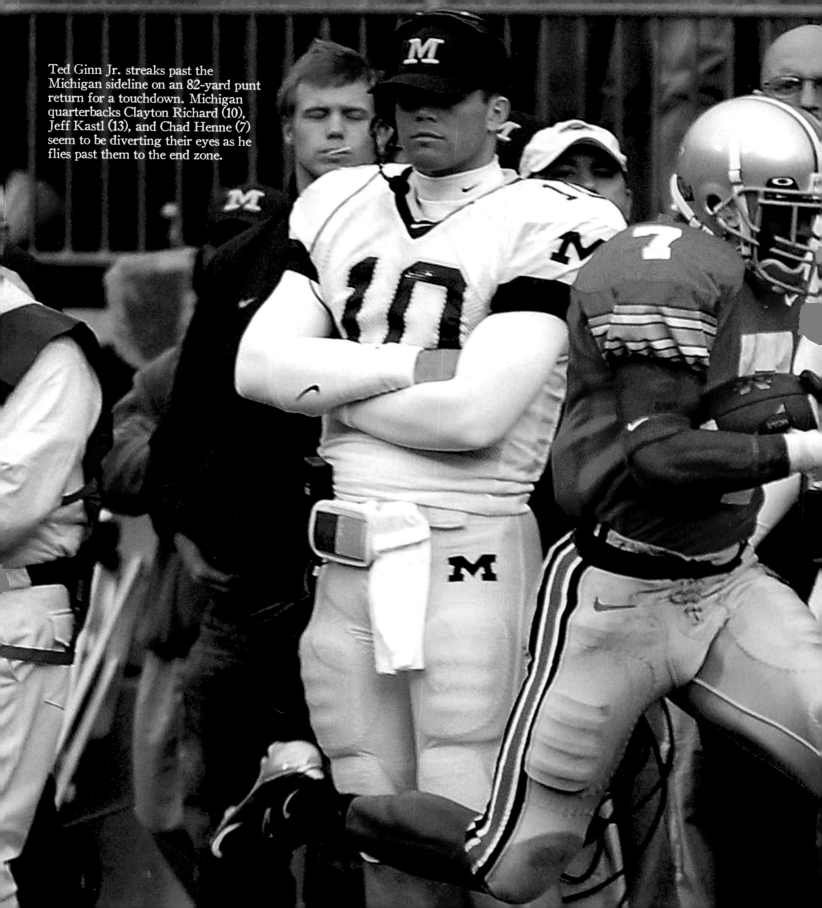

Ted Ginn Jr. streaks past the Michigan sideline on an 82-yard punt return for a touchdown. Michigan quarterbacks Clayton Richard (10), Jeff Kastl (13), and Chad Henne (7) seem to be diverting their eyes as he flies past them to the end zone.

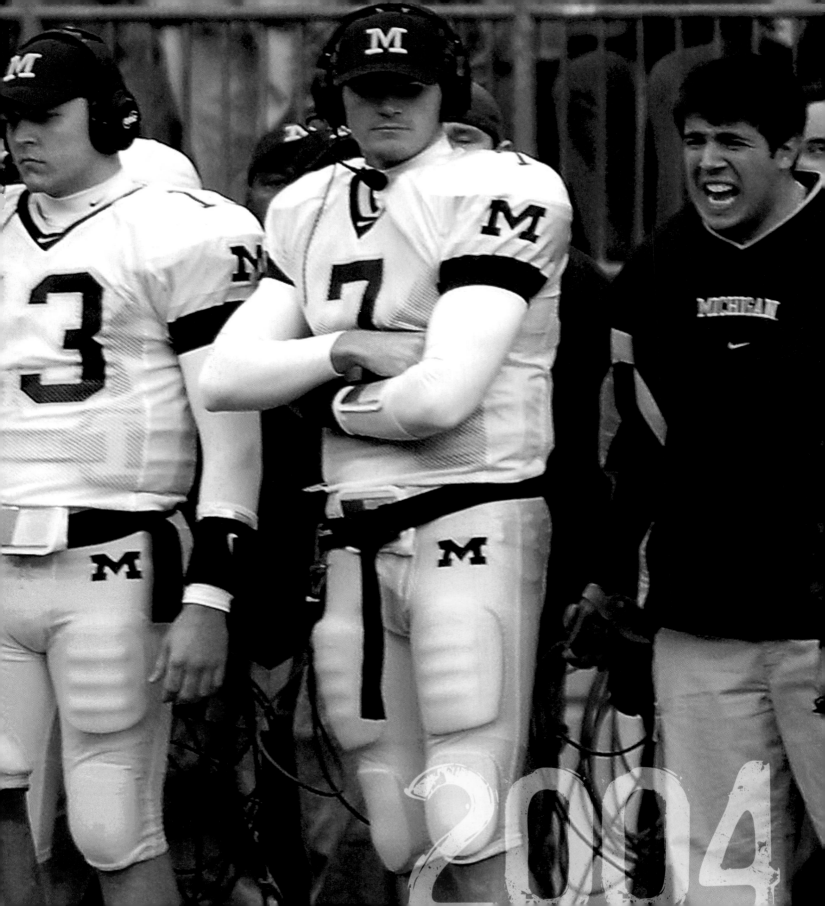
2004

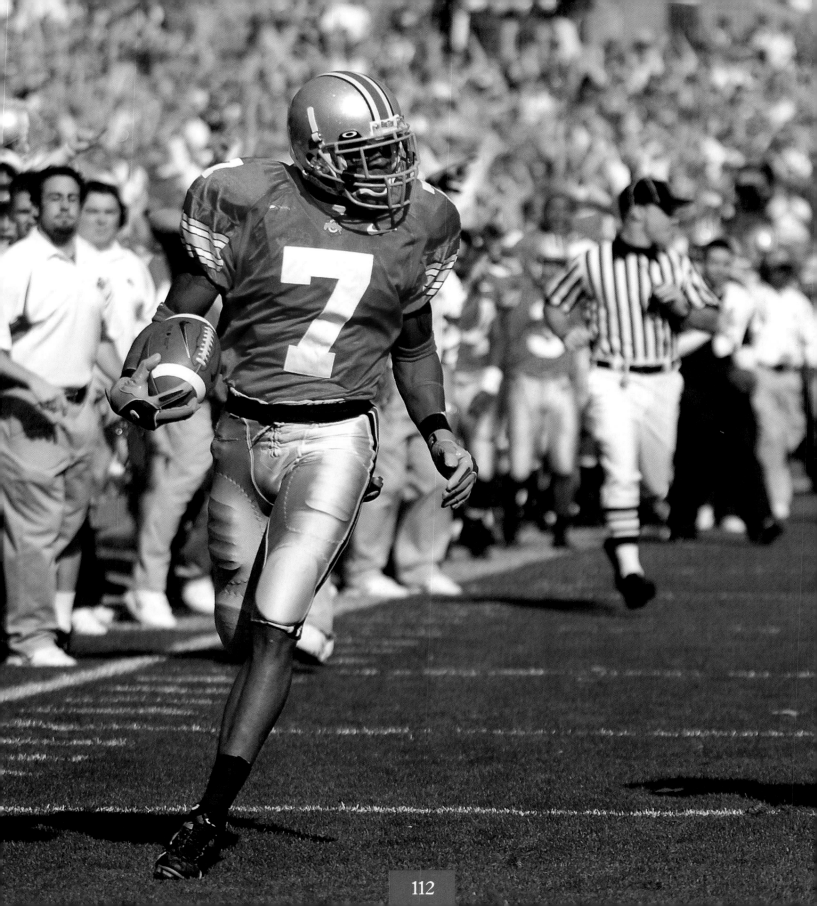

2004

Tim Spencer left the staff for the Chicago Bears. As a result, Dick Tressel was moved from the director of football operations spot to running backs coach.

The Buckeyes began the season with three victories and rose to No. 7 in the polls after the third one, a 22–14 win at North Carolina State. Then the wheels came off.

OSU traveled to Northwestern to open the Big Ten season and was upset by the Wildcats in overtime. It was the first Buckeyes loss at Northwestern since 1958 and started a three-game skid. They lost the following week at home to Wisconsin 24–13. The low point of the season occurred a week later when the Buckeyes were completely dominated by Iowa at Iowa in a 33–7 pasting. That loss left the Buckeyes at 3–3 on the season and 0–3 in league play. It also left them without their starting quarterback. Zwick was injured near the end of the game and could not return. Backup quarterback Troy Smith came off the bench to complete eight of 12 late in the game.

Changes were made the following week against Indiana. The injured Zwick was replaced by Smith and Roy Hall started at wide receiver over Bam Childress. Maurice Hall moved into the starting tailback spot over Ross. Additionally, freshman running back Antonio Pittman began getting

On his way into the end zone on a 67-yard punt return, Ted Ginn Jr. takes a glance back to his left to see that the only pursuer is Penn State kicker Jeremy Kapinos. The punter is not going to catch Ted Ginn.

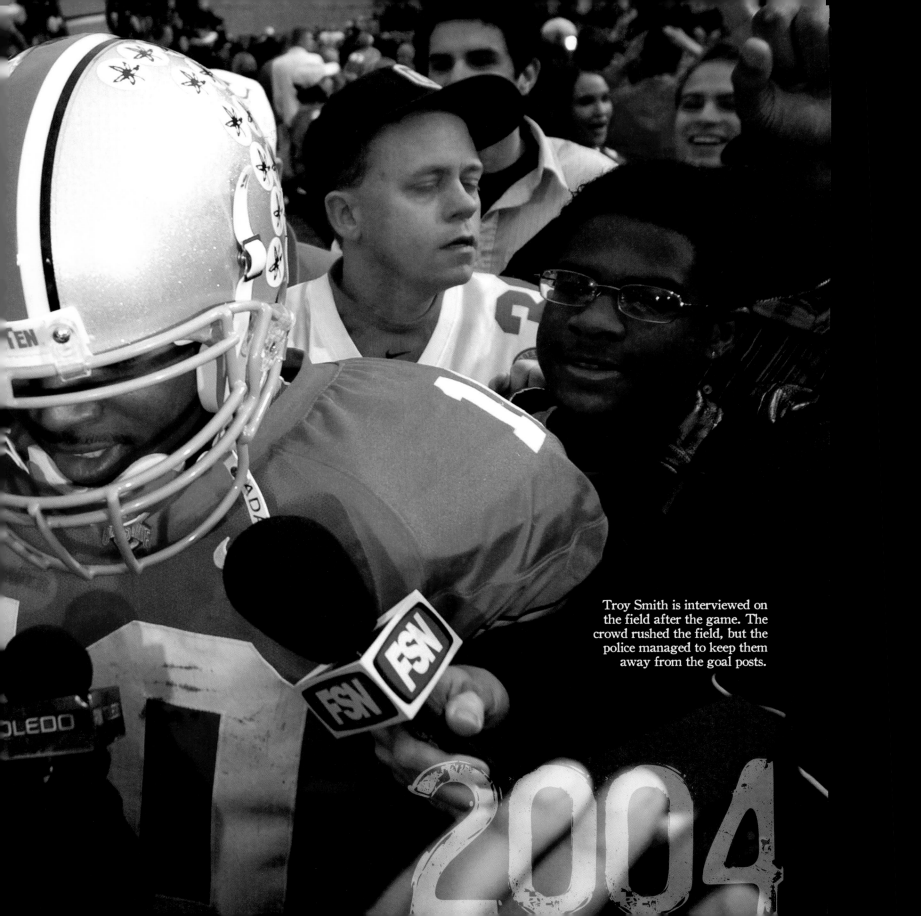

Troy Smith is interviewed on the field after the game. The crowd rushed the field, but the police managed to keep them away from the goal posts.

2004

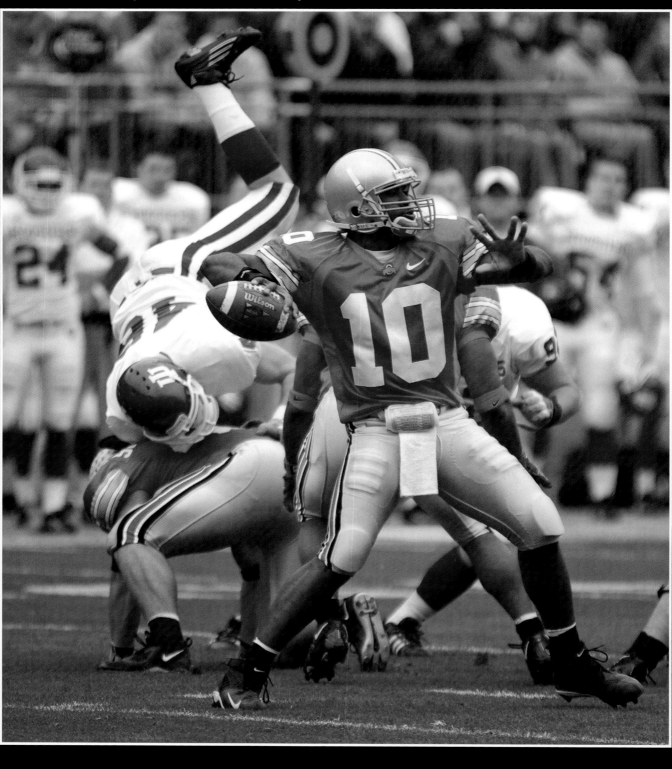

more carries while wide receivers Anthony Gonzalez and Ted Ginn Jr. also saw more action.

On the defensive side of the ball, Ashton Youboty replaced Brandon Underwood at corner and Tyler Everett began seeing more time at safety. Mike Kudla also earned the starting nod at defensive end. Additionally, Kirk Barton had already replaced Schafer at right tackle some weeks earlier. The changes were being made. Pittman rushed for 144 yards on 20 carries against Indiana and Smith added 58 more. He also threw two touchdown passes, one a 58-yard bomb to Ginn.

The Buckeyes reeled off three consecutive wins as the team evolved. The OSU offense that had been stagnant for several seasons suddenly became explosive with Smith at quarterback. Additionally, Pittman and Hall brought just enough to the rushing game to give the offense some balance, though Smith also contributed to the running game from his quarterback position.

The Buckeyes lost a tough one on the road to Purdue but salvaged the season when a brilliant performance by Smith against Michigan led the unranked Buckeyes to a 37–21 over the No. 4 Wolverines at Ohio Stadium. After throwing three interceptions against Purdue, Smith was a one-

(opposite) Indiana linebacker Jake Powers goes flying head-over-heels as Brandon Schnittker blocks for quarterback Troy Smith.

(left) Ted Ginn silences the crowd in Spartan Stadium after scoring on a 17-yard reverse play.

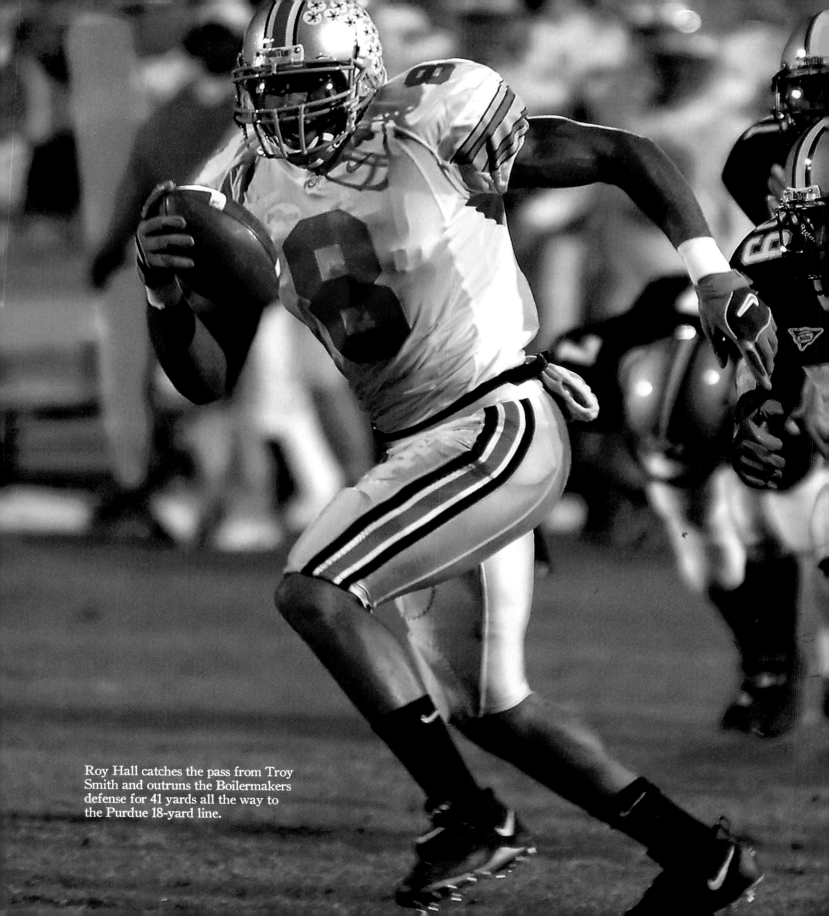

Roy Hall catches the pass from Troy Smith and outruns the Boilermakers defense for 41 yards all the way to the Purdue 18-yard line.

2004

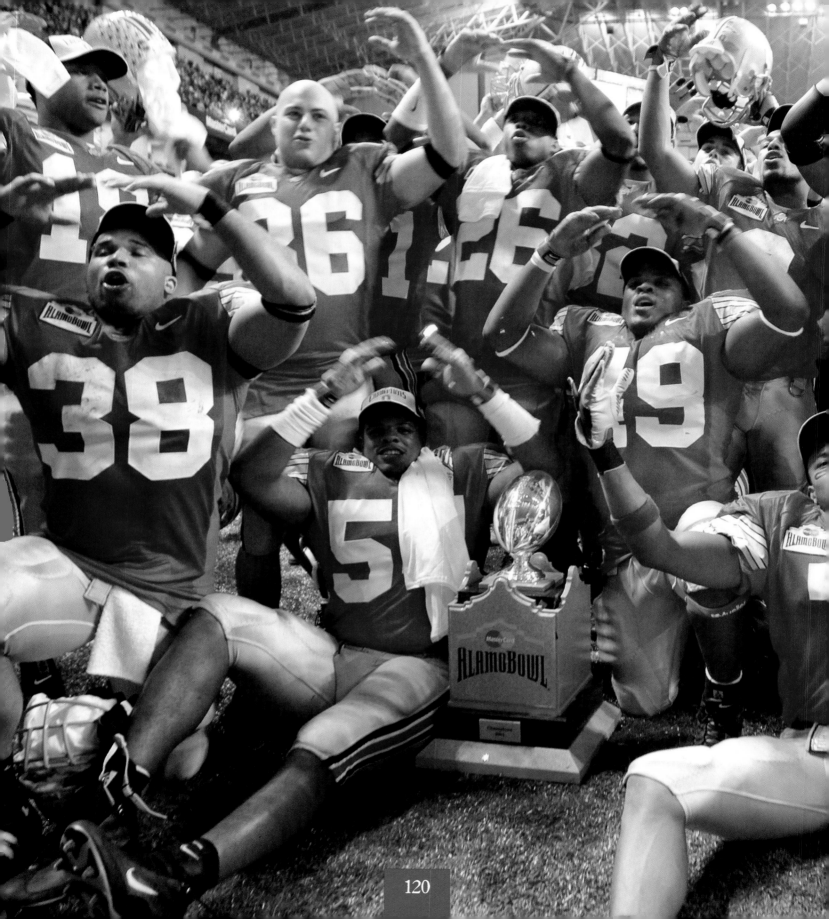

2004

man wrecking crew against Michigan. He rushed for 145 yards on 18 attempts and scored a touchdown. Just over a minute into the game he connected with Gonzalez for a 68-yard touchdown strike that put OSU up 7-0. For the game he was 13 of 23 passing for 245 yards and two touchdowns. He accounted for 386 yards of total offense. Ginn was also brilliant with an 82-yard return of a punt for a touchdown. It was his fourth punt-return touchdown of the season, which tied an NCAA record. Ginn also had five receptions for 123 yards to go with 123 yards on four punt returns.

The win over Michigan returned OSU to the polls. They were No. 24 in the country when they went to San Antonio to play Oklahoma State in the Alamo Bowl. The Buckeyes went there, however, without Smith.

The NCAA declared Smith ineligible for two games for taking $500 from a booster. Those two games were the bowl game and the season opener in 2005. Zwick returned to the starting lineup against Oklahoma State and had an excellent game, leading the Buckeyes to a 33-7 win. Despite pulling a hamstring early in the game, Zwick completed 17 of 27 for 189 yards, one touchdown, and no interceptions. Ginn had six catches for 78 yards and also rushed eight times for 40 yards and a touchdown. ■

The Buckeyes sing "Carmen Ohio" after their 33-7 Alamo Bowl victory over Oklahoma State.

2004 STATS

Overall: 8–4 • Big Ten: 4–4
Final Ranking: Associated Press No. 20, USA Today No. 19
Major Award Winners: Mike Nugent – Lou Groza Award
First Team All-American: A. J. Hawk (linebacker), Mike Nugent (kicker)
First Team All-Big Ten: A. J. Hawk (linebacker), Mike Nugent (kicker)

W/L	Date	PF	Opponent	PA	Location
W	09–04–2004	27	Cincinnati	6	Columbus, OH
W	09–11–2004	24	Marshall	21	Columbus, OH
W	09–18–2004	22	North Carolina St.	14	Raleigh, NC
L	10–02–2004	27	Northwestern	33	Evanston, IL
L	10–09–2004	13	Wisconsin	24	Columbus, OH
L	10–16–2004	7	Iowa	33	Iowa City, IA
W	10–23–2004	30	Indiana	7	Columbus, OH
W	10–30–2004	21	Penn St.	10	Columbus, OH
W	11–06–2004	32	Michigan St.	19	East Lansing, MI
L	11–13–2004	17	Purdue	24	West Lafayette, IN
W	11–20–2004	37	Michigan	21	Columbus, OH
W	12–29–2004	33	Oklahoma St.	7	San Antonio, TX

Running back Brandon Joe rumbles for
seven yards to the five-yard line against
Oklahoma State.

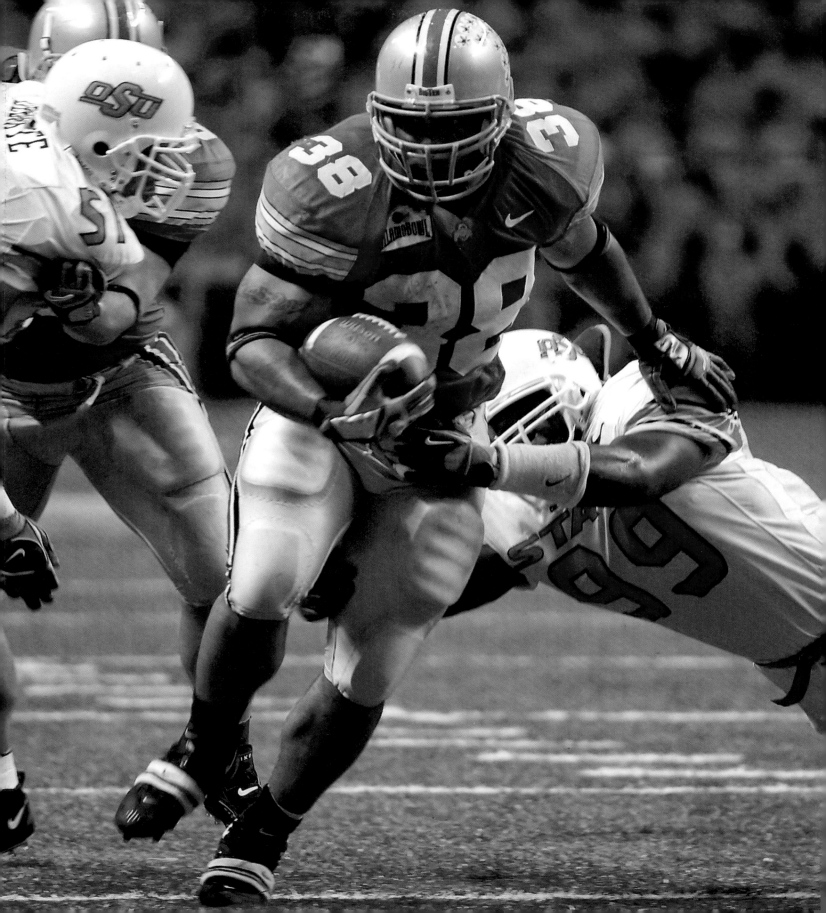

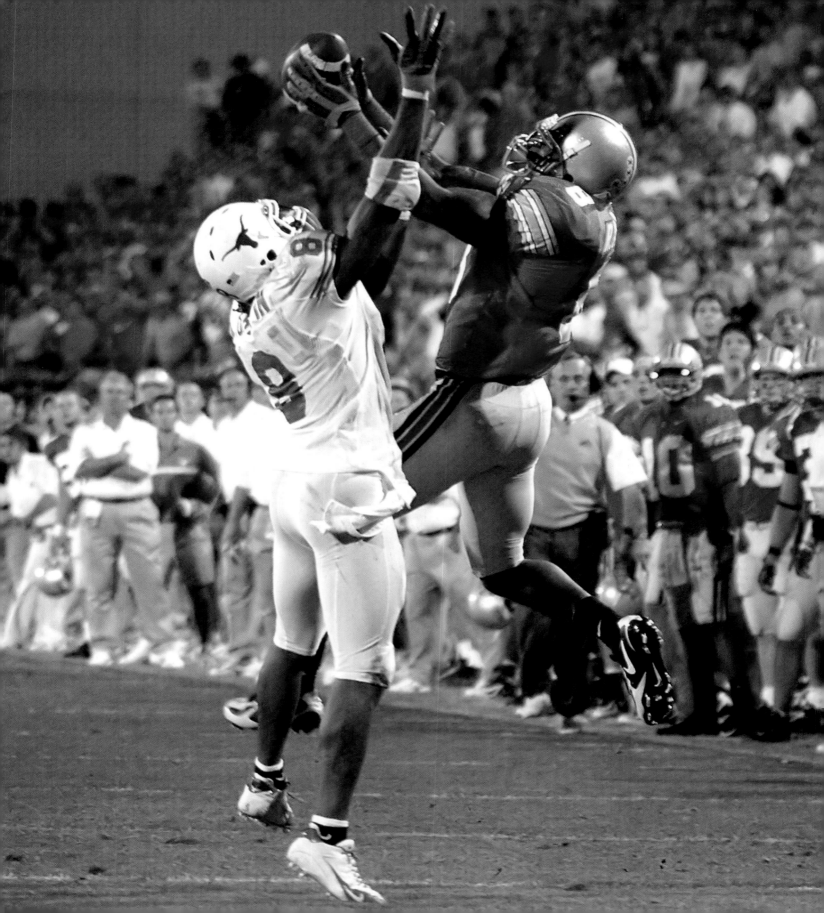

2005
Season of Rebound

If 2004 was a season of change, 2005 was a season of rebound. The Buckeyes rebounded not only from a lackluster 8–4 record the previous season but also from a 3–2 start in 2005. After a loss to Penn State they reeled off seven straight wins to finish the year at 10–2. The streak propelled OSU from No. 15 in the polls to No. 4 by season's end.

The Buckeyes had experience and skill returning at every position. Santonio Holmes and Ted Ginn Jr. were back at wide receiver and a bigger, stronger, faster Antonio Pittman assumed the role of the starting tailback. The line of Doug Datish, Rob Sims, Nick Mangold, T.J. Downing, and Kirk Barton was big, strong, veteran, and played as a unit in every game.

With an abundance of speed and skill in the wide receiver corps, the Buckeyes often played with four or even five wide receivers. Wide receivers Anthony Gonzalez and Roy Hall frequently found themselves on the field with Ginn and Holmes. The Buckeyes also had a capable stable of fullbacks and tight ends. Stan White Jr. was a mainstay at fullback along with Dionte Johnson. Ryan Hamby returned at tight end and got help from newcomer Rory Nicol.

On defense, David Patterson, Quinn Pitcock, Mike Kudla, and Marcus Green all returned up front from the 2004 squad. Joel Penton and Jay Richardson provided depth. At linebacker, Bobby Carpenter, A.J. Hawk, and Anthony Schlegel were seasoned veterans. In the defensive backfield, Nate Salley, Donte Whitner, Ashton Youboty, and Tyler Everett returned as an experienced unit.

The Buckeyes were stacked. All they were missing as the season began was their quarterback.

Wide receiver Roy Hall elevates over Texas cornerback Cedric Griffin to grab a 22-yard reception from quarterback Justin Zwick. Head Coach Jim Tressel and quarterback Troy Smith look on from the sideline.

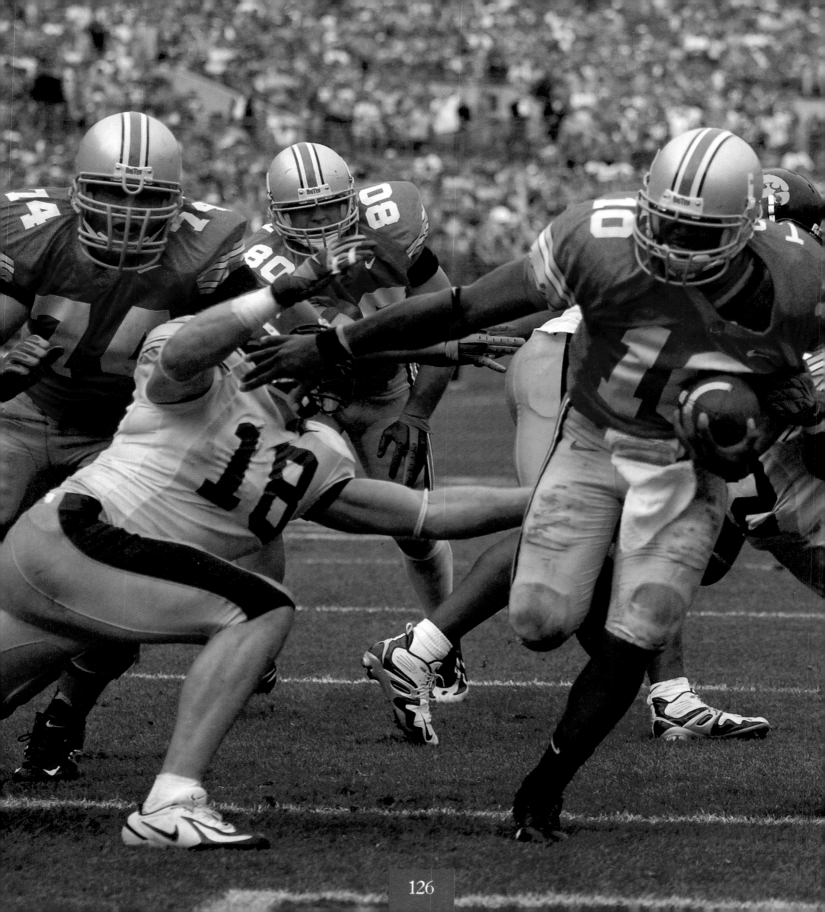

2005

Troy Smith remained on NCAA suspension for the season opener. He was not able to practice with the team until after the suspension. That left OSU shorthanded at a key position early in the season, most importantly for a marquee nonconference confrontation with Texas in the second game of the season.

Zwick played well in the season opener against Miami of Ohio, completing 17 of 23 (73.9 percent) for 156 yards, one touchdown, and one interception. Despite the fact that Smith was eligible for the Texas game, Zwick got the starting nod against the Longhorns, though the game plan did call for Smith to rotate in during the game.

The Buckeyes were ranked No. 5 when No. 2 Texas came to Columbus on September 10. The Buckeyes took a 20–16 lead into the fourth quarter. With just 2:37 remaining in the game when Longhorns quarterback Vince Young completed a 24-yard touchdown pass to Limas Sweed to give his team the lead at 23–22. A late safety led Texas to a 25–22 win over OSU. Young and the Longhorns went on to win the national championship.

As planned, Smith got into the game for limited action against Texas and threw a touchdown pass to Santonio Holmes in the second quarter. His performance earned him the start the following week against San Diego State, but he still shared the quarterback duties with Zwick. Against Iowa,

Troy Smith threads his way through the Iowa defense for his second touchdown against the Hawkeyes.

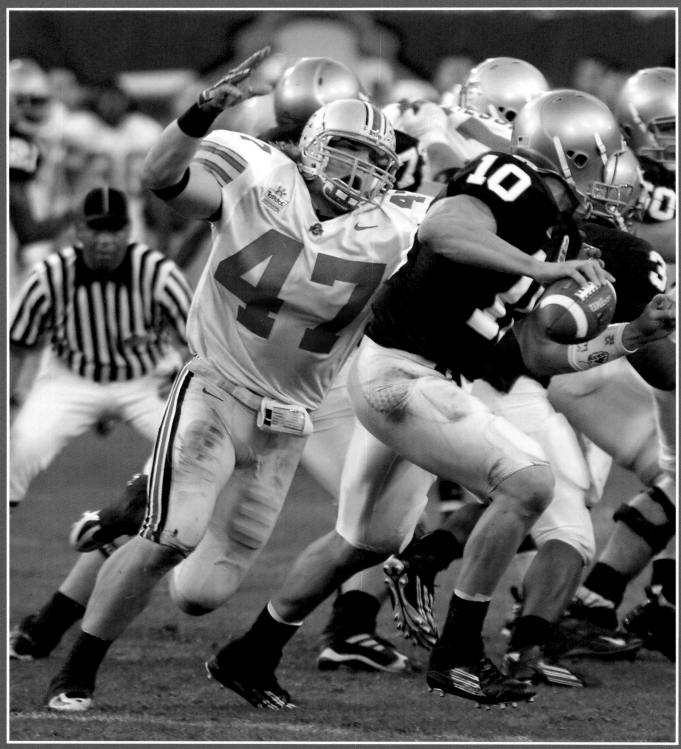

2005

Smith started and played most of the game and the No. 8 Buckeyes ripped No. 21 Iowa 31–6 at Iowa City. The next week against Penn State Smith was not particularly effective and seemed rattled by the Lion pass rush. The Buckeyes lost that game 17–10 in Happy Valley, but the experience seemed to refocus Smith who improved every game for the rest of the season.

By the time the Michigan game rolled around, Smith was in full form. Once again he played his finest game against the Wolverines. OSU trailed 21–12 deep into the fourth quarter but Smith directed two touchdown drives in the last 7:49 of the game to put the game into the win column for the Buckeyes. He threw one touchdown pass of 26 yards to Holmes to cap a five-play, 67-yard drive and pull the Buckeyes to 21–19 with 6:40 remaining. Smith then worked one last miracle late in the game. He directed a 12-play, 88-yard drive in 3:54 that produced the game-winning touchdown by Antonio Pittman from three yards out, with only 24 seconds left to play. The winning touchdown was set up by a pass from Smith to Anthony Gonzalez who made an acrobatic, leaping catch to give the Buckeyes a first down on the Michigan 4-yard line. Smith passed for a career-high 300 yards on 27–37

(opposite) A. J. Hawk bears down on Notre Dame quarterback Brady Quinn during the early stages of the second half. Hawk sacked Quinn (his future brother-in-law) for an eight-yard loss.

(left) Members of the Ohio State Marching Band celebrate a Buckeyes touchdown against San Diego State.

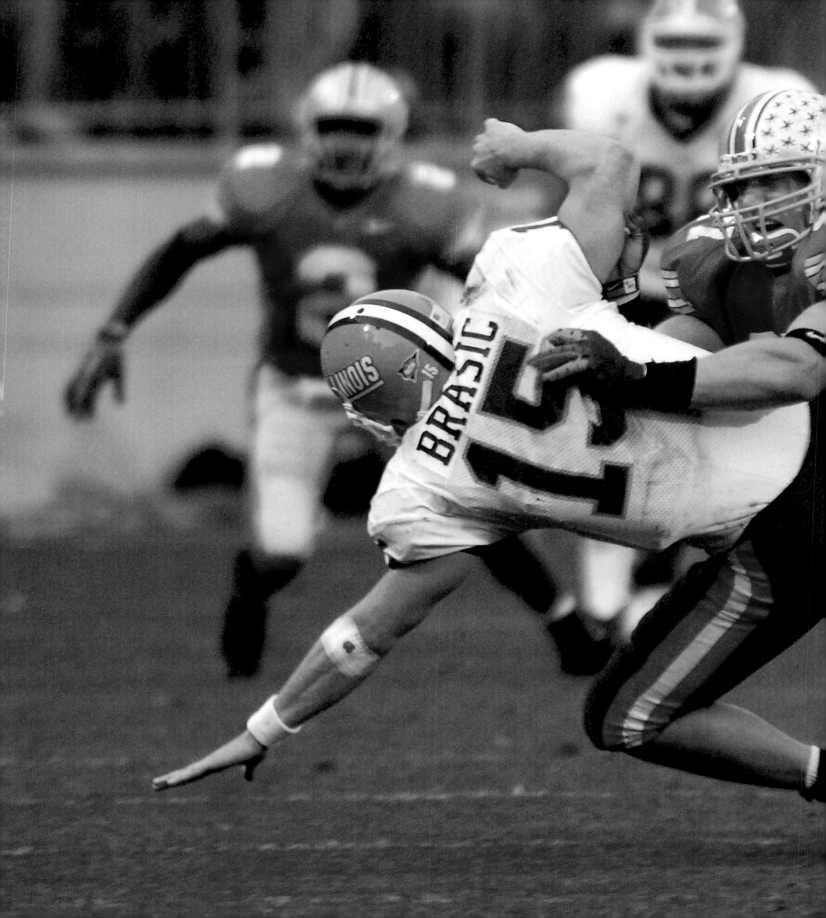

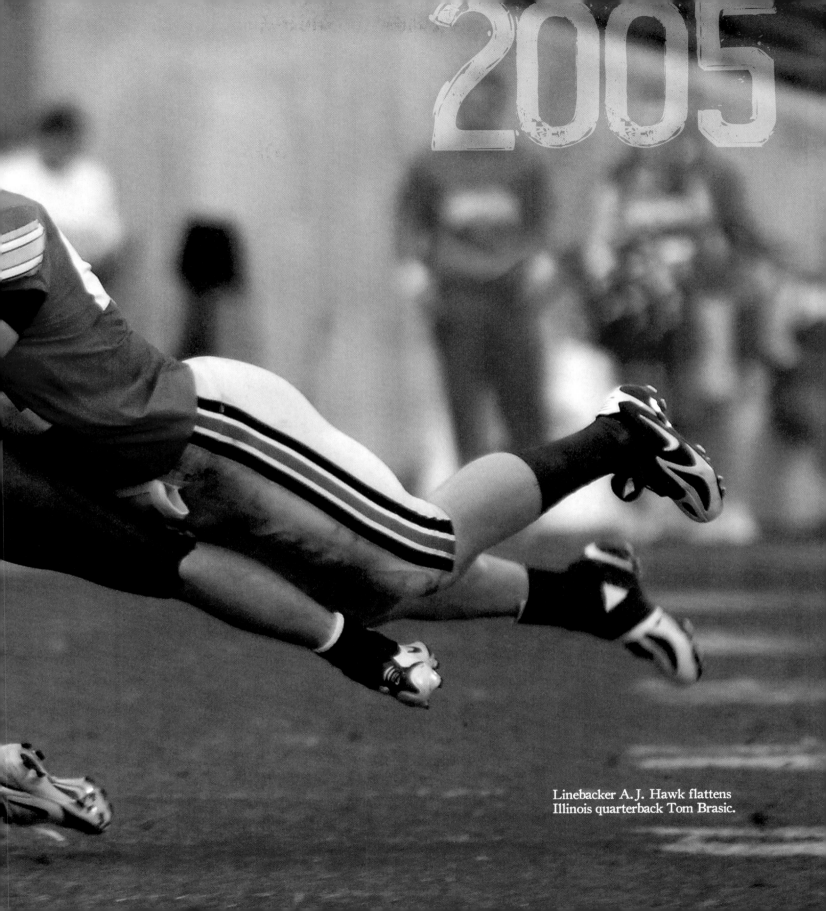

2005

Linebacker A. J. Hawk flattens
Illinois quarterback Tom Brasic.

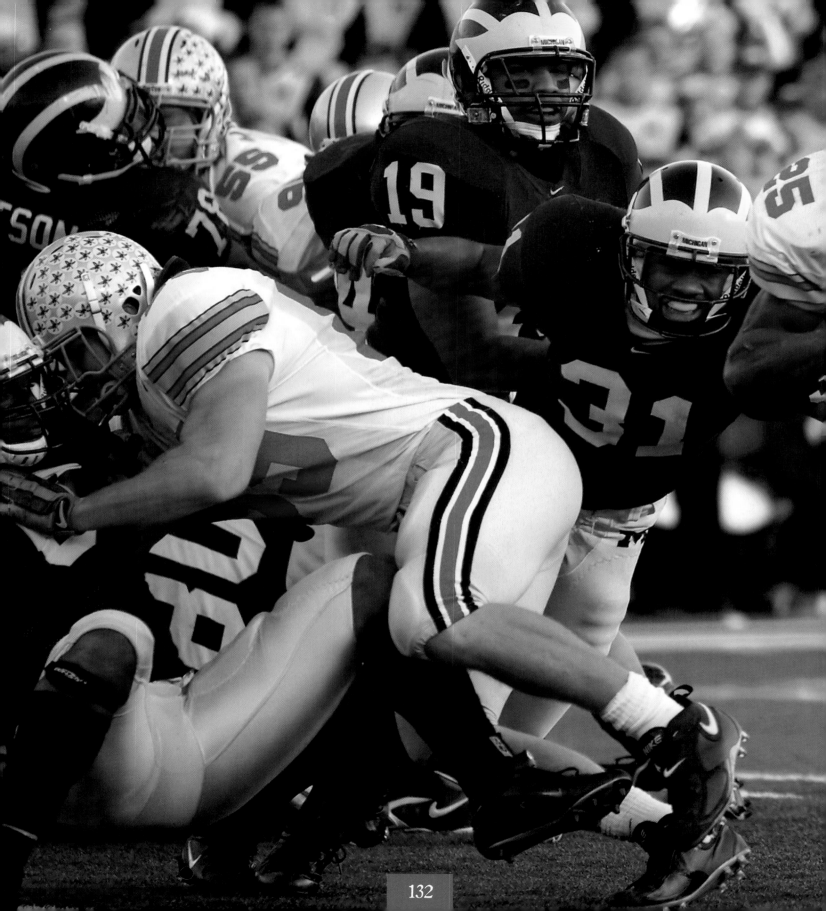

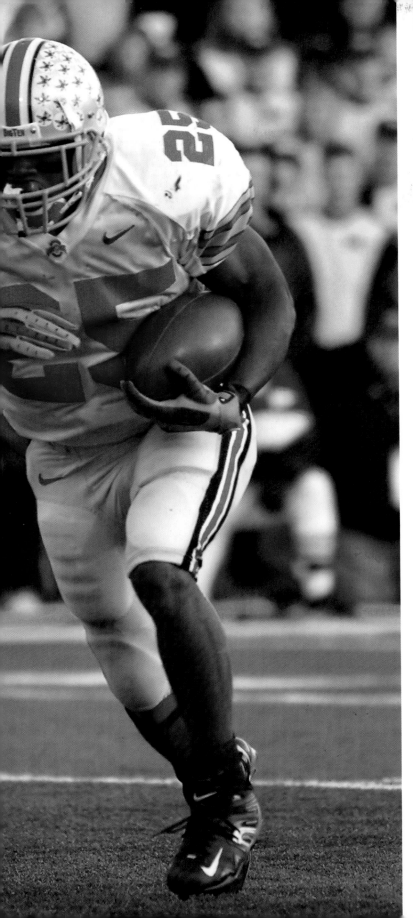

passing in the game. He also rushed for 37 yards and a touchdown.

Ohio State returned to the Fiesta Bowl where they met No. 6 Notre Dame coached by first-year head coach Charlie Weis. The No. 4 Buckeyes were too much for the Irish and won 34–20 in a game that was not as close as the final score indicated. OSU made big plays in both the passing game and running game against the Irish defense. Smith threw touchdown passes of 56 and 85 yards to Ginn and Holmes, respectively. Ginn also scored on a 68-yard reverse play and Pittman went 60 yards for a touchdown on a simple off-tackle play.

Ohio State finished the season on the upswing and a seven-game winning streak. But as Texas won the national title, the Buckeyes were left to wonder how their matchup with the Longhorns would have gone if Smith had been ready to play when the season began. ▪

(left) Antonio Pittman heads to his left, supposedly to center the ball for an attempted field goal, and finds nothing but grass between him and the go-ahead touchdown late in the game against the Wolverines. Stan White Jr. did an outstanding job collapsing the defensive line from his tight end position and Pittman walked into the end zone untouched with only 24 seconds remaining on the clock. Pitman's TD gave OSU a 25-21 win in Ann Arbor.

(above) The OSU Marching Band entertained the crowd in Michigan Stadium during halftime in Ann Arbor.

2005 STATS

Overall: 10–2 • **Big Ten:** 7–1, Conference Co-Champions
Final Ranking: Associated Press No. 4, USA Today No. 4, Harris Rankings No. 4
National Awards Winners: A.J. Hawk – Lombardi Award
First Team All-American: A.J. Hawk (linebacker),
Donte Whitner (safety), Nick Mangold (center)
First Team All-Big Ten: A.J. Hawk (linebacker), Mike Kudla (defensive end),
Nate Salley (safety), Rob Sims (offensive guard), Josh Huston (place-kicker), Santonio
Holmes (wide receiver), Donte Whitner (safety), Ashton Youboty (cornerback)

W/L	Date	PF	Opponent	PA	Location
W	09–03–2005	34	Miami (OH)	14	Columbus, OH
L	09–10–2005	22	Texas	25	Columbus, OH
W	09–17–2005	27	San Diego St.	6	Columbus, OH
W	09–24–2005	31	Iowa	6	Columbus, OH
L	10–08–2005	10	Penn St.	17	State College, PA
W	10–15–2005	35	Michigan St.	24	Columbus, OH
W	10–22–2005	41	Indiana	10	Bloomington, IN
W	10–29–2005	45	Minnesota	31	Minneapolis, MN
W	11–05–2005	40	Illinois	2	Columbus, OH
W	11–12–2005	48	Northwestern	7	Columbus, OH
W	11–19–2005	25	Michigan	21	Ann Arbor, MI
W	01–02–2006	34	Notre Dame	20	Tempe, AZ

OSU Head Coach Jim Tressel and the Buckeyes stand before
the OSU cheering section and sing "Carmen Ohio" in Michigan
Stadium following the win over the Wolverines.

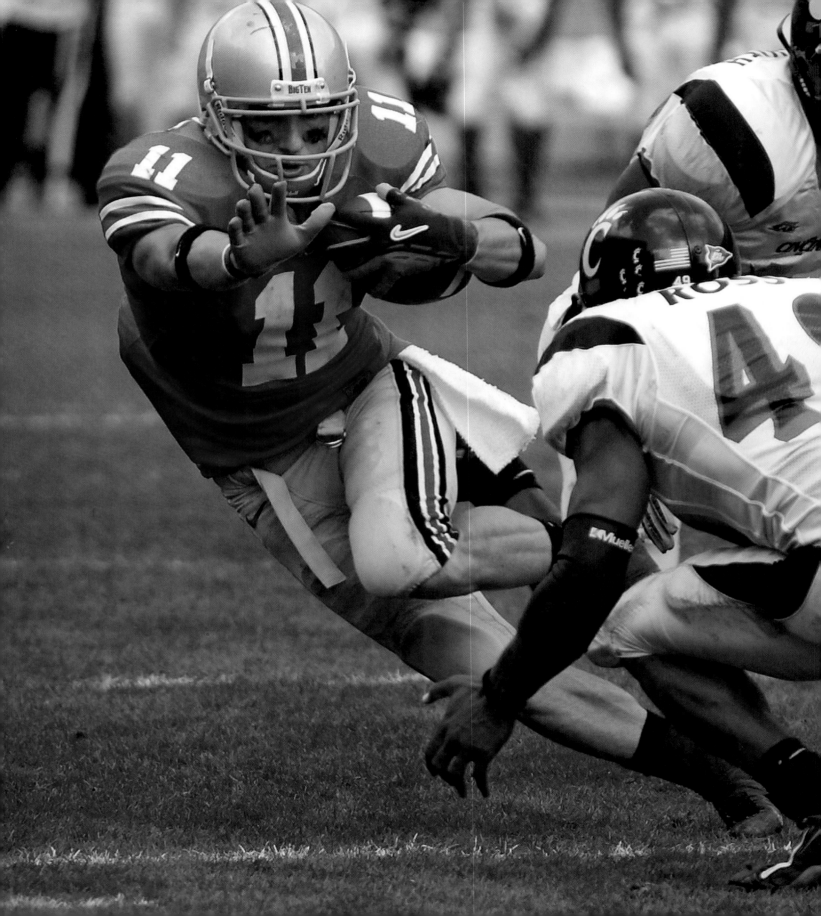

2006
A Year at the Top

The Buckeyes entered the 2006 season ranked as the No. 1 team in the nation. They posted a perfect 12–0 regular season record and in doing so went wire-to-wire at the top of the polls.

Only two teams were able to stay within 17 points of the Buckeyes during the regular season. Illinois fell by a final of 17–10 and Michigan was beaten 42–39. The rest of the games on the schedule were one-sided affairs. The OSU offense averaged 39.8 points per game and scored 35 or more points in nine of 12 contests. The defense held opposing offenses to 10.4 points per game during the 12–0 run. They surrendered more than 10 points just three times.

The season was highlighted by not one, but two wins over the No. 2-ranked team in the nation. The Buckeyes avenged a nonconference loss to Texas the previous season with a 24–7 win at the No. 2 Longhorns in the second game on the schedule. In the final game of the season Ohio State and Michigan met ranked No. 1 and No. 2 for the first time ever in the storied history of that rivalry.

A veteran defensive line and a group of young playmakers in the back seven spearheaded the Buckeyes defense. Sophomore linebacker James Laurinaitis led the team with five interceptions in his first season as a full-time starter. Sophomore corner Malcolm Jenkins added four more. OSU recorded 38 quarterback sacks led by sophomore defensive end Vernon Gholston's 8.5 and senior tackle Quinn Pitcock's 8.0.

The Buckeyes offense was varied and dynamic. Junior tailback Antonio Pittman rushed for 1,233 yards averaging 5.1 yards per carry. Freshman

Wide receiver Anthony Gonzalez strikes a Heisman-like pose as he takes a pass from eventual Heisman winner Troy Smith for a 13-yard gain to the Cincinnati 13-yard line.

tailback Chris "Beanie" Wells added 576 more while averaging 5.5 yards per attempt. Fullback Stan White Jr. cleared the path for both of them very effectively and caught an occasional pass. Junior wide receiver Ted Ginn Jr. led the team in all-purpose yards with 781 receiving, 440 on kickoff returns, 266 on punt returns, and 17 rushing. Ginn accounted for 11 touchdowns: one as a punt returner, one as a kick returner, and nine more as a receiver. Ginn and fellow wide receiver junior Anthony Gonzalez combined for 1,515 total receiving yards and 17 scores.

The OSU offensive line was veteran, tough, and dominant. Doug Datish, T.J. Downing, and Kirk Barton started every game at center, right guard, and right tackle respectively. Alex Boone, Steve Rehring, and Tim Schafer combined for the rest of the starts at left guard and left tackle.

Stars were everywhere in 2006, but no star shone brighter than that of quarterback Troy Smith. Smith was the catalyst that made the OSU offense move. He led the team in total offense with 2,283 yards passing and 373 rushing. He threw 30 touchdown passes against six interceptions. His game-day decision-making was superb, his command of the offense excellent, and his ability to make plays at crucial moments uncanny. As he had been the two previous seasons, he was magnificent in the

With the Buckeyes nursing a four-point lead in the third quarter, tailback Antonio Pittman rushes over right guard for a 56-yard touchdown against Michigan.

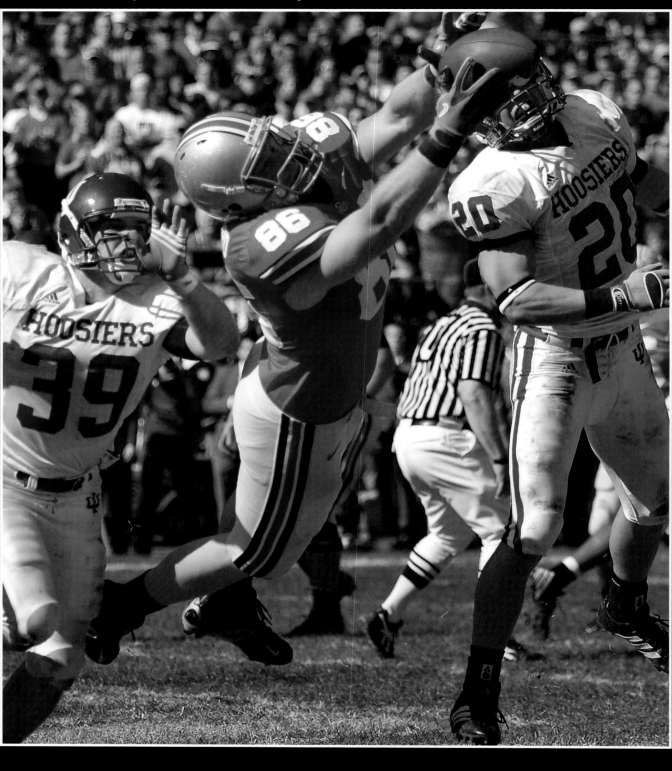

Michigan game when he passed for 316 yards and four touchdowns on 29 completions in 41 attempts, a completion rate of just over 70 percent. For his efforts, Smith was awarded the Heisman Trophy following the regular season, becoming the sixth Buckeye to win college football's greatest honor. It is no mystery what made the 2006 team so good during the regular

(opposite) Tight end Rory Nicol reaches full extension as he grabs a pass from Troy Smith in the end zone for a 23-yard touchdown. Nicol added another touchdown catch later in the game in OSU's 44–3 win over the Hoosiers.

(left) Golfing great and OSU alumnus Jack Nicklaus dotted the "I" in Script Ohio at the Minnesota game.

(above) Quarterback Troy Smith looks over the Hawkeyes defense and sets up a few blocking assignments before getting the snap from center Doug Datish.

2006

season. What will forever remain a mystery is what made them so bad in the BCS national championship game against Florida.

The team that spent the year at the top of the rankings couldn't stay there at season's end when Florida completely dominated them in every phase of the game for a 41–14 thrashing. The once-proud OSU defense was shredded and Smith completed just four passes while throwing one interception. His fumble near the end of the first half led directly to a Florida score.

There were very few bright spots that day for the Buckeyes. One was a 93-yard return for a touchdown of the opening kickoff by Ginn. Even that play had its downside, however. Ginn was injured by a teammate as they celebrated his play and Ginn did not return to the contest the rest of the way. Antonio Pittman also gave the Buckeyes something to cheer about when he went 18 yards for an OSU touchdown in the second quarter, but it would not be enough.

The loss was so devastating for Buckeyes fans that they completely lost sight of the previous accomplishments of the team and looked on the season as nearly a total failure. The previous 12 wins and an entire season at the top of the polls had surrounded the Buckeyes with euphoric, adoring fans. The loss to Florida, or more accurately the way they lost to Florida, instantly changed that.

Antonio Pittman heads up the middle of the Spartans defense for seven yards before being taken down at the MSU 15-yard line.

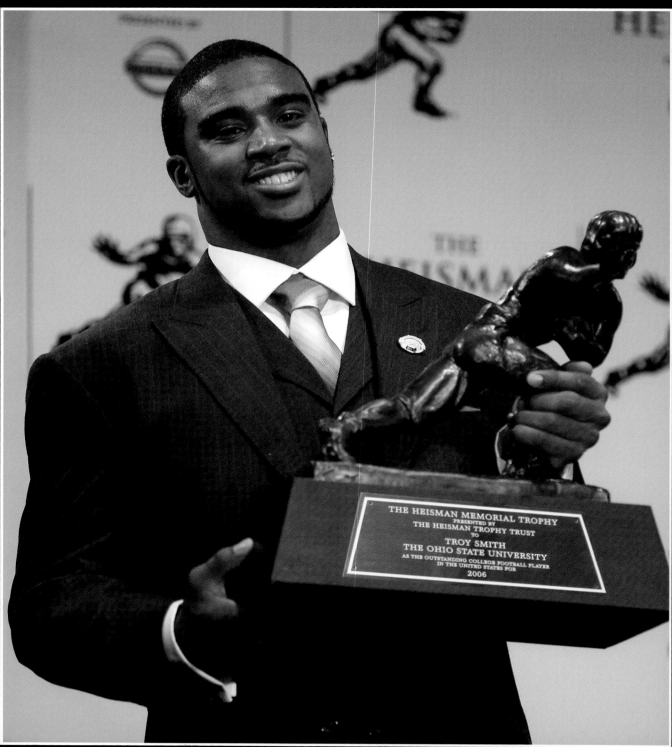

2006

As disappointing as the BCS National Championship Game was, with time this team—and in particular the win over No. 2-ranked Michigan in Ohio Stadium—will be remembered fondly. The rankings of both teams already had put the emotion of the Michigan game at a fever pitch in the week leading up to it. Those emotions then reached unprecedented levels when former Michigan head coach and Ohio native Bo Schembechler died the day before the game. It is hard to imagine that a more emotional game was ever played in the series, or for that matter, all of college football, and the Buckeyes came out on top. The win over the Wolverines was OSU's fifth in the previous six meetings. Troy Smith had been the OSU starting quarterback in three of them.

There were many milestones set in the season. One of the more significant is that the Buckeyes became the only team in college football history to play three games in one season that matched up the No. 1 and No. 2 teams in the polls. ■

(opposite) Troy Smith proudly hoists his Heisman Trophy at the post-award-ceremony press conference at the Hard Rock Cafe in Times Square, New York City. Smith was the sixth Ohio State Buckeye to be honored as the most outstanding player in college football.

(left) The cheerleaders celebrate the touchdown by Antonio Pittman. Unfortunately, it would be OSU's last score of the BCS Championship Game.

Overall: 12–1 • **Big Ten:** 8–0, Conference Champions
Final Ranking: Associated Press No. 2, Harris Rankings No. 1
(pre-bowl ranking), USA Today No. 2
National Award Winners: Troy Smith – Heisman Trophy,
James Laurinaitis – Nagurski Award
First Team All-American: Troy Smith (quarterback), James Laurinaitis
(linebacker), Quinn Pitcock (defensive lineman)
First Team All-Big Ten: Troy Smith (quarterback), Antonio Pittman
(running back), Anthony Gonzalez (wide receiver), Doug Datish (center),
T. J. Downing (guard), Ted Ginn Jr. (wide receiver), Quinn Pitcock (defensive line),
James Laurinaitis (linebacker), Malcolm Jenkins (defensive back),
Antonio Smith (defensive back)

W/L	Date	PF	Opponent	PA	Location
W	09–02–2006	35	Northern Illinois	12	Columbus, OH
W	09–09–2006	24	Texas	7	Austin, TX
W	09–16–2006	37	Cincinnati	7	Columbus, OH
W	09–23–2006	28	Penn St.	6	Columbus, OH
W	09–30–2006	38	Iowa	17	Iowa City, IA
W	10–07–2006	35	Bowling Green	7	Columbus, OH
W	10–14–2006	38	Michigan St.	7	East Lansing, MI
W	10–21–2006	44	Indiana	3	Columbus, OH
W	10–28–2006	44	Minnesota	0	Columbus, OH
W	11–04–2006	17	Illinois	10	Champaign, IL
W	11–11–2006	54	Northwestern	10	Evanston, IL
W	11–18–2006	42	Michigan	39	Columbus, OH
L	01–08–2007	14	Florida	41	Glendale, AZ

Linebacker James Laurinaitis gets ready to launch into
the Gator backfield on the snap of the ball.

TRESSELIZED
Ohio State versus Michigan – 2006

Writing about the biggest game in the Ohio State versus Michigan series in your lifetime, maybe even the biggest game in that series ever, is a lot harder than you think. If you are an Ohio State or Michigan fan, what could I possibly tell you that you don't already know? I could tell you that the rivalry game is big, and that the No. 1 versus No. 2 match-up in 2006 was really big.

Right. If you don't already know that, then you are probably a cabbage. What could I possibly tell you about that game that would make you say 'Gee, I haven't seen that before?' Well, here it is. I'm going to tell you why OSU fans were comfortable about that game in 2006 and why Michigan fans were sweating more than usual. It can be summed up in two words: Jim Tressel.

The Ohio State football program has been under Jim Tressel since 2001. By 2006 it was truly his. The players on the team were all recruited by him and the upperclassmen had all been "Tresselized", and that, for the most part, is why Buckeyes fans were calm and comfortable that day in 2006 and why Wolverines fans were just a bit more anxious than they care to admit.

Jim Tressel (or Cheaty McSweatervest to detractors) is not charismatic like a Bo Schembechler or Woody Hayes. He is not clever like Lou Holtz. He is not flashy, not urbane, not exciting at all. He is however the consummate leader for a college football team.

Tressel's leadership is characterized by two qualities: he is a rare mix of an individual who has a clear understanding and firm grasp of the big picture, and yet is obsessively immersed in

OSU Head Coach Jim Tressel shares a moment with Michigan's Lloyd Carr before the classic 2006 No. 1 vs. No. 2 match-up between the Buckeyes and Wolverines. The 2006 season would mark Carr's final trip to Columbus as the head coach of the Wolverines. The game marked the only time in the storied history of the rivalry that Ohio State and Michigan have met in a one versus two match-up.

every detail of his undertaking.

Those two qualities almost never coexist in people. That's why we have CEOs (big picture people) and accountants (detail people). Tressel, however, embodies both for his football team. He provides clear-cut big picture goals, yet is involved in every detail of the day-to-day operations of his team.

Tressel's players recognize that after enough time in his program they have become "Tresselized," mirrors of Tressel, from the way they prepare for games to the way they react to situations. They even start to sound like him.

"I know you look at organizations, football teams, whatever the case may be, and ordinarily the organization takes on the personality of its leader," said 2006 OSU wide receiver Anthony Gonzalez. "Since Coach Tressel is our top leader, yeah, I think that does trickle down a lot. It's kind of funny. If you listen to the interviews that we give I think a lot of the stuff is taken directly from stuff he's said."

Tressel is what he is. You can always count on him performing a certain way, no matter what the situation. He never, ever, ever varies. His consistency is maddening for local media members. All of them can predict exactly what he will say in every situation. It makes writing about him hard. It is also what makes him successful. He truly believes in his message, his ideals, his way of doing things, and that allows him to remain maniacally consistent. His consistency has enabled him to accomplish the most difficult task for any coach or leader: getting those who he is leading to internalize his vision and concepts. He does it not with eloquence or flash, but by example. He is consistent, down to the smallest detail, and expects those whom he leads to be the same.

"We're all who we are, we all have our own little things, but it comes from the top down," said OSU linebackers coach and co-defensive coordinator Luke Fickell. "Here's an example. You walk in in the morning and Coach Tressel is picking up trash off the ground as he's walking through the parking lot. I'm thinking 'I better pick up some if he's picking up trash.' What kind of example is that? Just little things like that."

Antonio Smith was a senior starting cornerback in 2006. He had five years of "Tresselization". He came to recognize the process and its impact.

"When you come to college and you're 18 years old and still growing into a young adult, but when you leave here you leave with a lot values and great things that Coach Tressel instills in us," said Smith. "Whenever Coach Tressel speaks we all listen. He definitely has great things to say, but he doesn't really get too fired up. What you see is what you get. How you see him now is pretty

Antonio Smith (14) and James Laurinaitis put a hit on Michigan quarterback Chad Henne.

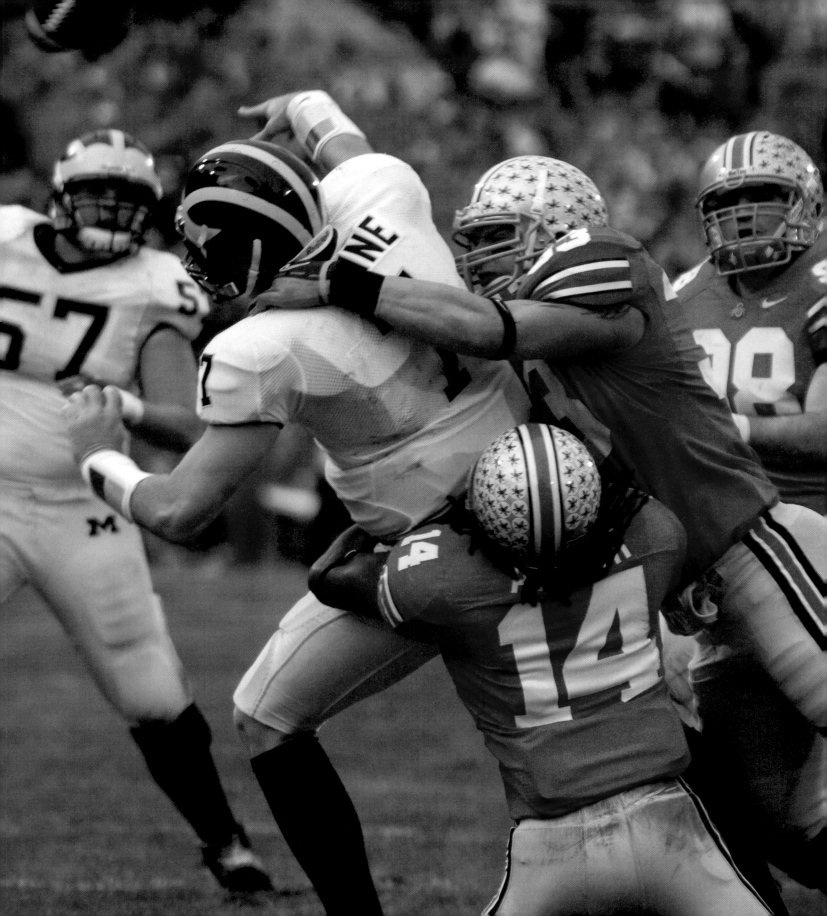

much how he stays each day throughout our practice and throughout the game. He doesn't get too fired up but as a team we're ready to play."

In 2006, before arguably the biggest football game in a lifetime, Tressel coached with the firm belief that the qualities he had been preaching all year would allow his team to be the best it could be. He did not hype the game to his players. He didn't have to. He had already let them know how important it was, not because of the circumstance of that particular game, but because it is their job, week after week, to be the best they can be. That, he believes, is all he needs his team to believe.

"Is his demeanor different (Michigan week)? I think his demeanor is rather consistent, I really do. He's pretty even-keeled guy all the way across," said Gonzalez.

Tressel's approach is perfect for the rivalry. His methodical "Get a little better ever week" approach with emphasis on "Being the best you can be by the end of the season" is exactly what is needed by a football program whose rivalry game is, coincidently, always the last game of the season. His approach de facto makes the Michigan game the focus of the entire season.

"In the beginning of the season, we know we have to take one step at a time, one game at a time and we have to focus on our specific role that week," said Smith. "When it's the last game of the season that is our task at hand that week. We know we have to focus on Michigan and Michigan only. We can't focus on the national championship game, we can't focus on our records in previous years, we have to focus on Michigan. Coach Tressel just does a good job of preparing us throughout the year."

When the game kicked off in 2006, Jim Tressel was on the OSU sideline wearing his familiar sweater vest. His headphones were on and his focus was riveted on one thing and one thing only—doing his part on the sideline to win the football game. That's what every coach does on game day. Tressel also had something else going for him. He had a team on the field that was fully "Tresselized"—one that has bought into the value system that he believes allows them to be the best they can be in The Game of Games.

The Buckeyes won against second-ranked Michigan on that Saturday in 2006. They did so because their coach gave them the best opportunity to be as good as they can be in the biggest game in memory. They had a good game plan, they were well-conditioned, they were well-drilled, but most importantly, they were "Tresselized" from the first day of their Buckeyes careers.

"When you're a freshman you learn what's important here," said 2006 starting defensive tackle and team captain David Patterson. "You learn that winning is important, that November is important and that humility is important. You start becoming a Buckeye."

And that is the ideal that calmed you on that day in 2006, Mr. Ohio State fan, and worried you more than just a little, my Wolverine friend. ■

(left) Running back Chris Wells takes off on a 52-yard touchdown jaunt to put the Buckeyes up 14–7 against the Wolverines.

(above) Linebacker John Kerr (52) is literally tackled from behind (no penalty) as he attempts to bring down Mike Hart in the Michigan backfield.

2007
A Year of Overachievement

The loss of a Heisman-winning quarterback is usually not a good thing for a team. The 2007 Buckeyes had to contend with just that and whole lot more, yet they put together an outstanding season in 2007.

Heisman Trophy winner Troy Smith graduated and moved on to the Baltimore Ravens, so the Buckeyes were looking for a quarterback as 2007 began. When Antonio Pittman, Anthony Gonzalez, and Ted Ginn Jr. all declared for the draft after their junior year of eligibility, the Buckeyes were stripped of returning skill players as well. Additionally, three of their top four defensive tackles all exhausted their eligibility in 2006. Second-teamer Todd Denlinger was the only returner on the interior defensive line from the previous year's two-deep.

Junior Todd Boeckman won the competition for the quarterback spot over Robby Schoenhoft and Antonio Henton. Beanie Wells stepped in for Antonio Pittman at running back and the two Brians—Robiskie and Hartline—took over at wide receiver. The group was talented but largely unproven.

To some extent the number of veterans that returned on the offensive line, at fullback, and at tight end offset what the Buckeyes lacked in experience at the skill positions. Three of the five starters from the previous year's line returned including Kirk Barton at right tackle, Alex Boone at left tackle, and Steve Rehring at left guard. Redshirt junior Ben Person moved into the right guard spot after spending three years as an understudy. Redshirt sophomore Jim Cordle took over at center. Rory Nicol and Jake Ballard returned at

Todd Boeckman's pass to Brian Robiskie in the end zone goes just beyond Robiskie's grasp in OSU's game against Washington.

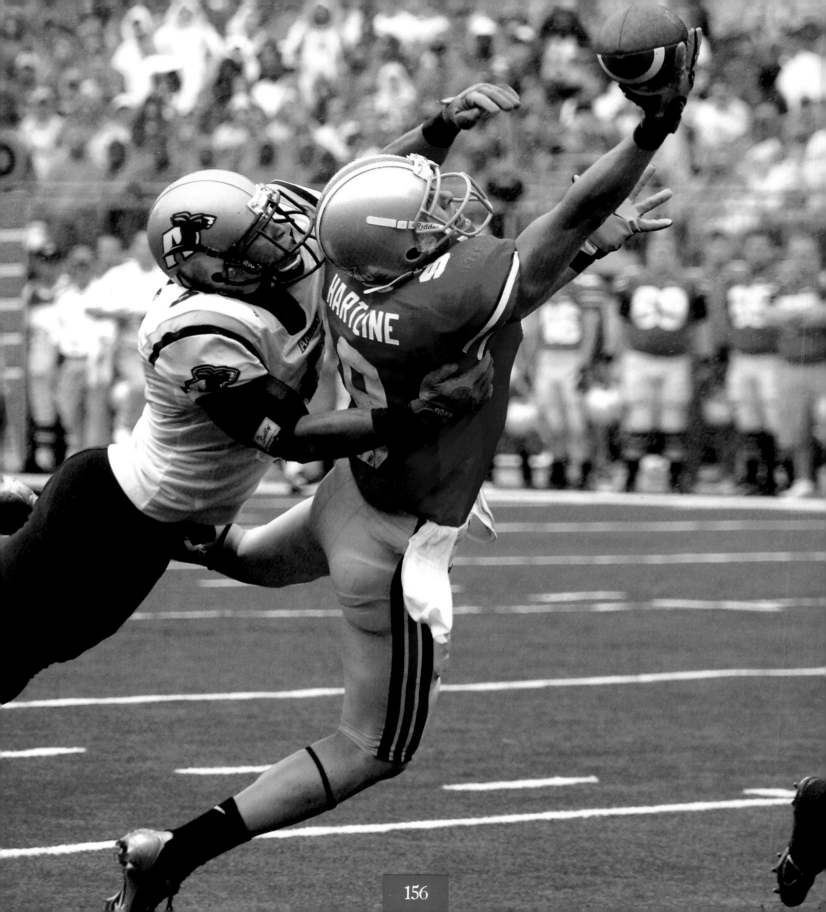

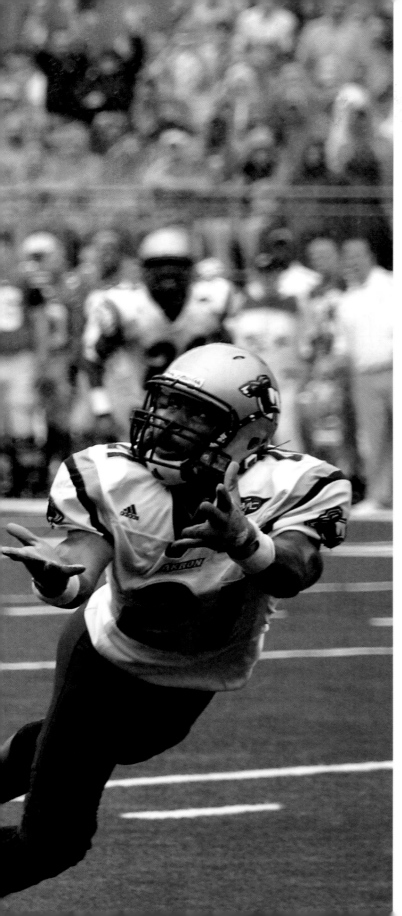

tight end and team co-captain Dionte Johnson and Tyler "Tank" Whaley at fullback.

The defense was surprisingly strong in 2007 despite the youth on the interior defensive line. Defensive end Vernon Gholston had an outstanding season and recorded 14 sacks. The injury bug bit the Buckeyes at the other defensive end when starter Lawrence Wilson broke his leg in the season opener and was lost for the rest of the year. His backup, Robert Rose, also struggled all season with injuries. True-freshman Cameron Heyward was pressed into service and performed better than anyone could have reasonably expected.

The linebacking corps of James Laurinaitis, Marcus Freeman, and Larry Grant was good when the season started and improved as the season progressed. In the defensive secondary third-year players Malcolm Jenkins and Donald Washington held down the corners. True-sophomore Kurt Coleman entered the lineup as a starting safety and third-year player Anderson Russell returned after sitting out the latter half of the previous season with a knee injury.

The OSU defensive interior line was young but managed to play well enough to help the Buckeyes to an excellent season. Doug Worthington moved over from defensive end to the inside as one starter and Denlinger moved into the other starting posi-

Brian Hartline reaches as far as he can to make a catch against Akron.

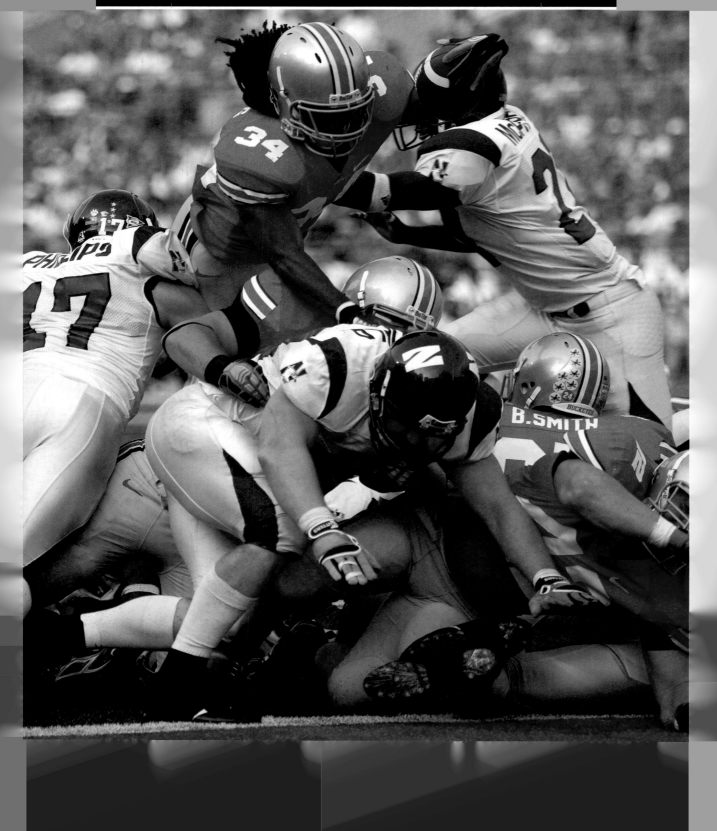

2007

tion. They were backed up by redshirt freshman Dexter Larimore and redshirt junior Nader Abdallah, both of whom saw extensive action.

Offensive tackle Kirk Barton decided to forego the NFL draft and return for his senior season. Reporters raised an eyebrow when Barton told them that he wanted to come back for one last crack at a national championship. With the loss of all that skill the Buckeyes couldn't possibly contend in 2007, could they? No one really seemed to think so. Barton, it turns out, knew a lot more than the pundits.

The Buckeyes began the season ranked No. 11 in the country. They reeled off eight straight wins—including road victories at Washington, Minnesota, and Purdue—to earn a spot at the top of polls, a spot they had become very accustomed to the previous season.

OSU carried the top ranking into the ninth contest; a night game at No. 22 Penn State. Before the season most had thought that contest would be a stern test but the game turned out to be a walk in the park for the Buckeyes. Boeckman completed 19 of 26 for 261 yards and three touchdowns. Ohio State did not punt once and led 37–10 late in the fourth quarter. A 97-yard kickoff

(opposite) Tailback Maurice Wells (34) launches himself into the end zone over the Northwestern defensive line for the final score of the game with 2:08 remaining in the third quarter. The Buckeyes won the game 58–7.

(above) Brutus Buckeye gets the crowd fired up before the Northwestern game.

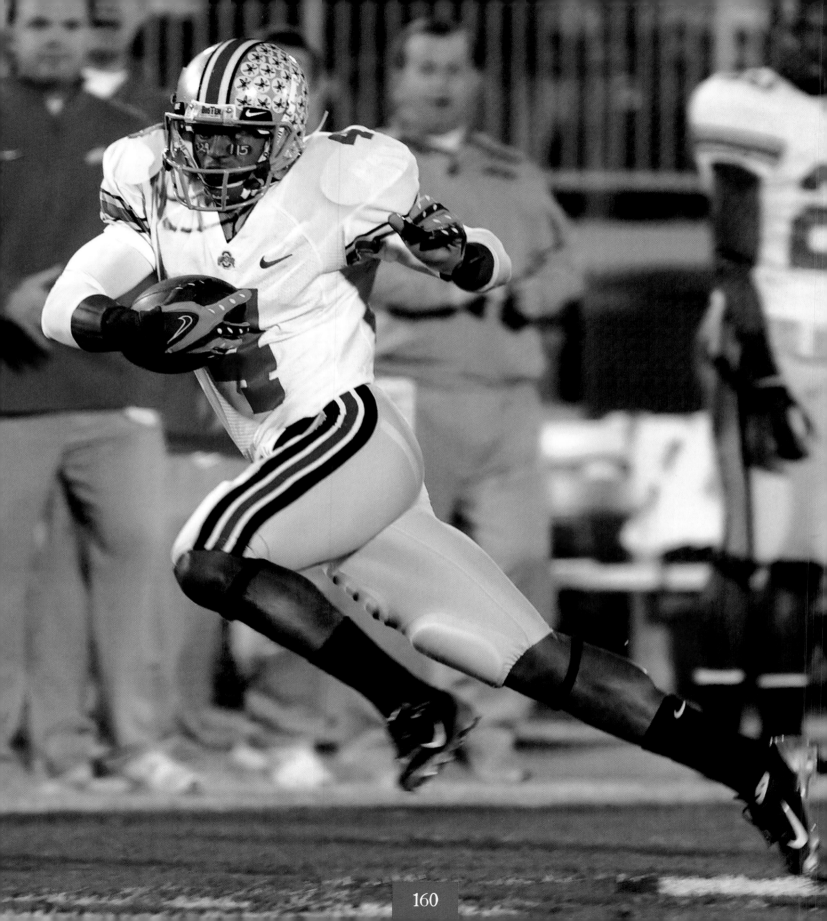

return for a touchdown by Penn State's A.J. Wallace saved some face for the Nittany Lions.

OSU defeated No. 19 Wisconsin 38–17 the following week and remained No. 1 headed into a home matchup with Illinois.

The Buckeyes stumbled when the unranked Illini came into Ohio Stadium and upset them by a score of 28–21. Illinois quarterback Juice Williams was incredible that day. Williams passed for a career-high four touchdowns and ran for 70 yards on 16 carries while Boeckman was intercepted three times. The loss knocked OSU down to No. 7 in the polls and seemed to end any hopes of returning to the national title game. There were still many reasons to get up for the next game: the annual showdown with Michigan.

Michigan seniors Chad Henne, Mike Hart, and Jake Long had returned for their senior seasons for a final crack at the Buckeyes after three straight losses to OSU. After the Wolverines opened their year with losses to Appalachian State and Oregon, Ohio State became Michigan's motivation for the rest of the season. Also at stake were a Big Ten championship and an opportunity to make a trip to the Rose Bowl.

The game against the No. 23 Wolverines was played in a steady downpour that hampered both offenses, particularly in the passing game. The

Wide receiver Ray Small (4) came up big against Penn State with this 60-yard catch and run that carried to the Nittany Lion 8-yard line.

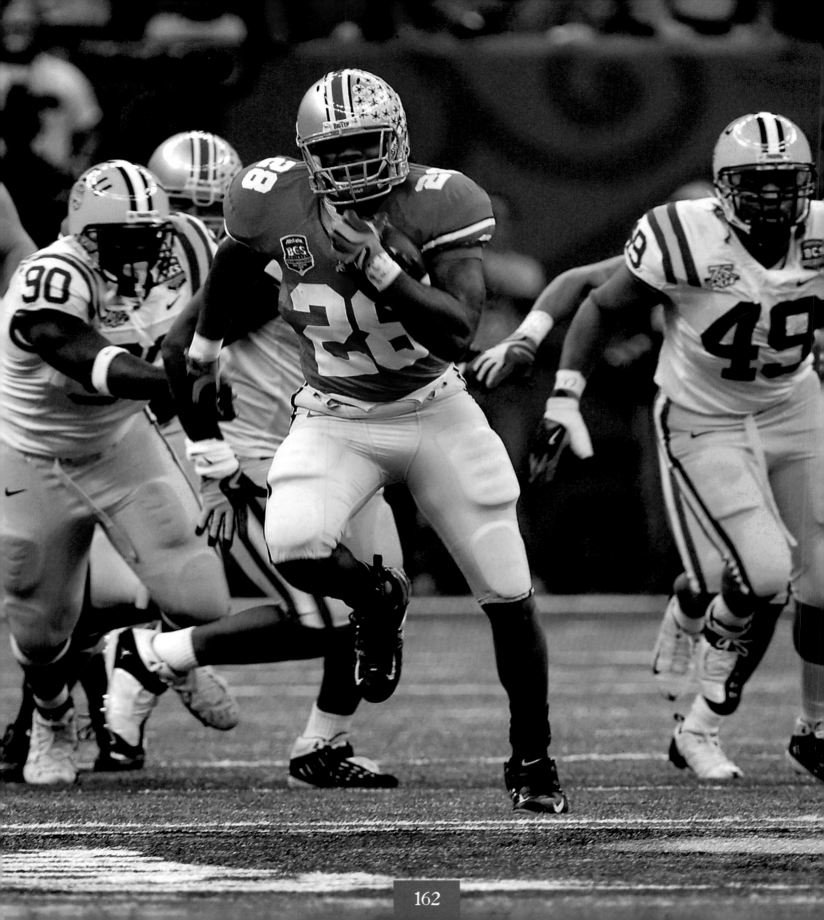

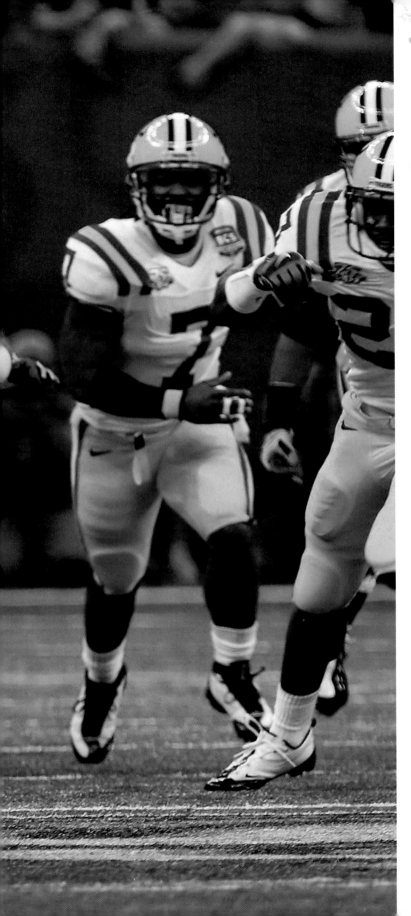

2007

Buckeyes passed for just 50 yards all day, Michigan 76. The difference in the game was OSU tailback Beanie Wells who rushed for 222 yards on 39 carries. Wells' two touchdowns on a one-yard run in the second quarter and an electrifying 62-yard jaunt in the third quarter were the only two touchdowns scored all day as OSU claimed a 14–3 win.

It was OSU's sixth victory over Michigan in seven years and made Tressel the only Buckeyes coach in history to beat Michigan six out of seven games. It was a devastating loss for Henne, Hart, and Long. All three ended up winless in their careers against OSU and the Buckeyes claimed the Big Ten title they so coveted. In the rain-soaked game, Hart was held to 44 yards rushing on 18 carries. Henne was sacked four times and hit repeatedly by the OSU defense. He was 11 for 34 passing for 50 yards, an average of 1.47 yards per attempt. Long, who would later be the No. 1 pick in the NFL draft, was bowled over by Vernon Gholston on an unforgettable sack of Henne. It also was the last Big Ten game coached by Michigan Head Coach Lloyd Carr who announced a week later that he would retire after the Michigan bowl game.

When the regular season ended, it appeared that the Buckeyes would play in the Rose Bowl as

Buckeye tailback Chris "Beanie" Wells breaks the line of scrimmage and outraces the rest of the LSU defense for a 65-yard touchdown run in the BCS National Championship Game.

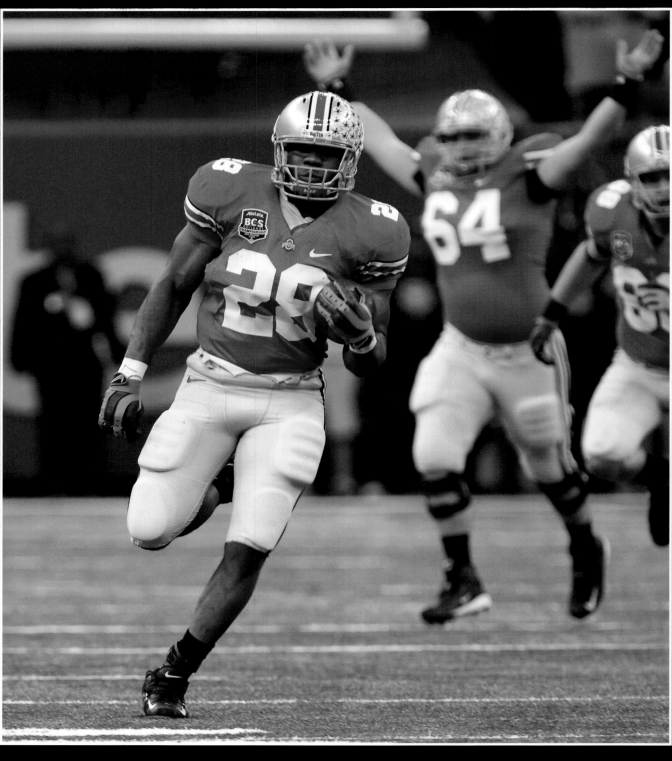

the Big Ten representative. But a series of unlikely events moved them back into the top spot in the polls as they sat idle. Losses by Missouri, West Virginia, and Kansas set up a BCS national championship game in the Sugar Bowl that featured the Buckeyes and LSU.

For the second straight season the Buckeyes lost in the BCS National Championship Game to an SEC team, but the loss did not produce the malaise that followed the loss in 2006. The Buckeyes made too many mistakes to win but never folded their tents against a very veteran and talented Tigers team. On OSU's first possession, sophomore tailback Beanie Wells gave Buckeyes fans something to cheer about with a career-long 65-yard jaunt for a touchdown to put OSU up 7–0 just two minutes and 26 seconds into the game. A Ryan Pretorious field goal put OSU up 10–0, but LSU then scored 31 unanswered points to take a 31–10 lead midway through the third quarter. Todd Boeckman hit Brian Hartline with a five-yard scoring strike to close the gap to 38–24 before the third quarter ended. LSU was able to answer with a touchdown early in the fourth quarter to put the game out of reach. The Buckeyes added a score late when Boeckman

(opposite) Chris Wells gets to the outside and turns up the field, roaring 65 yards across the field to the end zone as center Jim Cordle (64) signals the touchdown.

(above) Director of Football Performance Eric Lichter fires up the Buckeyes as they take the field.

2007 STATS

Overall: 11–2 • **Big Ten:** 8–0, Big Ten Champions
Final Ranking: Associated Press No. 5, Harris Rankings
(prebowl) No. 1, USA Today No. 4
National Awards: James Laurinaitis – Butkus Award
First Team All-American: James Laurinaitis (linebacker), Kirk Barton (offensive
tackle), Vernon Gholston (defensive end), Malcolm Jenkins (defensive back)
First Team All-Big Ten: Todd Boeckman (quarterback), Chris Wells
(running back), Kirk Barton (offensive tackle), Vernon Gholston (defensive end),
James Laurinaitis (linebacker), Malcolm Jenkins (defensive back)

W/L	Date	PF	Opponent	PA	Location
W	09–01–2007	38	Youngstown St.	6	Columbus, OH
W	09–08–2007	20	Akron	2	Columbus, OH
W	09–15–2007	33	Washington	14	Seattle, WA
W	09–22–2007	58	Northwestern	7	Columbus, OH
W	09–29–2007	30	Minnesota	7	Minneapolis, MN
W	10–06–2007	23	Purdue	7	West Lafayette, IN
W	10–13–2007	48	Kent St.	3	Columbus, OH
W	10–20–2007	24	Michigan St.	17	Columbus, OH
W	10–27–2007	37	Penn St.	17	State College, PA
W	11–03–2007	38	Wisconsin	17	Columbus, OH
L	11–10–2007	21	Illinois	28	Columbus, OH
W	11–17–2007	14	Michigan	3	Ann Arbor, MI
L	01–07–2008	24	Louisiana St.	38	New Orleans, LA

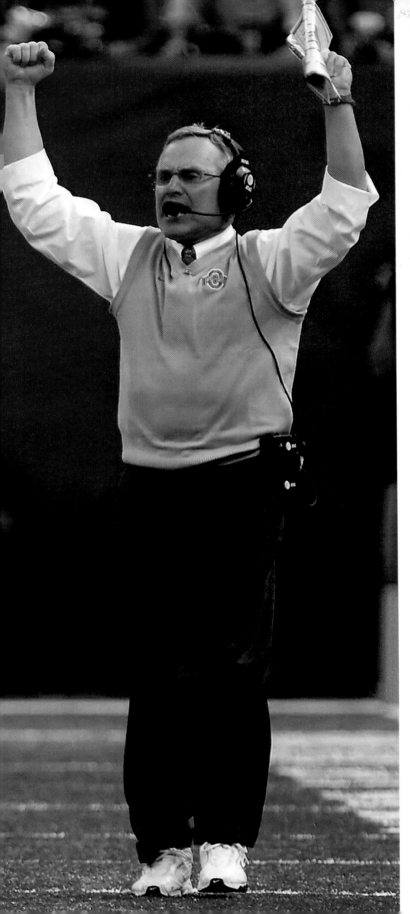

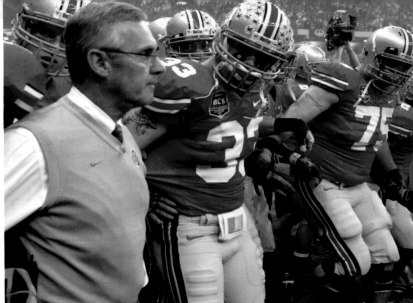

again found Hartline for a touchdown to make the final 38–14.

Ohio State actually outgained LSU 353 yards to 326 but costly mental errors, penalties, and mistakes in the kicking game led to their undoing against a very good Tigers team.

As was the case in 2006, following the season a number of OSU underclassmen faced the decision of whether to declare for the NFL draft or stay for one more year with the Buckeyes. Unlike 2006, most of them decided to stay. Linebackers James Laurinaitis and Marcus Freeman, defensive back Malcolm Jenkins, wide receiver Brian Robiskie, and offensive lineman Alex Boone all had legitimate prospects in the draft and all decided to return to OSU for one last year. Defensive end Vernon Gholston elected to enter the draft and was the sixth-overall pick by the New York Jets. ■

(left) Head Coach Jim Tressel displays his enthusiasm on the sideline during the BCS National Championship Game.

(above) The Buckeyes were anxious to get on the field in the BCS National Championship Game but the Fox Network representative (out of the frame to the left) had them wait for a cue from the network before letting them run onto the field.

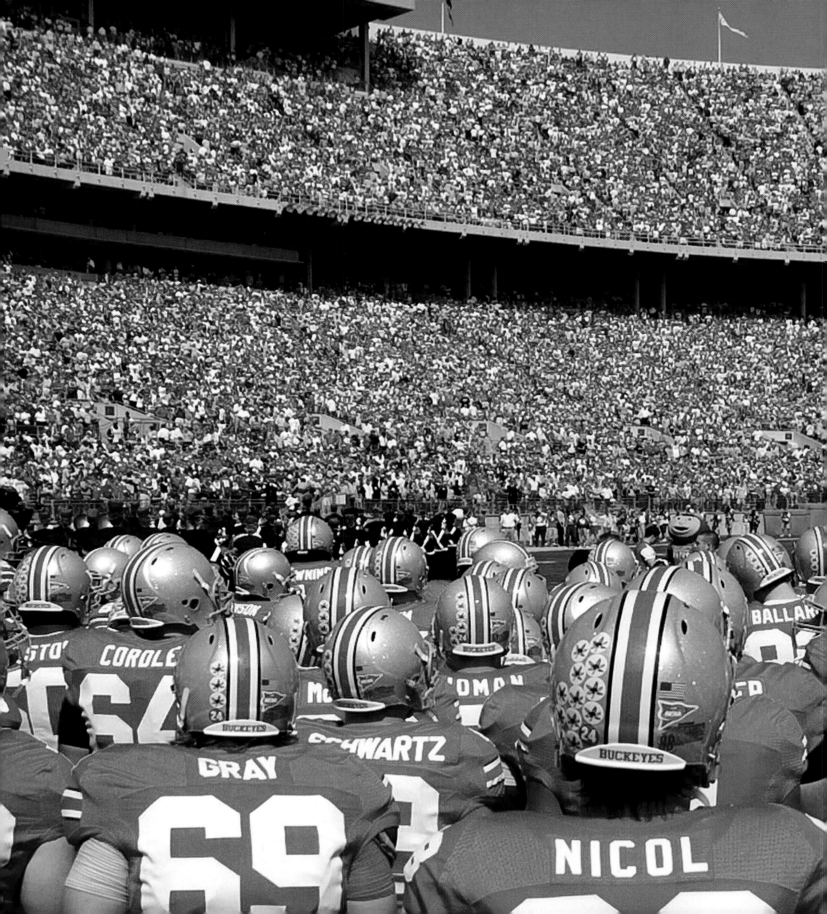

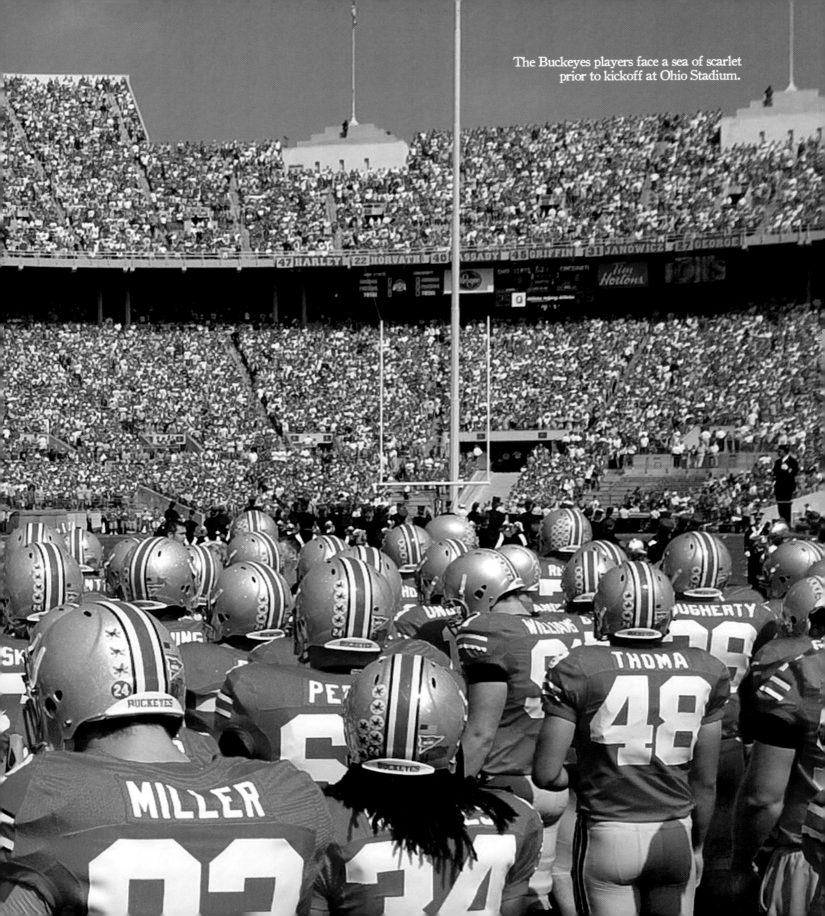

The Buckeyes players face a sea of scarlet prior to kickoff at Ohio Stadium.

BIG NEWS

Buckeyes Football: THE Big Story in the Buckeye State

It was big news when Ohio State unexpectedly qualified for the BCS National Championship Game in 2007. Around the Buckeye State it was—without question—the biggest news: OSU would be going to New Orleans to play LSU for the national championship.

OSU Head Coach Jim Tressel was the headliner for OSU's pre-bowl media day in Columbus following the announcement. Tressel met with reporters in the basement of the Fawcett Center on the campus of The Ohio State University. The location is the home of WOSU broadcasting and provided a studio location for the event, complete with studio lighting for the dozens of videographers on hand. It had to be held there because, quite frankly, all the regular venues at OSU for that kind of event would have been too small.

Tressel drew a press contingent of close to 150 representatives; each of the 63 chairs in the studio was filled. Around 20 video cameras (with operators) from media outlets from Ohio, Louisiana, and other parts of the country were in action on a raised camera deck to bring the tally of attendees to just over 100. At least 35 to perhaps 50 more reporters and photographers lined the side walls of the studio as can be seen in the photo on page 172. It was a full house, and it wasn't a crowd of lightweights.

In addition to the contingent of reporters who regularly cover the Buckeyes were national reporters from *Sports Illustrated*, ESPN, CBS, and others. The national people were there because it's a national game, but the Ohio contingent was there because when the Buckeyes make news, it is *the* news around the Buckeye State.

John Damschroder is the Columbus Bureau Chief for Fox 8 News in Cleveland, Ohio. Damschroder's job is to cover the top stories, the

The Buckeyes make the long pregame march down the staircase in the Metrodome for the final time. When they return to Minneapolis in 2010, the Golden Gophers will host them in their new on-campus open-air stadium.

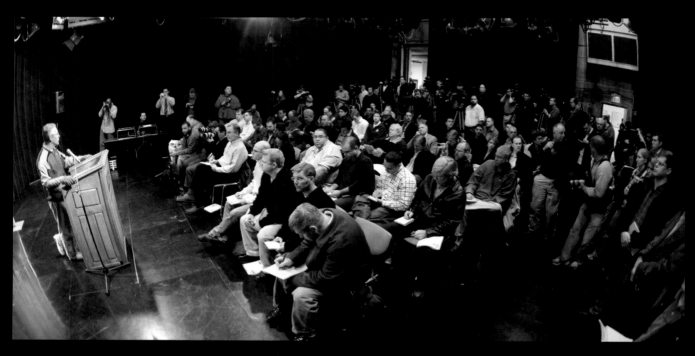

big stories in Columbus, and for the most part that means the state government. Damschroder recently covered the conviction of Governor Robert Taft breaking ethics laws in 2005 to become the first sitting governor in Ohio to be convicted of a crime.

"You're talking about a special governor. You're talking about the great-grandson of a president and supreme court chief-justice, grandson of a senator, son of a senator," said Damschroder.

Damschroder was on hand the day Taft met with the media following his conviction. It was big news. It was also small potatoes compared to the press conference Damschroder attended prior to OSU's appearance in the BCS Championship Game in 2007.

"[Taft's] news conference was half the size and one tenth of the length of Tressel's," said Damschroder. "You had some national interest in that (Taft) story. CNN was here for instance. It was a national story, but Tressel with the press has a much more elevated stature than any Ohio political figure."

If you are not from the Buckeye State that probably seem out of whack, but during the press conference Tressel was asked about the abundance of college head coaches from the state of Ohio. In his answer, Tressel alluded to Ohio's cultural attachment to the game of football.

"Culturally, Ohio is very interested in football," said Tressel. "Paul Brown, who I think is one of

Jim Tressel addresses the media at a press conference in Columbus prior to the team's departure for New Orleans and the BCS National Championship Game.

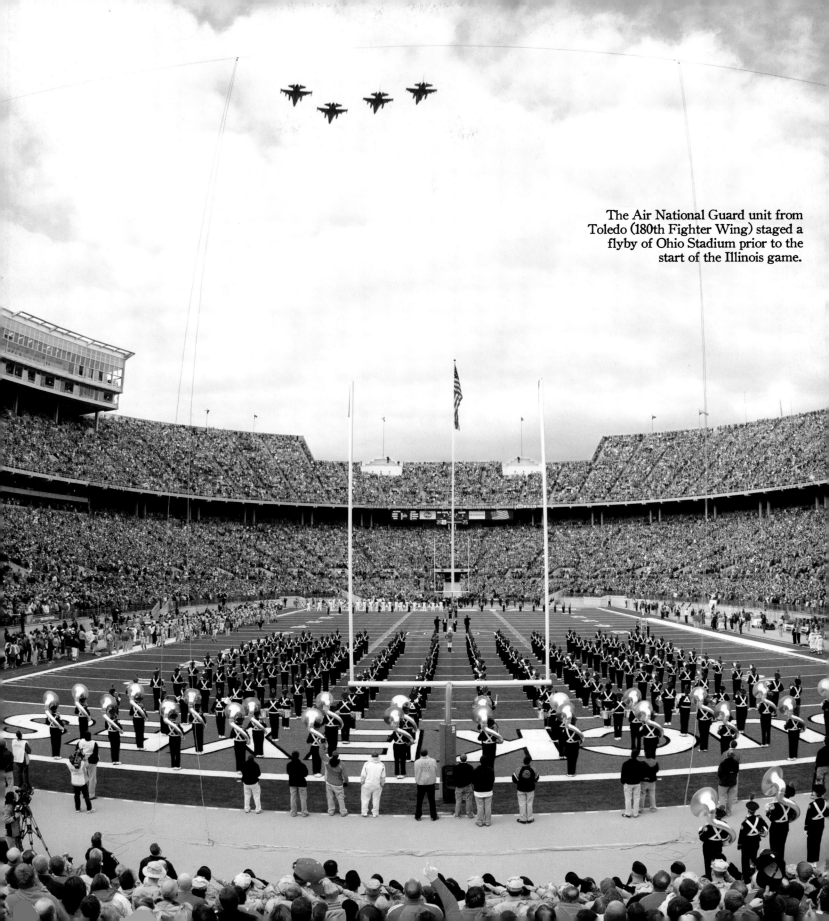

The Air National Guard unit from Toledo (180th Fighter Wing) staged a flyby of Ohio Stadium prior to the start of the Illinois game.

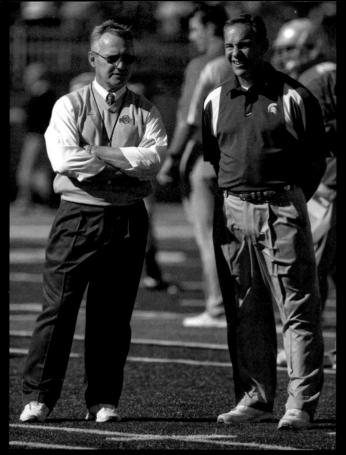

Jim Tressel talks things over with former OSU defensive coordinator and current Michigan State Head Coach Mark Dantonio before the game.

the giants of the game of football and one of the giants of making Ohio State what it is today, was one of the first coaches that had a playbook and studied film and did all those things. I just think there is a lineage of people who have been around the game. We've got two professional franchises. High school football is very important and 35 or so colleges that play football in the state. It's a place that really values its football." said Tressel.

That inherent cultural interest is exactly what makes OSU football the biggest story in the state—always. That's why Damschroder was on hand when Tressel took the podium to talk about the Fiesta Bowl against LSU.

"It goes back to what's the bigger story, and there is no bigger story than Ohio State football," said Damschroder. "When Tressel speaks to the culture of Ohio, my presence basically underscores that, by what's a big high-interest story, as well as what is important. Ohio State football is important to the psyche of the people of Ohio."

Damschroder added, "I don't think there are 12 people in the state who can speak knowingly on our economic competitiveness and how state government affects that. Every second waitress at Bob Evans (restaurants) knows when the Buckeyes have a bad game plan."

The importance of the game of football in Ohio

has elevated Tressel to a level of celebrity that overshadows every political figure around the state. With that celebrity, however, is a level of pressure that would make even the most hardened politico cower.

"Everybody in the state has their entire year affected when the Buckeyes go stink the joint out in the national championship game (as they did in 2006)," Damschroder said. "In terms of relative pressure, it is exponentially higher on Tressel than it is on any government official. Moreover, government officials excel at pushing accountability to someone else. There is no one except the man in the arena in the sports field. Essentially, there's no one he can push it to."

And around the Buckeye State that's pressure, and a really big story. ■